Expressions in Wood

Masterworks from
The Wornick Collection

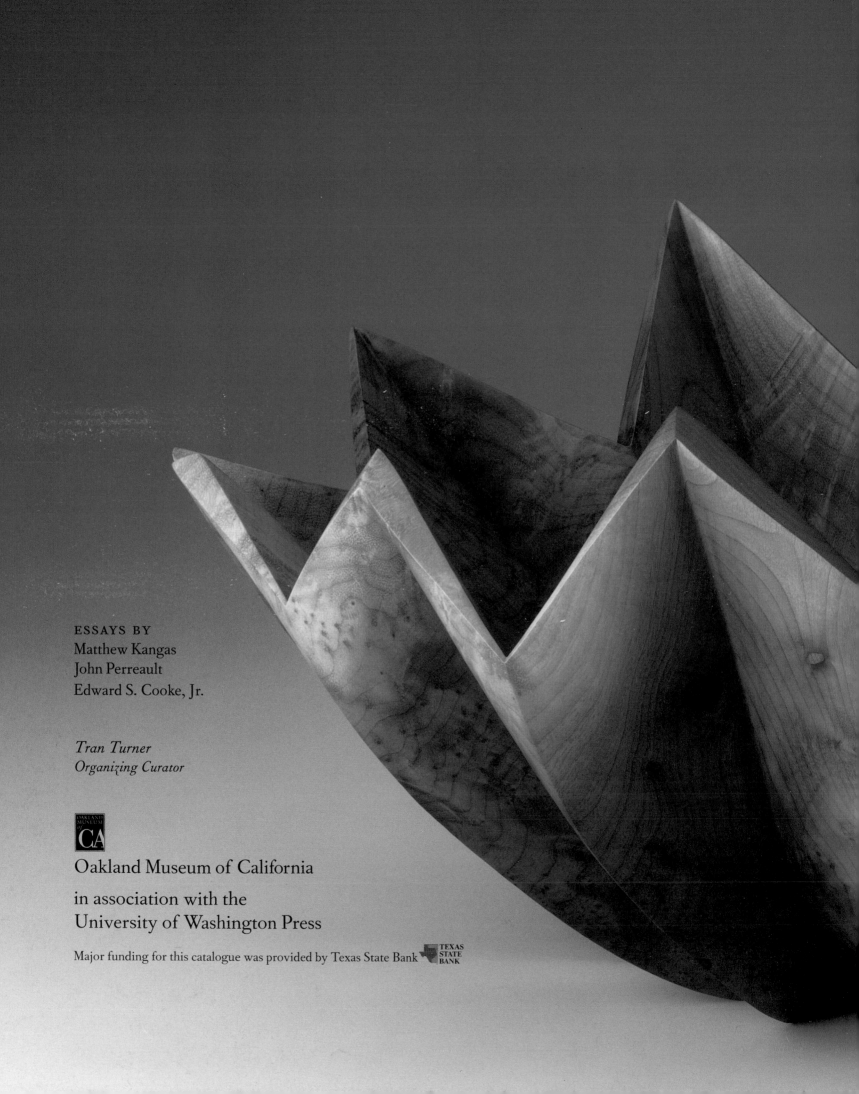

ESSAYS BY
Matthew Kangas
John Perreault
Edward S. Cooke, Jr.

Tran Turner
Organizing Curator

Oakland Museum of California

in association with the
University of Washington Press

Major funding for this catalogue was provided by Texas State Bank

Expressions in Wood

Masterworks from
The Wornick Collection

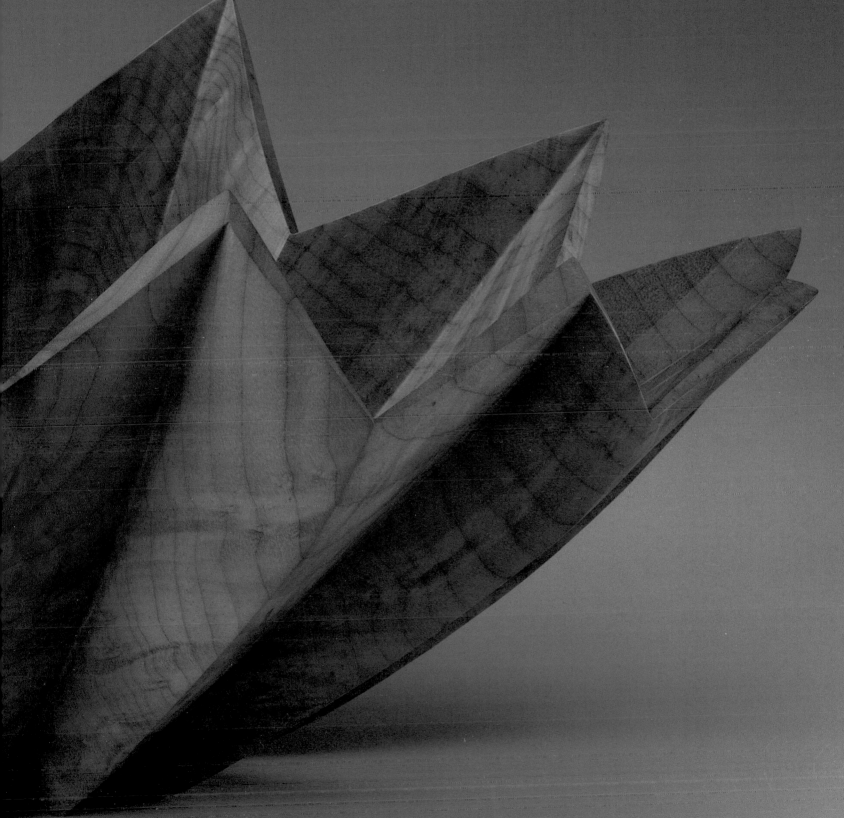

Expressions in Wood: Masterworks from The Wornick Collection

Major funding for this catalogue was provided by Texas State Bank.

Library of Congress Catalog Card Number: 96-67343

ISBN: 1-882140-13-3 Softbound
ISBN: 1-882140-15-x Hardbound

Oakland Museum of California
Art Department
1000 Oak Street
Oakland, California 94607-4892

Catalogue produced by Marquand Books, Inc., Seattle
Designed by Noreen Ryan
Printed in Hong Kong
Distributed by the University of Washington Press
P.O. Box 50096, Seattle, WA 98145

This book is published to coincide with an exhibition of the same name held at the Oakland Museum of California, February 8–July 20, 1997, and the McAllen International Museum, McAllen, Texas, October 7, 1997–January 4, 1998.

Front cover: David Ellsworth, *Machel* (p. 73)
Title page: David Groth, *#2* (p. 83)
Page 6: Robyn Horn, *Pierced Geode* (p. 89)
Page 8: Ronald C. and Anita L. Wornick, at home, with selections from their wood collection
Page 20: Stephen Hughes, *The Protector* (p. 97)
Page 28: Ron Fleming, *Embrace* (p. 79)
Page 38 and back cover: Todd Hoyer, *Peeling Orb* (p. 91)

Contents

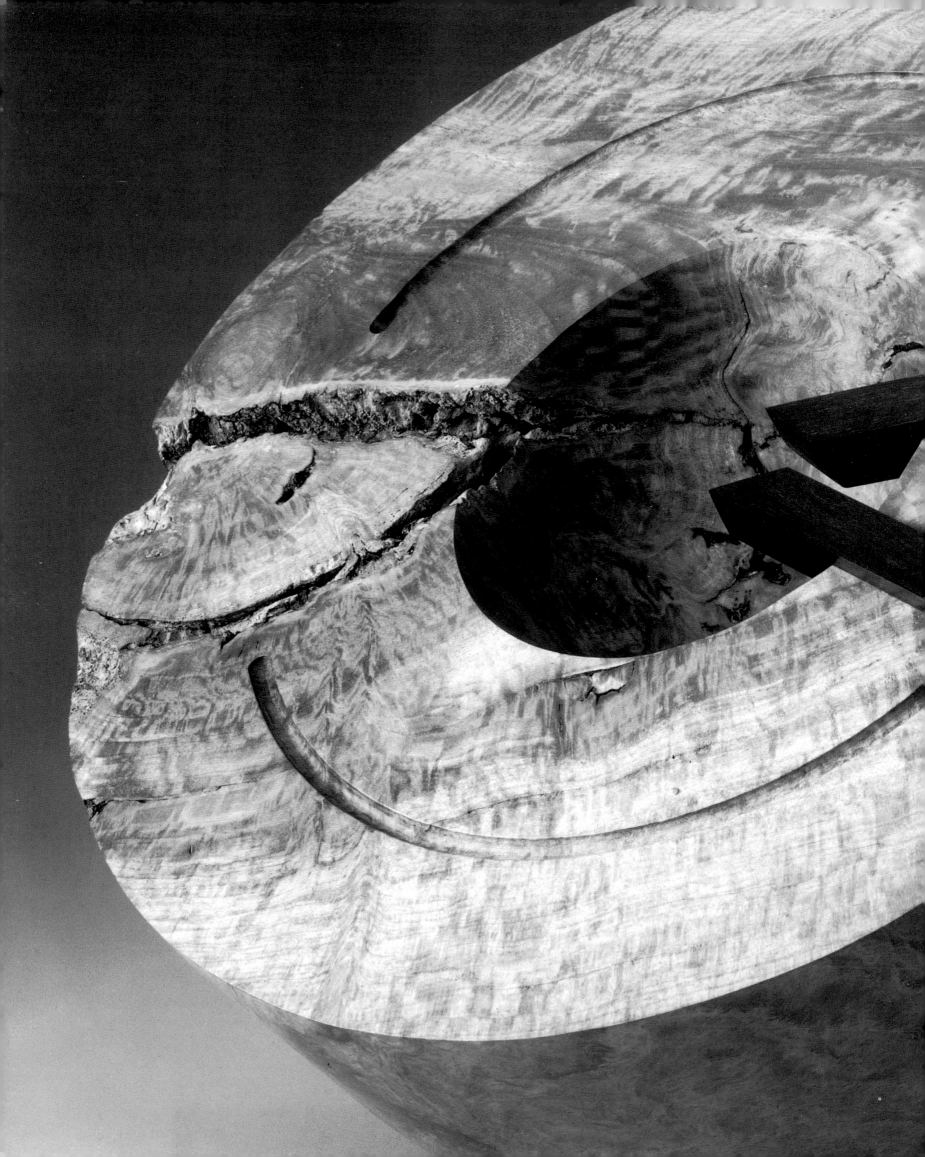

Foreword

This exhibition and its accompanying publication bring us great pleasure and pride. First, the work on display is satisfying to view. The colors and patterns of wood are inherently handsome. The unique shapes and quality of sculpting are delightful to behold. There is immense creativity evident in the crossover from functional vessel to work of art. We know visitors to this exhibition and readers of this catalogue will enjoy the results as much as we do.

A second reason for feeling satisfied with this project is that, again, the curatorial staff of the Oakland Museum of California treads on ground not walked by many other museums. Is turned and shaped wood what we would call craft or is it art? Are we seeing functionality reduced to nonfunctionality, or is this truly an endpoint in the evolution of turned and shaped wood, from utilitarian object to art form? Art curators, historians, and critics will enjoy such discussion. We think most viewers will be unencumbered with the concerns of craft versus art—they will simply be awestruck with a medium not often seen in museum exhibitions.

The third reason that this project was pleasurable is more personal. Working on the exhibition and catalogue gave us the opportunity to get to know Ron Wornick and his wife, Anita. Read his essay, "Expressions about Wood," and you will get to know him, too. Here is a man who, to satisfy his desires to acquire art, has assembled a great collection. We hope the collection will not someday be dispersed—the opportunity to see wood (and art) in new ways and to reflect on the character of the man who collected it is too valuable to lose. He has chosen to share his vision with us, and we are grateful.

I am reminded of the integrity of a forest, and of the inherent beauty of every single, living tree. Captured and subdued by humans, forests and trees usually become only functional and interesting—they become lumber. That lumber, put in the hands of one of these artists, goes beyond being restored to its former integrity, beauty, and interest. It is as if a spirit from the original organism has been found and released. Thank you, Ron and Anita Wornick, for sharing these spirits, and your own, with us.

DENNIS M. POWER

Executive Director
Oakland Museum of California

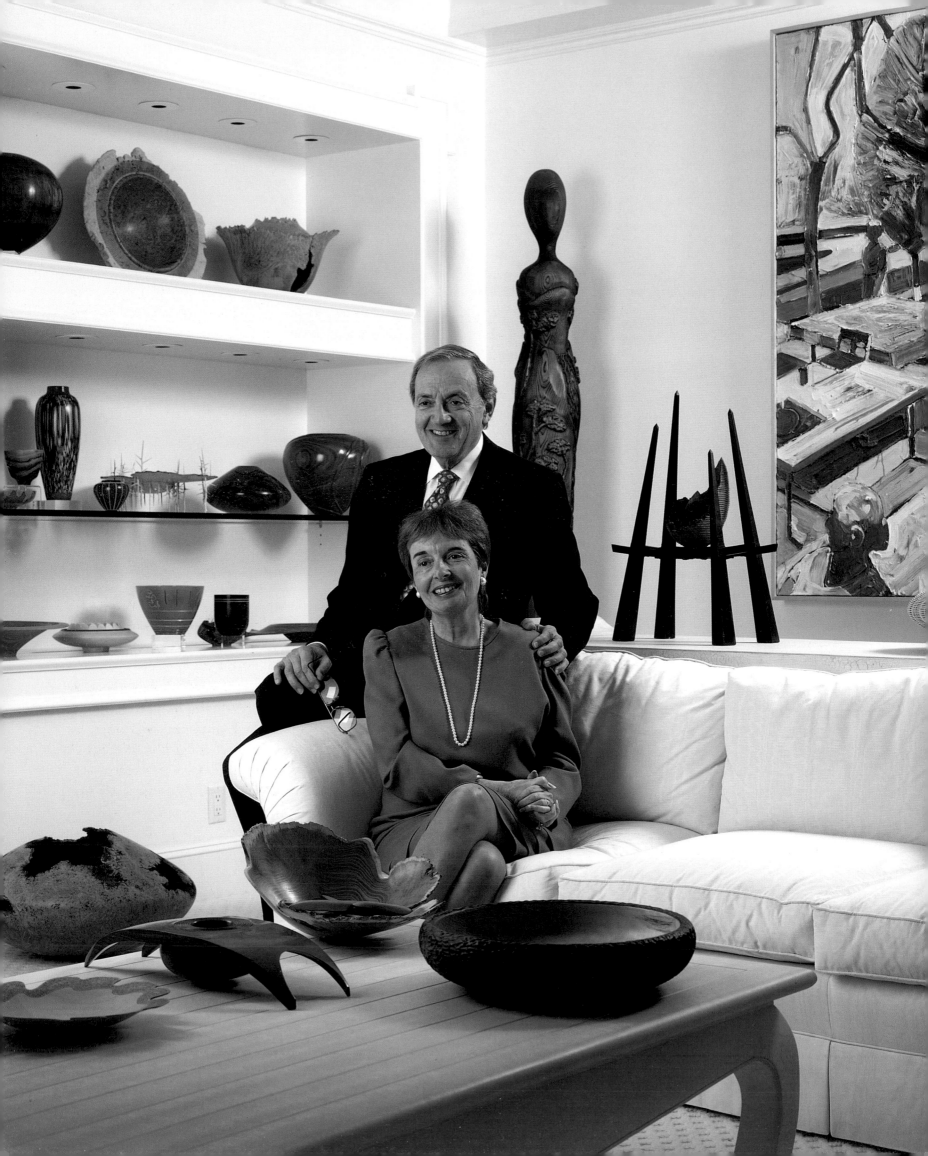

Ronald C. Wornick

Expressions about Wood

Alone in a darkened sickroom, breathing musical sounds from my first harmonica, it seemed to me that I had stumbled into a world of instant gratification. I resolved to be a musician. I was seven years old. Not surprisingly, many other equally joyful discoveries followed, each of which replaced the "career" in music. The pattern continues to this day. The lure of learning, or of simply doing, has led me to activities and careers of various duration—artist, journalist, musician, community activist, scientist, woodworker, basket maker, yachtsman, philanthropist, businessman, cook, collector (reorganizer of anything), not to mention husband and father.

Now, at age sixty-four, this unwillingness simply to accept things as they are and leave things as I find them must be viewed as a permanent, probably genetic, addiction. My life's work, whatever it may be, will most likely not be completed. The process may well have been the goal all along and certainly has been reward enough. In any case, *Expressions in Wood: Masterworks from The Wornick Collection* is a recent stage from that restless journey.

Credit and blame go primarily to my wife, Anita, who has insisted on our making time for galleries, museums, private collections, travel, reading, artists, music, and theater—the catalysts that jolt and open the mind. I truly envy her ability to draw so much immediate fulfillment from these stimulations. For me, these experiences too often become preoccupations, followed closely by an attempt to get involved. It's a silly and distracting conceit, but I would not readily part with it.

Why wood? Visitors to the Wornick collection may well wonder how we became involved in such a little-known art form, so late in life. For seven generations my father's family had been woodworkers, carpenters, and cabinetmakers. When my father, a Russian-speaking immigrant, arrived in the United States in 1918, at the age of twenty, he naturally turned to the only trade he knew. For nearly sixty years, with great pride and joy, he worked as a finish carpenter in the construction trades. He was overwhelmed by the miracle of America—the right to a public education, choice of career, home ownership, and limitless opportunity. He made and kept an early promise, that his son would not be a carpenter, and he refused to teach me his craft or allow me the use of his tools. It was tough love. My assigned responsibility was to take advantage of the opportunity for a "better" life in America.

With little enthusiasm for my father's expectations, I nonetheless proceeded as he wished. I pursued an education and a career. Although real career choices were not clear to me at that time, the absence of personal choice is recalled now as a heavy burden.

Then, remarkably, many years later, after marriage, a maturing career, and three sons of my own, I began to notice that lumberyards, sawmills, timber trucks, fresh-cut

boards, and even a split log turned my head, riveting my attention. The fresh scent of wood lingering in my nostrils produced a swelling in the chest. Ah, if I had those fresh-cut boards in my hands—what I could do with them!

As with many others drawn to wood, I began with small projects—a copper-lined walnut cigar humidor (with a major finger-smashing lid problem), a flower stand displaying multiple complex joints (narrow at the bottom and heavy at the top, assuring frequent tipping), a carved rounded-back love seat (with the grace and strength of a train wreck), and, of course, any number of "beautifully" turned vessels augmented with unintended checks, tear-outs, and cracks beyond filling or sanding—and some with no bottoms at all!

All hobbyists are familiar with the learning process, but foolishly I learned to swim from the middle of the pool. It may be quicker, but it's not pretty to watch. It never occurred to me to begin at the beginning. Although more recently my work has occasionally earned moderate to enthusiastic praise from close friends and family, I am painfully aware of the blunders covered with design changes and the discrepancy between what was planned and what in fact resulted. Halfway through a piece the conflict begins: shall I abandon this piece now that I have learned how to make it and move on to the magnificent image in my head, or shall I stay with it? I almost always stay with it, but rarely long enough to convert all the lessons learned and to see the design conflicts resolved in the completed piece.

Responsibilities of life, business, family obligations, and other temptations seem always to intrude, and the making of objects becomes sporadic, fitful, and hurried. I have imagined, but never enjoyed, the luxury of continuous, uninterrupted exploration of a piece from one stage to the next, and from one piece to the next. Nonetheless, I believe my modest skills are growing. At the same time, the more I learn, the more my respect grows for the professionals who produce work of such impact as to transcend the process. Their pieces are of such originality, technical perfection, inspired design, and sensitivity to the material as somehow to be more than they are. And so, hoping to find "art" in my own work set the stage for collecting.

One wonderful weekend in the spring of 1987, Anita and I, together with our then new friends Dorothy and George Saxe, drove north from San Francisco along the Pacific coast. Our destination was loosely considered to be Mendocino, but we were open to any adventures that might be serendipitously encountered along the way. The most remarkable adventure occurred, not along the way, but in the car. It was the conversation. We shared our lives, our disappointments, our achievements, our aspirations, our children, and then, as a surprise gift, Dorothy and George spoke with passion about how and why they had begun to collect contemporary craft, particularly studio glass. As their collection had grown, so too had the layers of their lives, enriched not just by the art with which they were surrounding themselves but by the new artists, galleries, and other collectors as well.

The Saxes' approach to collecting was attractive, knowledgeable, appealing. Previous to that weekend I had been mildly contemptuous of collectors. I believed collecting to be a frivolous vanity, and certainly trivial when compared to the artist's skill. By what privilege does a collector determine what will be collectible? How arrogant to seek a partnership in someone else's creative labor. Then, through the eyes of the Saxes, I began to see how to substitute respect for arrogance, learning and exploration for the acquiring process. Most important, I began to recognize that in creating a collection one is engaging in a creative process not so very far removed from the creating of art and, for me, not very different from mounting an unexplored piece of wood on the lathe. You begin with what exists and hope it evolves in gradual, intuitive steps into something new.

By the time we arrived in Mendocino we had bonded. The Saxes and the Wornicks were now "old" friends. After lunch we accompanied them on a gallery tour, first to Gallery Fair, where they expected to see new work by an artist they knew. We tagged along. On entering the gallery I scanned the landscape of colorful fiber art, ceramics, metal, jewelry, glass, baskets, and wood—oh, yes, wood. Furniture, boxes, canes, cutting boards, sculpture, and turned-wood vessels. Among the vessels one stood out. It seemed not to have been turned, and, as I learned later, it wasn't. It was too asymmetrical. It was unlike anything I had ever seen. From every angle of inspection it revealed new lines. It had been designed, shaped, and apparently polished by very skilled hands. It seemed to me to be complete perfection. It was thought-provoking, arresting, unique, and eleven hundred dollars! A princely sum for a noncollector to pay for a small wooden object.

I returned to where the Saxes were standing, then circled the gallery, and went back to the piece; I inspected it again and again. Finally, prudence prevailed and I exited the gallery with eleven hundred dollars still in my pocket. George had watched me going through this deliberation and had whispered, simply, "Buy it, buy it!"

We returned to the gallery later in the afternoon with George breathing down my neck. However, I could not abandon my kinship with the makers of art and my ambivalence toward collecting—the distinction that Ned Cooke, Charles F. Montgomery Associate Professor of American Decorative Arts, Department of the History of Art, at Yale, draws between "having" and "doing." The gallery closed and the vessel remained inside on its pedestal.

I do not enlarge on the truth to tell you that the piece remained illuminated in my mind throughout the evening and through a restless night, as I continued to consider its remarkable intricacies. By sunrise, infatuation had turned to obsession. What if someone else were to buy it and I would never see it again! I was on the gallery doorstep when it opened, money in hand, and moments later, with the piece firmly in my grasp, I had crossed over the line. It was my first acquisition. The artist, and I use the word without reservation, is David Groth of Mendocino, California. He titled the

piece, which is from his Cock's Comb Oyster series, *#2* (p. 83). It is as powerful and wondrous for me today as when I first saw it and exemplifies the qualities that I have sought in subsequent acquisitions. Comments on Groth's piece offered by Matthew Kangas in his essay for this catalogue are especially insightful.

How we went from one piece to ten, to one hundred, to hundreds, or more, and particularly why we acquired so many works will, I hope, be clear to those who visit the exhibition.

What we seek and how we select objects are difficult questions with multiple answers, but a few specific criteria can be articulated. There are also qualities so elusive, complex, and intangible as to defy description, but that are just as pertinent. Furthermore, our selection process is never fixed—it is dynamic, evolving, responding to new possibilities, and never tied to finite expectations.

For me, the first connection with a piece often comes from a careful consideration of the raw material. Just as fine wine cannot be achieved without great grapes, an uninteresting piece of wood may restrict or narrow the artist's possibilities. The wood need not be precious or exotic but should show some complexity, or at least potential for making a strong statement.

Is the finished piece consistent with the starting material? Wood has a voice of its own. Has the artist married his design and its execution to the obvious, special qualities of the wood being worked? We have encountered countless objects that could have been spectacular but for their dissonance with unavoidable and obvious poor qualities of the wood. It is also useful for us to look for subtle, but unmistakable, technical mastery. The technicality should not intrude on the sculptural presence of the piece, but a technical triumph often separates and elevates favored pieces above an attractive wooden vessel. When an especially appealing raw material is sensitively married to a fresh design, and executed with full mastery of the craft, the result is likely to fall in the realm of the collectible.

A footnote to technical matters. Many, but not all, of the pieces in the collection belong to the category of lathe-turned object. We do not embrace the lathe as necessary, as painters of fine art are not grouped according to the type of brush they use. The lathe is simply one of many tools available to the master craftsman or artist.

All else aside, the object must have a strong sculptural presence. The profile, size, surface texture, thickness, color, and sculptural markings introduced by the artist should disappear into the special qualities of the piece of wood being worked, resulting in one strong, overall sculptural statement. However dynamic its design, the work needs to be at rest, in balance, complete—bathed in a sense of its own fulfillment.

When you see one, you will know it. So we use one other guideline. If we love it, we buy it. Occasionally we acquire wonderful pieces that violate at least some of our guidelines, but we never forget that we collect for our pleasure, not for the creation of a narrow and pedantically defined collection. The collection is about what we enjoy, what we respect, what we judge to have timeless value. We began the collection with

very private objectives, and our personal presence in the collection is inescapable and unavoidable.

What a wonderful surprise for us to be able to share this experience with the Oakland Museum of California and its public. The mounting of a museum show is a massive undertaking, as I only now understand. The process to get from the curator's initial "I love it" to "Let's do it" to opening night requires a museum professional with imagination, vision, courage, focus, endless energy, political acumen, patience, and luck. Kenneth R. Trapp, currently Curator-in-Charge of the Renwick Gallery of the National Museum of American Art, Smithsonian Institution, in Washington, D.C., and former Curator of Decorative Arts at the Oakland Museum, is entirely responsible for the birthing of *Expressions in Wood: Masterworks from The Wornick Collection* at the Oakland Museum. When Ken left for the Renwick early in the project, Tran Turner, as Acting Associate Curator of Crafts and Decorative Arts, assumed responsibility. His judgment, experience, focus, and unflappable professional leadership brought the catalogue and exhibition to fulfillment. Anita and I, as well as the artists in this field, will be forever indebted to Ken and Tran for the essential role they have played.

If the showing of our collection helps to attract others to enjoy wood as a sculptural vessel material, we will be doubly rewarded. With over five thousand professionals and amateurs working in the field and an unlimited variety of wood (no two pieces are alike), the opportunities to practice the art and to collect fine originals are abundantly available.

It is also our hope that our collection might forecast for the discerning viewer what lies ahead. The best professionals are moving beyond technique, art and craft colleges are increasingly recognizing wood as a worthy medium in fine-arts training, and the public is displaying a heightened appreciation for handmade objects across a wide market. If a golden age were to develop for sculptured wooden vessels, it may well lie just ahead. How wonderful for my grandchildren!

An Appreciation

The arts have always been an important part of our lives. It was music that originally brought us together when we were very young, and as our tastes broadened, our interests grew.

We bought paintings and prints—kept some, discarded many—but it was Ron's consuming passion for wood that culminated in our major focus represented by the wonderful examples in this exhibition.

My interest in these sculptural forms is purely aesthetic, what the eye beholds. The hackneyed phrase "I know what I like" applies to me. It is Ron who opens my eyes to the artistry and artisanship of a piece. He looks at each one with a true and educated sensibility and helps me to understand why he chooses one over another. It's an inborn ability but one that he has developed into a refined and particular aesthetic, which I admire and respect.

For the two of us, one of the many dividends of collecting has been the opportunity to share our collection with others, to introduce the art of wood to so many people and to see them become appreciative and aware of the possibilities that wood offers. It is a great pleasure for us share the collection with those who will see it in a museum setting and in this catalogue.

ANITA L. WORNICK

January 1996

Acknowledgments

I inherited *Expressions in Wood: Masterworks from The Wornick Collection* from Kenneth R. Trapp, former Curator of Decorative Arts at the Oakland Museum, who initiated the project more than three years ago. I gratefully acknowledge Ken's tireless enthusiasm for this exhibition and his help in making the final selection of works from the Wornicks' unparalleled collection of objects in wood.

I cannot thank Ron and Anita Wornick enough for making their outstanding collection available for this exhibition. Unstinting with their time and energies, they were crucial throughout the planning and execution of all phases of the exhibition and catalogue.

Of course, without the artists, there would be neither a Wornick collection nor an exhibition drawn from that collection. I want to express my appreciation to all of the artists whose work is represented in the exhibition. My heartfelt gratitude goes to each of them. My deep appreciation also goes to Nina Sorensen, executive colleague of Ron and Anita Wornick at the Wornick Company. Nina has been a constant presence from day one, acting as a crucial liaison for everyone involved in this project.

Many patrons have recognized the importance of this project and have given generous financial support. Initially, George and Dorothy Saxe provided a major contribution for travel and photography. Others followed suit, including Doug and Dale Anderson, Dr. Robert and Judith Aptekar, Alexander and Camille Cook, Frederick and Shelby Gans, John and Robyn Horn, Samuel and Eleanor Rosenfeld, William and Judith Timken, and David and Ruth Waterbury.

Expressions in Wood travels to the McAllen International Museum in McAllen, Texas. Director Terry Melton immediately recognized the strengths of the project, and he invited Texas State Bank to become a major financial supporter of the catalogue, participation that allowed the exhibition catalogue to expand into a book-length publication. I am exceedingly grateful to everyone involved in this collaborative effort, especially Glen Roney, Chief Executive Officer and Chairman of Texas State Bank, and Dennis M. Power, Executive Director of the Oakland Museum of California.

Thanks also go to Del Mano Gallery of Los Angeles, perhaps the art gallery most supportive of artists working in wood today. Not only did they make a generous financial contribution, but the administrative staff answered a seemingly endless number of questions. For this, special thanks go to Ray Leier and Kevin Wallace.

I would like also to thank my colleagues in the Art Department who worked closely with me to keep everything in line: Karen Tsujimoto, Senior Curator; Harvey Jones, Senior Curator; Arthur Monroe, Chief Registrar; Janice Capecci, Assistant Registrar; Joy Tahan, Coordinator of Rights and Reproductions; Karen Nelson, Interpretive Specialist; Kathy Borgogno, Curatorial Specialist; Denis Yasukawa, Chief Preparator; and David Ruddell, Assistant Preparator. In particular, I would like to thank curatorial interns Jocelyn Ferguson, Karen Hanus, and Jennifer Rollins, who worked on various stages of the project with unflagging devotion. Without their efforts, this exhibition and this catalogue would not have happened.

For the catalogue, I am deeply grateful to the three authors who accepted a last-minute invitation to contribute scholarship: Matthew Kangas, independent curator and art critic, Seattle; John Perreault, Executive Director of UrbanGlass and former Senior Curator of the American Craft Museum; and Edward S. Cooke, Jr., Charles F. Montgomery Associate Professor of American Decorative Arts, Department of the History of Art, Yale University. For accommodating numerous changes to the outline and schedule of the catalogue, I am grateful to Ed Marquand, Marta Vinnedge, Marie Weiler, Jessica Eber, and Noreen Ryan of Marquand Books. Their patience made the catalogue production process run smoothly. A thank-you must also go to M. Lee Fatherree for his outstanding photography. For the superlative installation of the exhibition itself, I thank the exhibition designer, Ted Cohen.

Without the help of many individuals and colleagues at museums, libraries, universities, and cultural agencies across the country and overseas, this project would not have been realized. The authors and I are indebted to those who contributed to the completion of this book: Jeffrey Akard; American Craft Council—Tracey Friesen and Julie Turley; The Arkansas Arts Center Decorative Arts Museum, Little Rock—Alan DuBois and Ruth Pasquine; William and Nancy Baran-Mickle; Silvia and Garry Bennett; Bettmann Archive—Ron Brenne; Burchfield-Penney Art Center—Nancy Weekly; Canberra School of Art Gallery, Australia—Merryn Gates; Marcia Chamberlain; Craft Victoria, Australia—Alison Bennett; Dartmouth College, Special Collections; Bart de Malignon; Iona Elliott; Imogene Geiling; The Hagley Museum and Library, Wilmington, Delaware—Barbara Hall; The Museum of Fine Arts, Houston—Misty Moye and Cindi Strauss; Sidney Hutter; Isamu Noguchi Foundation, Inc., Long Island City, New York—Amy Hau; Forrest L. Merrill; The Metropolitan Museum of Art—Catherine Hoover Voorsanger; Sandor Nagyszalanczy; National Gallery of Victoria, Australia—Geoffrey Edwards; Otto Natzler; Paula Cooper Gallery, New York—Natasha Sigmund; Portland Art Museum, Oregon—Ann Eichelberg; Powerhouse Museum, Sydney, Australia—Grace Cochrane; Martin Puryear; Elsa Rady; Saxon Enterprises, Inc., Palo Alto, California—Barbara Harpell; Merryll Saylan; Kay Sekimachi; Society of Arts and Crafts, Boston—Stephen Bird; Syracuse University, New York—Dr. Edward Aiken; Texas State Bank, McAllen—Nancy Schultz; The Toledo Museum of Art—Davira S. Taragin and Patricia J. Whitesides; Edgar Whipple; Gregory Whipple; William Traver Gallery, Winterthur Museum—Jennifer Menson; Woodfind, Edmonds, Washington—Jerry Magelssen; Wood Turning Center, Philadelphia—Albert LeCoff; Woodworker West, Los Angeles—Ron Goldman.

And finally, I would like to thank my entire family: my parents, Joyce and Byron Turner, and especially my four-year-old son, Tré.

TRAN TURNER

Tran Turner

The Artist and the Crafted Object

Since the late nineteenth century, with the two world wars acting as points of reference, studio artists creating handmade objects of functional form (or form perceived to be functional) declared themselves independent of the social and economic, as well as the formal, tradition of applied arts. These proponents of the handmade and would-be functional in the dominant media of clay, glass, metal, wood, and fiber created a studio movement as a separate constituency within the history of crafts production, establishing a critical framework more closely aligned with what is now the canon of modernist art history. These artists also sought to develop a market that would support their separateness and consequently a cultural rhetoric aligned with that of their contemporary modernist practitioners in painting and sculpture. Whether through a formalist vessel aesthetic conditioned by media-specific interests, the employment of three-dimensional formal abstraction, or the use of ironic or socially inspired subject matter, their production respected the functional tradition of their various media, a tradition they chose to follow both as a point of historical reference and as contemporary self-identification. This is certainly still the case for the artists represented in this exhibition, whose primary concern is to promote the wooden object as a vehicle for vital aesthetic expression with historical continuity from earlier theory and the history of crafts production. They do this while embracing the intensified crossover value system of high art/low art that has surrounded crafts production since the 1950s.

It is appropriate that at this moment, when art historians are questioning the validity of received histories, when the screaming of modernist "idealism" is being dissected through the critique of its artist/promoters (such as Le Corbusier [1887–1965] and others) and the institutions that the modernist movement fostered (e.g., the Museum of Modern Art in New York), a different historical frame for the late-twentieth-century crafts movement, one that posits a separate history of craft, be proposed. For the field of contemporary wood, in which the vessel form has attained a greater "art" status during the past twenty years, it is an alternative history. One based on social attitudes and aesthetic positions referring to the loss of individuality in urban, industrial societies of the late nineteenth and twentieth centuries, it is an expression of personal aesthetics, creativity, and skills focused on the shaping of functional and functional-seeming objects in the context of an ever-dominant, impersonal, and mechanized consumer society.

As with other contemporary craft media, the current aesthetic imprints we find in wooden vessels have their origins in the historicist, nostalgic, anti-industrial sentiment of the mid- to late-nineteenth-century reform movements that encompassed the applied arts as well as the burgeoning crafts movement. Through philosophical

promoters like William Morris (1834–1896) and Charles R. Ashbee (1863–1942) in England, transcendentalist thinkers Walt Whitman (1819–1892) and Henry David Thoreau (1817–1862), and crafts-promoters like Gustav Stickley (1858–1942) and Elbert Hubbard (1856–1915) in the United States, the late-nineteenth-century Arts and Crafts movement fostered an egalitarianism based on the ideals of a utopian lifestyle complemented by simple, handmade objects, often of historical form. The Arts and Crafts movement in the United States generated a market that became large enough to encourage its promoters to accept many of the industrial methods of production and retailing. This hybrid system of form and production was manifested in what are now the mainstream material-based studio media of wood, ceramics, metal, textiles, and glass, while still being accompanied by the rhetorical philosophy of the movement itself.

The Arts and Crafts movement is conventionally viewed as having dispersed in the years following World War I, decomposed by what is taken to be the overwhelming force of industry. This industry is said to have produced objects that were reconceptions of traditional historical forms or cubist or biomorphic ones created by a new profession of industrial designers for a "Machine-Age" consumer market. In reality, handcraft production continued in many of the forms it took during the late nineteenth century. It continued in the arena of industry that required handwork: from prototype production to the assimilation of handcraftsmanship, particularly in glass-blowing, furniture making, and metalsmithing. It also continued in the survival of culturally based crafts and the romantic revival of historic or ethnic craft traditions, promoted in many cases by elite patrons nostalgically attached to the values of treasured pasts and hand-fashioned objects of other cultures.

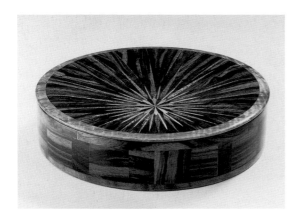

fig. 1. Howard Whipple
UNTITLED (Intarsia Lidded Box #116)

1947
Mahogany and various rare woods, 1½ × 6 in. (3.8 × 15.2 cm)
Collection of the Oakland Museum of California, Gift of Mrs. Howard Whipple. 77.40.6

Most significantly for the crafts movement of the second half of the twentieth century, the crafts tradition continued to evolve away from the guild and group workshop practices of the Arts and Crafts movement toward the mainstream use of individual studios, where craft-based artists championed their new self-consciousness and self-promotion. The late nineteenth century had not only reformed the craftsman, it had created a new one. Crafts production in the twentieth century would first and foremost begin with an artistic identity. Looking at the field of woodworking, an early proponent of this change was Wharton Esherick (1887–1970), who was active beginning in the 1920s. James Prestini (1908–1993), among others, followed in the 1930s, and by the end of the decade, master woodturner Bob Stocksdale began to create his formative wooden vessels. In the post–World War II era, new concentrations on material and technique, and on oriental philosophy and innovative craft practices enhanced the woodworker's synonymous position as artist/creator. By the 1950s and 1960s wood artists in furniture like Sam Maloof (b. 1916), Art Espenet Carpenter (b. 1920), and Walker Weed (b. 1918), as well as vessel makers like Emil Milan (1922–1985), George Federoff (b. 1906), and Howard Whipple (1881–1959; figs. 1, 2) entered the field. A system of education, exhibition, and patronage, extensively developed from the 1960s

onward, began to support the separateness and aestheticization of studio woodworking. By the 1970s these contributing factors led to the establishment of an international movement for makers of the wooden vessel, producing objects considered by craftsman and patron alike to be different from the purely functional, merely useful. This movement continues to ask for a separate place in the history of useful-arts production. Indeed, it demands either critical alliance with fine art itself or a critical value system that is equal to that of fine art. For more than a century, studio craft artists, whether working in wood, clay, glass, metal, or fiber, have tried with increasing success to be treated separately and equally. There exists today a wide commercial, critical, and institutional network of support for wood artists and the aesthetic component of their production.

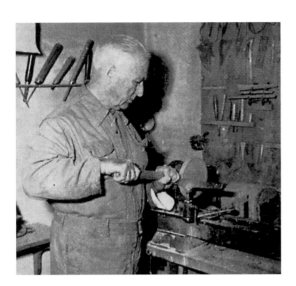

fig. 2. Howard Whipple at his lathe, ca. 1949–50. He began using a lathe in 1934. Photograph courtesy of the American Craft Council

Matthew Kangas

Sculptural Heritage and Sculptural Implications
Turned-Wood Objects in the Wornick Collection

For my father, Arvid Kangas—logger, carver, turner, and sculptor of wood

The fate of sculpture in the twentieth century has been so wrought with conflict, tension, liberation, and near extinction that it is almost dizzying to contemplate expanding sculpture's parameters yet again to include objects of wood made by turning them on a lathe. But why not? Everything else (including the kitchen sink; see Robert Gober [b. 1954]) has been allotted aesthetic status as sculpture, so why not turned wood? In order to justify conferring such a status on works in the Wornick collection, it is necessary to backtrack to the origins of twentieth-century sculpture, briefly scan precedents made of wood that have undisputed sculptural status, examine how they differ from turned-wood objects, and then fast-forward to the late twentieth century. Now, once again, the handmade object with the strong physical presence of natural crafts materials (wood, clay, glass, metals, and fiber) is being seen to embody, not only a rescue mission for sculpture, but perhaps a primary redefining quality: evidence of its making.

In the process, we may come to reappreciate humble qualities of construction, fabrication, and function as gauges of aesthetic power (so present in turned-wood objects) and resolve issues that discomfort establishment curators, dealers, collectors, and artists, such as How can craft be art? What is the content or meaning of such art? or How can we accommodate the new hybrid craft/art forms into the canon of twentieth-century art history? A cardinal characteristic of the postmodern period is an emphasis on scrutinizing art at the margins or fringes of the art world and society. Seen in this light, turned-wood objects are definitely marginalized. Now is the time to move them toward the center, cast a critical light on them, and set them in a new context: modern and contemporary art.

Another question that arises in this context is, What is sculpture? To answer, we also need to remember how properties defining sculpture in the twentieth century alternately contracted and expanded any prevailing definition. Reacting to the monumental and commemorative status of works by nineteenth-century sculptors (Jean-Baptiste Carpeaux [1827–1875], François Rude [1784–1855], Antonio Canova [1757–1822]), modern artists radically shrank the size of sculpture to the more personal and intimate scale of the pedestal. The nature of the sculptural object next shifted to the use of found objects (Pablo Picasso [1881–1973], Julio González [1876–1942]) and readymades (Marcel Duchamp [1887–1968]). This contraction denigrated craft and construction as defining properties of sculpture, thus opening up limitless potential on the one hand (a hardware-store snow shovel, a galvanized-steel bottle rack), yet forsaking the technique that prior generations had admired in sculptures of bronze, carved wood, ceramic, or other materials whose working requires skill.

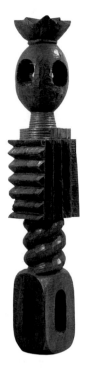

fig. 1. Constantin Brancusi
KING OF KINGS

early 1930s
Oak, 9 ft. 10 in. (299.7 cm)
The Solomon R. Guggenheim Museum, New York.
© The Solomon R. Guggenheim Foundation, New York.
Photograph by David Heald

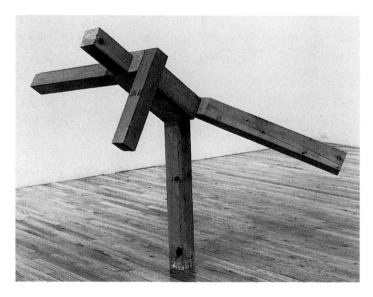

fig. 2. Joel Shapiro
UNTITLED

1980
Pine, 52⅞ × 64 × 45½ in. (134.3 × 162.6 × 115.6 cm)
Courtesy PaceWildenstein, New York

In this sense, early modernism posited an anticraft aesthetic that was articulated most clearly by the Swiss architect Le Corbusier (1887–1965) in his 1925 book, *The Decorative Art of Today* (English trans., Cambridge, Mass.: MIT Press, 1987). In this great paean to the superiority of the machine, Corbusier launches an all-out attack on the decorative and the handmade, using phrases such as "useless knickknacks," "bad taste," "disastrous," "Handicraft: Cult of Failures," and finally the dicta, "Modern decorative art has no decoration," "Decoration is no longer possible," and "There is no mystery in the crisis of decorative art; the miracle can occur of an architecture that *will be,* the day when decorative art *ceases to be.*" Understandably, Corbusier was reacting against the prior twenty-five to fifty years, when late-nineteenth- and early-twentieth-century movements such as Arts and Crafts, Jugendstil, and Art Deco reigned in the productions of such artists as Louis Comfort Tiffany (1848–1933), Emile Gallé (1846–1904), Peter Carl Fabergé (1848–1920). Great store was placed on the unique, handmade, decorated object. Corbusier's broadside is full of other attacks associating decoration and the instruction of craft skills with "girls' schools."

Nevertheless, it is important to note that wood survived modernism's machine aesthetic and Corbusier's attacks and continued throughout the same period (and after, as we shall see) to attract the interest of artists who developed its uses in functional furniture (Gerrit Rietveld [1888–1964], Jean Dunand [1877–1942]) as well as in sculptural and decorative objects, specifically (for our purposes) abstract sculpture.

There is a natural yet hitherto unnoted continuity between early modernist or abstract sculpture and the turned-wood object. The simple reductive properties of abstract wood sculpture—plane, volume, mass, profile—also apply to the turned-wood object and are supplemented by craft qualities common to works in the Wornick collection: carving, construction, fabrication, and wood grain. Meaning and content in twentieth-century abstract wood sculpture (including turned-wood objects) revolve around issues of geometry, space, figurative implications, color, horizontality, and verticality. These are formal issues, to be sure, but the meaning of much modern art is tied up with such issues in lieu of psychological or compulsory ideological content. Leaving aside the primacy and privilege of traditional bronze casting, then, many early modern sculptors turned to wood for its antimachine look and rustic appearance. It was a way of treating themes of form and shape, line and mass, without the expense or elaborate technical processes of bronze.

Thus, *King of Kings* (early 1930s; fig. 1), for example, by Constantin Brancusi (1876–1957), may be reassessed for its craft qualities: evidence of fabrication, cutting, carving, segmenting, and surface. Rough-hewn and crudely hierarchic, *King of Kings* also may bear residual allusions to Romanian folk art. In fact, the longer one looks at Brancusi in this light, the more basic and earthy, the more crafty, *King of Kings* becomes. With the sculpture's bearing strong evidence of the human hand, the tool marks become a new kind of surface decoration, the evidence of the object's own making.

Nearly sixty years later, Joel Shapiro (b. 1941) undertook various wood-block or four-by-four-inch lumber sculptures, which reject the upright structure of *King of*

Kings in favor of the frozen motion of extended limbs (see fig. 2). Eventually cast in bronze and more widely known in those versions, Shapiro's figurative sculptures of wood provided an escape route for him from minimalism without sacrificing the formal austerity and use of the serial unit, in this case, the four-by-four.

In contrast to Brancusi and Shapiro, *Cumulus* (1990; p. 123), by William Moore, adopts the former's segmented vertical structure without recourse to the latter's stylized "arms" and "legs." Is *Cumulus* really figurative at all then? Like *King of Kings*, it has a vertical segmented structure, and, with its spun-copper top surface covering, it could also be said to have a "head." Admittedly, at fourteen inches high, it does not compare in size to the ten-foot-high Brancusi, but much of the power of the turned-wood object involves creating an intimate rather than a monumental object.

The division of sculptural volume became a central tenet of early modern abstract sculpture. Often the sculpture was divided into the separate modular parts later revived and admired by the minimalists of the 1960s and 1970s. In the aftermath of cubism, however, European sculpture of the 1920s sought ways to reinvigorate the object or have it reflect utopian ideals or universalizing qualities. Todd Hoyer's *Untitled* [Vessel] (1994; p. 93) withstands a comparison to *Construction of Volume Relations* (1921; fig. 3), by the Belgian artist and Piet Mondrian's (1872–1944) De Stijl colleague Georges Vantongerloo (1886–1965). Obsessed with mathematical approaches to art, Vantongerloo believed that this approach through the application of orderly systems could embody spiritual values basic to humanity. As a result, in works like *Construction of Volume Relations*, mahogany slabs pile up into a vertical form that pushes outward into various planes in space. Its smooth surfaces are far different from those of Hoyer's vessel, wherein the turning process on emery oak leaves jagged areas exposed beside the deeper cuts into the solid wood walls around an inner core.

Vantongerloo's stacking of the mahogany posited an extension by the object outward into space. With Hoyer's turning process, the tools cut into the wood, both altering the exterior surface into comparably segmented areas and protecting the inner void of the vessel form. No matter how lofty the rationale of the Belgian artist's sculpture (he was the author of two theoretical works), it is the blatant physicality of the mahogany that allows the work to retain its power today. Later in the century, it is the materiality of modernism that has survived, not necessarily its theories, utopian or otherwise.

If Brancusi's *King of Kings* sums up early approaches to the figure in modern wood sculpture, other artists like Jean Arp (1887–1966) borrowed aspects of the human body as impetus for their wood sculptures. With his many works of painted wood, Arp occasionally let the grain and figured pattern of the wood show through, as in *Objects Arranged According to the Laws of Chance*, or *Navels* (1930; fig. 4). With only clear varnish as a surface treatment, Arp assembled a sculpture with figurative or anatomical allusions short of the full figure.

Similarly, although it may not seem likely at first glance, Vic Wood created a work that also alludes to the human form: two breasts. His *Untitled* [Lidded Box] (1987; p. 160) shares Arp's mixture of flat and rounded forms. Wood's turned-wood object has latent functional purposes as well, but these are so unclear on first viewing that the Huon pine construction may operate equally for our purposes as an abstract sculpture. Whereas Arp's two-part title suggests both anatomical potential (navels) and

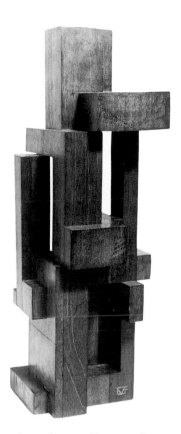

fig. 3. Georges Vantongerloo
CONSTRUCTION OF VOLUME RELATIONS

1921
Mahogany, 16⅛ × 5⅝ × 5¾ in. (41 × 14.3 × 14.6 cm)
The Museum of Modern Art, New York, Gift of Silvia Pizitz. 509.53. © 1996 The Museum of Modern Art, New York

fig. 4. Jean (Hans) Arp
OBJECTS ARRANGED ACCORDING TO THE LAWS OF CHANCE, or NAVELS

1930
Varnished wood relief, 10⅜ × 11⅛ × 2¼ in. (26.4 × 28.3 × 5.7 cm)
The Museum of Modern Art, New York. 79.36. © 1996 The Museum of Modern Art, New York

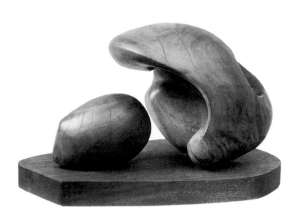

fig. 5. Henry Moore
TWO FORMS

1934
Pynkado wood, 11 × 21½ × 12⅛ in. (27.9 × 54.6 × 30.8 cm)
The Museum of Modern Art, New York, Sir Michael Sadler
Fund. 207.37. © 1996 The Museum of Modern Art, New
York

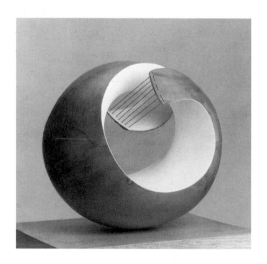

fig. 6. Barbara Hepworth
PELAGOS

1946
Wood with colored strings, 14½ in. (36.8 cm)
The Tate Gallery, London

purported random systems as a generative procedure ("law of chance"), Wood's sculpture functions on a highly abstracted plane. The properties of wood are what emerge most clearly nearly seventy years later. On Wood's lidded box, the bulging breastlike forms coexist in an undulating harmony reinforced by the light color of the pine and the gracefully turned and curved corners of each plane.

One of the great sculptors of the century to use wood, Henry Moore (1898–1986) made early smaller sculptures of wood that have often been overlooked in favor of his later monumental reclining figures in stone and bronze. Before World War II, the scale and size of Moore's wood sculptures remained intimate, pedestal size, and are far more conducive to human touch than would be the case once Moore attained heroic status as the greatest living British sculptor.

Moore's *Two Forms* (1934; fig. 5) employs a tropical hardwood, pynkado, as a material for a work that rejects the mathematical predictability of Vantongerloo's approach and presents instead an organic pretext that suggests the hollowed-out larger piece of wood "giving birth" to the adjacent smaller piece. The graining and cracking of the pynkado wood accentuate the growth or birth metaphor. With Moore and his contemporary Barbara Hepworth (1903–1975) stressing inner voids in sculpture (along with the Russian sculptor Aleksandr Archipenko [1887–1964]), it is possible to see their work of this period anticipating by sixty years the inner-vessel imagery of many of the turned-wood object makers.

In addition, the bipartite composition used by both British artists finds an echo in two works in the Wornick collection, *Peeling Orb* (1987; p. 91), by Hoyer, and *Sculptural Vessel* (1979; p. 117), by Mark Lindquist. Sharply distinct in their separate treatments for dual forms, Hoyer and Lindquist use strategies that arise out of the turning process. *Peeling Orb*, centrally bisected by a curving mesquite wood wall, seems more about separation and movement than natal growth. The groove marks on the spherical shape in *Peeling Orb* remind the viewer of the lathe blade's actions, whereas the surface of *Two Forms* is tranquil.

A second, upper form seems to emerge out of Lindquist's *Sculptural Vessel*, yet, unlike the Moore, it is still bound to the original piece of wood. Sharing an inner void with the larger part of *Two Forms*, *Sculptural Vessel* exploits the burl figuration of white ash for its surface animation, sharpening an allusion to cell or fetal growth. Not dependent on a matching oblong vase as is *Two Forms*, *Sculptural Vessel* declares its sculptural status more obliquely, less recognizably.

Over a decade later, Hepworth extended Moore's vessel-like voids farther into the puncture or the hole. In works like *Two Figures* (1947–48) or *Pelagos* (1946; fig. 6), Dame Barbara set up high surface contrasts between the elaborate graining of the elm (or plane wood or Spanish mahogany in other pieces) and the white-painted concave areas containing see-through penetrations.

Although eventually inspired by the transplantation of the machine aesthetic of constructivism into Britain by the artists Naum Gabo (1890–1977) and his brother Antoine Pevsner (1886–1962), both Hepworth and Moore could not escape their ties to British landscape, forests, and natural forms. This, too, brings them closer to the earthiness and craft character of the turned-wood object makers.

In an appropriate turnabout, *Pierced Geode* (1990; p. 89), by Robyn Horn, seems an indirect tribute to Hepworth. With *Pelagos* barely fifteen inches and *Pierced Geode*

fig. 7. Isamu Noguchi
THE SEEKER

1970
Black African granite and pine, 9¾ × 40 × 11½ in. (24.8 × 101.6 × 29.2 cm)
Portland Art Museum, The Evan H. Roberts Memorial Sculpture Fund. 80.37. © Isamu Noguchi. Illustrated with permission from the Isamu Noguchi Foundation. Photograph by Alfred A. Monner.

fig. 8. Robert Maki
VESTIGIAL FORM

1966
Laminated hemlock and Douglas fir, 26 × 134 × 35 in. (66 × 340.4 × 88.9 cm)
Courtesy of the artist, Seattle

twelve inches high, the smaller size of both artists' works is another bond. Whereas both Moore and Hepworth moved their studios outdoors to accommodate large-scale national and corporate commissions, it could be argued that much of their finest work, like that of the turned-wood sculptors, remains rooted in the smaller studio setting. The accessibility and approachability of their pedestal pieces allow for greater scrutiny and interaction on the part of the viewer to appreciate their craft properties. Their meaning lies in their making.

Pierced Geode is a bisected sphere that exposes, like a mineral geode or "thunder egg," the inner graining of the jarrah burl hardwood. At its center lies, not a puncture, but a concave hemisphere surrounded by a concentric cut-in circle. Instead of Hepworth's ubiquitous colored strings, Horn has affixed two ebony rods. On a formal level, they act as pure linear elements offsetting the cutting motion of the lathe. On another level, they represent maplike entry paths into the central void.

Isamu Noguchi (1904–1988), always sensitive to craft traditions, created important works in wood, stone, ceramics, metals, and paper. In the same vein, function was never far away from a Noguchi sculpture. In *The Seeker* (1970; fig. 7), stone and wood combine in a tablelike assemblage that elevates its upper stone form to nearly sacred or altarlike status. Upholding the horizontal stone section, two lower wooden "legs" may give figurative suggestions but they also summon functional references. *The Seeker* finds analogies in two works in the Wornick collection, *Untitled* [Vessel] (1994; p. 157), by Howard Werner, and *Zanthorean Offering Vessel* (1993; p. 98), by Stephen Hughes. Both turned-wood pieces share "legs" with *The Seeker*. The outer struts of Werner's turned and carved palm-wood sculpture differ from the inner supports of *The Seeker*. Both works share a crude vision that is transposed into a hearty elegance by the fashioning of the materials in each. Hughes's *Zanthorean Offering Vessel* has a tripartite support of slim pine strands. With its charred appearance, it carries a stronger ritual aura than *The Seeker*. At 15½ inches high, moreover, it summons up personal use rather than public ceremony but shares with the Noguchi a sense of indeterminate expectation of use.

Horizontal extension is carried to great extremes in *Vestigial Form* (1966; fig. 8), by Robert Maki (b. 1938), and in *Spoon from a Forgotten Ceremony* (1994; p. 139), by Norm Sartorius. Worlds apart in terms of allusions to ritual use or secular, cerebral, formal virtuosity, Sartorius and Maki nevertheless both address horizontal compositions. With Maki's laminated hemlock and Douglas fir lying directly on the floor, the pedestal is blatantly subverted and replaced with a frank acceptance of sculpture's undeniable debt to gravity. As the linear configuration claims the space around and above it, *Vestigial Form* is a remarkable technical tour de force, expanding the limits of what wood can do and how we expect sculpture to "behave."

Sartorius's double-handled object of pau ferro and ebony is equally forthright, and yet, with its functional title and ambiguous ritual references, it looks backward to heritage and traditions rather than forward to unexpected forms for wood. Sartorius and Maki both emphasize how wood can deny mass or volume and also act as line or void. Turning is the key operation for Sartorius; for Maki, it is laminating, drawing, and cutting.

fig. 9. Marilyn Levine
TWO-TONED BAG

1971
Ceramic, 10½ × 15 × 8 in. (26.7 × 38.1 × 20.3 cm)
Oakland Museum of California, Gift of Naomi and Robert Lauter. 86.36. Photograph by M. Lee Fatherree

fig. 10. Carl Andre
THE WAY EAST, SOUTH, AND WEST

1975
Western red cedar, four units, each 12 × 12 × 36 in. (30.5 × 30.5 × 91.4 cm); 36 × 60 × 48 in. overall (91.4 × 152.4 × 121.9 cm)
Courtesy Paula Cooper Gallery, New York. Photograph by Geoffrey Clements

While Maki touches on illusion in the way he makes wood bend and wind in unexpected ways in *Vestigial Form*, Michelle Holzapfel takes illusion much farther in her *Scarf Bowl* (1992; p. 87). In works like hers and Stephen Hughes's *Manta* (1991; p. 96), the potential suppleness and malleability of wood are encountered head-on and exploited to the limit. With ceramics normally considered the fountainhead of craft-material illusionism (see Marilyn Levine [b. 1935; fig. 9], Howard Kottler [b. 1930], Patti Warashina [b. 1939]), wood can also stake a claim for tour-de-force effects and the challenging of conventional reality.

It is worth remembering that the "folding" of wood, as we see in Holzapfel, goes back as far as sixteenth- and seventeenth-century English furniture with its elaborate "linen-fold" creases on cabinet and drawer fronts. Designer-artisans like Grinling Gibbons (1648–1721) took such ornate illusionism to great heights. It became a machine convention by the mid-nineteenth century, frequently repeated in Victorian revivals of dark-stained Tudor and Stuart furniture styles. Holzapfel emphasizes the tactile quality of wood, however, forestalling a completely convincing illusion of cloth in *Scarf Bowl*. The striated groove marks remind us of the lathe, thereby reinforcing all the more our wonder or disbelief at her accomplishment.

Manta is among the most graceful of examples in the Wornick collection. With the undulating curves around a central bowl cavity and absence of turning marks, illusion is used as a hallmark of further technical virtuosity through the concealment of fabrication traces. We know that *Manta* is stationary, yet its edges appear to be in motion. *Manta* appears about to be airborne; *Scarf Bowl* is definitely earthbound.

In a series of works executed in British Columbia in the mid-1970s, Carl Andre (b. 1935) extended his floor-hugging sculptures of firebrick and lead into the realm of wood. Exhibited in New York, Seattle, and elsewhere, these works acted like metaphorical compass points, pointers, or directional signs in a basic and simple manner. *The Way East, South, and West* (1975; fig. 10) uses cut blocks of western red cedar to embody its subdued approach to sculptural volume. Part of the power of such works today, however, lies in our apprehension of the graining, figuring, and cut marks in the cedar.

A decade later, David Groth made his own group of turned-wood bowls, the Cock's Comb Oyster series, and they bear a comparison to Andre's earlier endeavors. Cutting against the grain of the hard myrtlewood, Groth fractured the bowl form so that the eleven pointed tips surrounding it act separately in much the same way that Andre's red cedar sculpture-elements do. Instead of protecting the inner void, Groth pushes the wood outward and upward, exposing the center. The elaborately curving wood grain and figuring on the outer surface of *#2* (1984; p. 83) set up a tension with the threatening, jagged points of the segmented bowl wall. At barely nine inches high, *#2* does not assert sculptural space in the same way as Andre's art, but it carries a more accessible power, the kind of aesthetic encounter in which one could hold the work in one's hand. Groth has added an expressionistic touch to Andre's reductive imagery by his aggressive carving. We admire the deconstruction of the bowl form; for a work so small, it carries a near monumental impact when seen—and touched.

Finally, the concealment of inner space is shared by Martin Puryear's (b. 1941) 1990 sculpture of basswood and cypress, *Thicket* (fig. 11), with two much smaller

works in the Wornick collection by Ron Fleming, *Reeds in the Wind* (1988; p. 78) and *Embrace* (1994; p. 79). Far more romantic and pastoral than *Thicket*, Fleming's turned-wood objects interpolate a leaf or plant motif into the container form. With Fleming, there is a sense of precious mystery and enclosure in both works. For Puryear, the cut and assembled small planks of wood fit together like puzzle parts around a central core. The crisscrossing composition challenges our notion of how much wood is capable of: How can it bend? How can it be juxtaposed so effortlessly? With Fleming, turning has led to a baroque reconfiguration of the wood into leaf and reed forms. The spotting of the surface in *Reeds in the Wind* intensifies an outdoors atmosphere. The South African black ivory in *Embrace* is cut so that inner areas show through the rich shiny surface.

All three works depend for their aesthetic power on the mystery of concealment and enclosure. Puryear works from an additive, accretive position in the studio, preparing individual pieces of wood, which are then assembled into a complex whole. For the woodturners in the Wornick collection like Fleming, the studio procedures of turning and carving involve subtractive operations, chipping away at the original solid block.

As in all the other turned-wood objects we have examined, the unraveling of process is part of the viewer's encounter and enjoyment of the artwork. More than that, however, the meaning of each work varies greatly, dependent not only on revelation of process but on our final apprehension of form. Viewed both ways—process and result, beginning and end—the works by Ron Fleming, David Groth, Michelle Holzapfel, Robyn Horn, Todd Hoyer, Stephen Hughes, Mark Lindquist, William Moore, Norm Sartorius, Howard Werner, and Vic Wood all proclaim their object identity first, with their sculptural identity following only on close examination and contemplation.

As usual with objects made of craft materials, the viewer must be willing to go along for the ride. With programmatic or ideological content absent, the viewer is free to indulge in poetic fantasies of nature and culture, heritage and tradition, which are embodied in these works of technical skill and beauty, and which expand modernist abstract sculpture's reign far later into the twentieth century than anyone would have imagined.

fig. 11. Martin Puryear
THICKET
1990
Basswood and cypress, 67 × 62 × 17 in. (170.2 × 157.5 × 43.2 cm)
Seattle Art Museum, Gift of Agnes Gund. 90.32. Photograph by Paul Macapia

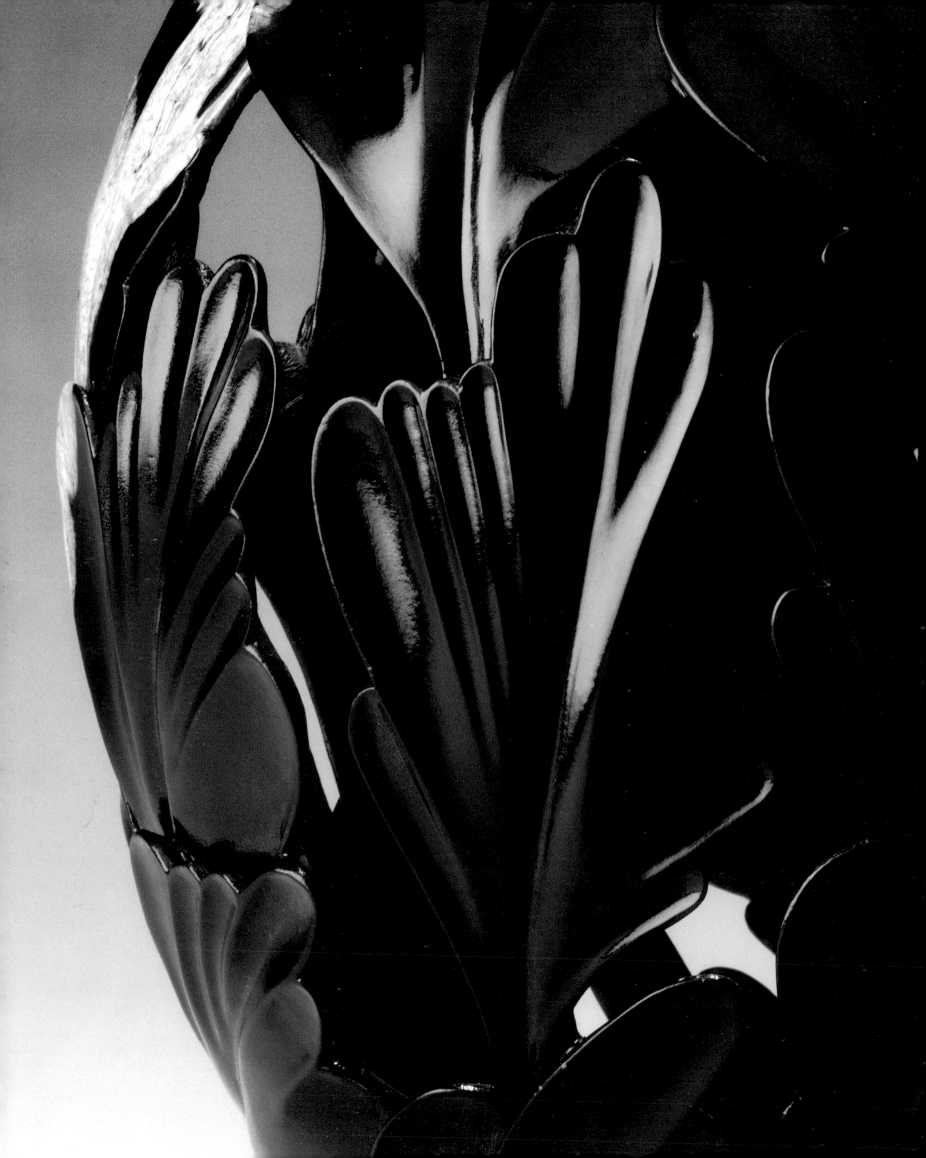

John Perreault

Turned On

Toward an Aesthetic of the Turned-Wood Vessel

INTRODUCTION

Most turned-wood vessels proposed as art are bowls; that is, they may be seen as sections of spheres, open at the top, and definitely larger in diameter than in height. A bowl, however, is merely one of many kinds of vessels. Cups, with or without handles, are another, as are vases, bottles, tureens, plates and platters (more or less), and pitchers. And if we are going to be precise, vessels are part of a still larger class: containers. Containers as a class includes vessels and boxes and baskets and I would say houses and all manner of buildings. Houses and buildings are containers that do not move, at least for the most part. Containers such as vessels and boxes—the latter includes both caskets and suitcases— are made to be moved from place to place, from kitchen to dining room, from table to mouth; from bed to parlor to grave; from country to country. I should point out that we may also look at trains, trucks, and planes as containers that move.

Here, however, since this essay has been written to honor the fine collection of turned- and shaped-wood vessels intelligently brought together by Ronald C. and Anita L. Wornick, we shall focus on the "bowl" form as a point of departure for aesthetic expression. The vessel contains all the meanings of its brother and sister objects in the larger container class. A container is a place to put things, store things, protect things; it is to transport, hide, serve, display, transform. The history of use is a large part of its meaning; no vessel is ever totally empty. Although we may not use turned-wood vessels to put things in, they cannot be totally divorced from the history of vessel forms.

Nevertheless, turned-wood vessels are increasingly being treated as art. Artists make them to be displayed and collected as art, and collectors collect them. Museums acquire, catalogue, and exhibit them; they are conserved, preserved, and insured. They are increasingly written about as art, by this author and others. I, for one, as an art critic and as someone with an interest in contemporary aesthetic issues, would not have agreed to write this essay if I were not convinced that the Wornick collection is a collection of art objects, and a fine one at that. According to the institutional definition of art, which is the instrumental definition, turned-wood vessels are art. It may take a few years before a turned-wood vessel is included in a Whitney Biennial or a Venice Biennale or a Carnegie International, but an informed consensus is in the making, close on the heels of the consensus about ceramics and glass art now nearly formed.

The cynic would add that not enough people have invested enough money to make the art status of these forms secure. But is status even stable? Art keeps changing. In

fact, the rapid change in turned-wood vessels would, borrowing from ethnology, certainly be an indication that we are dealing with art. Although individual turners may not change their works fast enough for some collectors, opening up suspicions of production work, the norm is formal and stylistic development, or there is at least a vocabulary large enough to generate variety and surprise. Fear of craft and fear of design—on the part of artists, collectors, curators, and critics—have not gone away. The notion of individualistic artists producing individualistic artworks, for better or worse, informs (and inspires) contemporary turning.

WHY ARE TURNED-WOOD VESSELS ART?

In a simple world without competing art forms, without history, without multitudinous viewpoints, without variant aesthetic and sensory capacities, without commercial or personal agendas, it might be sufficient to say that the Wornick collection is proof enough that turned-wood vessels are art. I could lead the viewer by the hand to examples by personal favorites such as Dennis Elliott, David Ellsworth, Mark Lindquist, and Howard Werner, all well-known figures within the field. And then I could add Vic Wood from Australia and Jim Partridge from England. But this is not a review. At this point in time, we need to add to the literature dealing with the turned-wood vessel as art. The seriousness of the discourse should reflect the seriousness of this new art form. Many who already appreciate turning and sense that it is art may not be able to explain their experience to others. To say, It's art because I say it's art, is not productive.

fig. 1. Bob Stocksdale and Kay Sekimachi
MARRIAGE IN FORM

1992
California black walnut with wood patterned by mistletoe roots and hornets' nest paper laminated with wallpaper paste, each 5 × 5½ in. (12.7 × 14 cm)
Collection of the artists. Photograph by Christopher Dube

This overlaps with the gut-reaction definition of art, which is an assertion of an emotion rather than an argument. By pursuing arguments we gain description through location; we may never settle all questions, but at least we will have circled the objects enough times to grasp their aesthetic weight.

We have already touched on the institutional definition of art: art is what is treated as art. This at least has the advantage of a certain open-mindedness. The gut-reaction technique may be how most people react to art, but it does not communicate very much. Worth exploring next are arguments by precedent and family resemblance: similar objects were classified as art in the past, or similar objects recently produced are now considered art; turned-wood vessels have a family resemblance to other artworks. If other craft-based art forms are art, then so are turned-wood vessels (see fig. 1).

But, before we continue, aren't craft materials too humble? Wood is everywhere. Although there is now greater awareness of threatened hardwoods, wood is ubiquitous and renewable. Most turners use ordinary wood. Rarity of materials does not make turned vessels art. Because of advances in contemporary art, the material

criterion for art no longer applies. An object does not have to be marble or bronze or paint on canvas to be art. Artwork can be made of rubber, dirt, glass (or broken glass), electricity, words—even ordinary wood.

If vessel forms in ceramics are in some cases accepted as art, then some in wood could be art, too. Certain Japanese bowls are accepted as art. But wood vessels, like glass and metal ones, have little history as art. Wood, glass, and metal vessels cannot fall back on the grand tradition of Japanese ceramics, where there is no doubt that a bowl or a cup can be of the highest, most praised, most sought after, and most expensive quality. Not all art critics or curators or collectors or artists will agree that ceramic vessels are art in the same way that paintings or sculptures are art, but given what history everywhere proclaims, it is likely that I am right and this short-sightedness will be rectified or eventually forgotten. It is much harder to make a similar argument for glass, metal, and wood vessels.

Glass and metal vessels have firm positions as acceptable and honored decorative art forms, but not more. Glass at present proclaims its vesselhood as art and has a full-fledged glass world to back up this claim: Dale Chihuly's (b. 1941) nested seaforms and his vases are greeted as art even within some parts of the painting and sculpture world, though a bit grudgingly. Metal vessels, in spite of Benvenuto Cellini (1500–1571) and Paul Revere (1735–1818) and Chinese bronzes, are yet to be forcefully put forth as contemporary art. But in terms of the argument by precedent for turned wood, limiting it to turned wood qua turned wood, we are turned back in our tracks.

SOME HISTORY

Not until 1950 in the United States was the turned-wood vessel even considered within the realm of the decorative arts, never mind art (as in fine art). It was in that year that Edgar Kaufman, Jr., the innovative curator of design at the Museum of Modern Art in New York, wrote his appreciative essay "Prestini's Art in Wood." James Prestini (1908–1993), who was influenced by the expatriate Bauhaus master László Moholy-Nagy (1895–1946) at the New Bauhaus in Chicago, was, according to Kaufman, a research engineer—thus implying that his turned-wood pieces were hobby art or the work of an amateur and not the work of an artist. Turning as art starts off on the wrong foot; the curse of hobby art will always be with us unless we look to Far Eastern traditions: the scholar poet-painter; the part-time raku master. What we now call professional art is largely a myth, since although many are called, few are chosen for total economic support of their passion. Art as a second career—a love career, either parallel or subsequent to livelihood—can be as productive, if not more productive, than a quixotic insistence on art as one's only source of income.

Fortunately, Kaufman was sensitive to Prestini's achievement; he writes tenderly of the artist's feeling for wood and his immaculate, inspired sense of minimal form. The times, however, did not allow Kaufman to anoint the bowls and plates as art. "His spare, smooth, and evenly accented forms," writes Kaufman, "more often borrowed from mechanization than protested against it." Kaufman seems to be claiming Prestini more for design than art, though he included in his discussion Prestini's saw-cut, hanging abstract sculptures and some shaped, biomorphic ones. The artist himself eventually moved totally to sculpture, with no particular success, although in

reproduction the works certainly look handsome enough. He is now remembered for his turned work produced from 1933 to 1954 and is generally seen as the grandfather of the turned-wood vessel as art, whether he himself (or his fan Kaufman) thought of these perfect pieces as such.

By 1950 another artistic turned-wood pioneer was in full force. Rude Osolnik of Tennessee (b. 1915; not represented in the Wornick collection) was receiving recognition for his turned candlesticks, but he had begun turning unique vessels in the early forties, sometimes experimenting with green wood, letting the drying-out process create warped edges that were intentionally expressive. By the late forties, Bob Stocksdale in California was turning exquisite vessels, many of them inspired by Japanese and Chinese ceramics.

But so far as I can tell, before Prestini, there were only salad bowls and tureens. Surely turning was part and parcel of woodworking, shop, and manual training. Surprisingly, turning as a royal hobby, rather than as a working-class or middle-class pursuit, goes back to the Europe of the eighteenth century, when turning manuals were produced with court patronage. In Great Britain in the 1780s, John Holtzapffel started producing ornamental lathes—only twenty a year—and his company's thorough tomes, under the series title *Turning and Mechanical Manipulation*, were reprinted not too long ago by Dover Press. The first woman known to have acquired a Holtzapffel lathe was the Marchioness Townsend, who registered hers on December 21, 1798. Decorative turning seems to have been more about finials, spindles, chair and table legs, canes (baseball bats came only much later), and a few candlesticks here and there.

The rise of the turned-wood vessel as art may be unprecedented, but it is not inordinately mysterious. Turning has its roots in the Arts and Crafts movement, beginning in the last century and lingering at least to the Great Depression, which in turn engendered hobby art, shop art, and all the charming products of manual training. The explosion of leisure time and the do-it-yourself trend after World War II also provided a context for turning. In 1976 fifty people attended the first woodturners' conference. In the twenty years since, turning has become firmly established in the craft world—both the Renwick Gallery in Washington, D.C., and the American Craft Museum in New York have the beginnings of significant turned-vessel collections. Turning is an international phenomenon, as the Wornick collection illustrates. The most significant turners, however, seem to come from Anglophonic countries: Australia, Canada, Great Britain, Ireland, and the United States. One could understand why turning was until recently exclusively male (Dad is in the cellar working away at wood, while Mom is upstairs sewing), but does one have to speak English to turn? It may be that the major woodworking magazines are published in English, but I suspect it has more to do with the hidden heritage of the Arts and Crafts movement, which was, after all, British-based.

IS BEAUTY ENOUGH?

The turned-wood vessel is art in the same way that painting, sculpture, and ceramics are art. Furthermore, it is an art we need, a new art of great subtlety, as attested by the Wornick collection. Art is something intended to be beautiful, produced by human

beings for human beings or in some cases for God or the gods. This definition of art is elusive; pleasure, enlightenment, appropriate form, and complex meaning all play a part. Beauty is a tool that can be employed toward the evolution of consciousness. And, of course, beauty changes over time and from culture to culture. Perhaps we are at a turning point; the turned-wood vessel is one of the few art forms devoted to beauty. Painting and sculpture are not. Glass is exploring the realms of sculpture and installation art. And ceramics have drifted into whimsy.

THE VESSEL PROBLEM

The vessel (i.e., bowl, cup, plate, vase, etc.) is associated with use. But use is no longer a detriment to art status. Those familiar with contemporary art will certainly know the sculptures of Scott Burton (1939–1989): they are chairs and other forms of seating furniture meant to be sat on. Dennis Adams (b. 1948) makes bus shelters; Chris Burden (b. 1946) once offered a handmade car as sculpture. R. M. Fisher's (b. 1947) lamps are accepted as sculpture by galleries and museums and are written about as such by art critics far and wide. Why, then, do some disdain the vessel because of its relationship to use?

The vessels we are here mostly concerned with are of hardly any use. Only an insane person would use a Lindquist or an Ellsworth to hold fruit on the dining-room table. Contemporary turned vessels intended as art are too expensive, too finely finished, too easily damaged for use—and they often (intentionally) have disgusting holes, fissures, and fractures in them. Even more than ceramic bowls as art, wooden vessels as art do not invite soups or, more to the point, salads. I happen to think that a functional wooden bowl could also be art, but the vessels now under discussion are not bowls of that kind. These vessels refer to useful forms, but they are clearly not meant to be used in any way other than artistic contemplation through sight and, if you own them, touch.

Touch, of course, is the dirty little secret of the crafts and the craft-based art forms that have developed now that we no longer require or seem to want handmade items for everyday use. Western art, including most forms of modernism in this century, has privileged sight. Slowly but surely, the tables, as it were, are being turned. Sight is not enough; because of movies, television, and computers we are imprisoned by sight. Trapped before our television sets and computer screens, the only touch we know is that of the buttons on our remotes and computer keyboards. Soon we will not even need those, as voice becomes the interface of preference. Paradoxically, the very tactility of the turned-wood vessel that provides the grounding of its artistic presence is also what slows down its acceptance as art. The vessel is the form that allows the turner to investigate the haptic and the tactile: weight, thinness/thickness, roughness, smoothness, the dry and the oily.

The vessel is no more confining a form than the rectangle of painting or, on another level, the portrait. Why is the vessel an inspiration? (See fig. 2.) Because of our eating habits, our bodies, and the earth and sky above, it is a familiar form. We move from breast to bowl, from convex to a combination of convex and concave. When the land is cleared to the horizon or we are at sea, on a plain, or in a desert, the sky above

fig. 2. Kay Sekimachi
PAPER BOWL (Untitled)

1989
100% kozo paper, 4¾ × 7½ in. (12.1 × 19.1 cm)
Handmade at Magnolia Mill and Press, Oakland, California.
Collection of the artist. Photograph by Tom Grotta

is a gigantic dome or inverted bowl. We make a vessel with ourselves at the center when we spread out our arms and spin. And curves are so lovely: breasts or chests, hips, buttocks, all the roundness fits the mind as well as the hands. Then, too, looking at a vessel in outline, seeing it from the side as a shape, we see the walls make lines that continue, turning in or out, expanding the void, outgoing or ingoing, expansive or introspective.

Vessels carry their space with them, unlike sculpture, which must be in a room or a plaza (see fig. 3). Vessels, particularly thrown, blown, or turned vessels, are movement solidified, movement remembered, movement projected through time. Vessels, unless they are chalices, are fairly private until they enter museums. Even funerary urns, loving cups, the wine glass or goblet used for toasting, and the wedding glass before it is smashed have a private life. The vessel (in clay, in glass, in metal, in wood) is to sculpture as poetry is to prose. Both have their uses. But the former, although smaller, is, in the long run, larger.

Public statues get pulled to the ground; monuments are toppled; abstract sculpture is railed against or covered with graffiti; but no one has yet destroyed a bowl to protest a tyrant, a tax, or the toll of life's unfairness. As art, the vessel is pure taste. It is a ritual of the spirit, but it is not above protest. The vessel protests the linear and therefore strict reason and workaday time. In throwing, blowing, and turning, the center is an implied subject—as is the spiral. You center the clay; a goblet or a drinking glass needs to be on center; to turn a chuck of wood and begin the process of turning it into a vessel, you need to find the center point to attach it to the lathe.

COMPARISONS ARE ILLUMINATING

How is the turned-wood vessel like and yet unlike blown glass, thrown clay, raised metal? All these processes are associated with production ware and with craft. All these materials are associated with craft and use. In fact, the areas of comparison include four of the five materials that have been identified as craft materials, which, it is claimed by the unsophisticated, are the defining materials of craft. Who has not heard the unthoughtful mantra, Craft is art made out of clay, fiber, glass, metal, or wood? Whatever happened to bone, to leather, to stone? If a basket is woven out of plastic ribbons, is it then not craft?

All four materials under consideration employ rotation as part of formation. The process of blowing glass requires that the glassblower keep the blowpipe and later the punty constantly turning so that 1) the glowing glob of glass at the end obtains and keeps its spherical, near spherical, or cylindrical shape, and that 2) this glowing glob does not succumb to gravity and fall off the pipe and drop to the floor. The ceramist throws clay by centering, opening, and forming, using fingers, palms, and tools against the rotating lump of material (see fig. 4). The metalsmith raises a pot by hammering metal against a block or an anvil while rotating the material in a programmatic way (see fig. 5). The turner works the wood while it is rotating. In blowing and turning the rotation is horizontal; in throwing, vertical; in raising, vertical, but certainly with the growing vessel, sort of upside down.

Heat is a factor in three of the four disciplines/art forms we are examining. Glassblowing involves material that has to be kept very, very hot by constant reheating in the glory hole. When shaped, it then must be annealed in another kind of furnace, so

fig. 3. Elsa Rady
VESSEL (Untitled)
1982
Glazed porcelain, 8¼ × 8¼ in. (21 × 21 cm)
Collection of the artist. Photograph by Bob Lopez

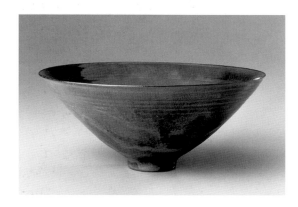

fig. 4. Otto and Gertrud Natzler
MOSS GREEN AND SANG REDUCTION VESSEL (F691)
1954
Glazed earthenware, 4⅛ × 10⅞ in. (10.5 × 27.6 cm)
Collection of Forrest L. Merrill. Photograph by M. Lee Fatherree

that the temperature is slowly decreased over twenty-four hours or more depending on the size and thickness of the piece. In ceramics, the clay is heated after it is formed. Raising metal requires some heat or annealing but not the great temperatures used in ceramics and glass. Only turning does not require heat, although a gouge or chisel can become quite hot.

In three of the four disciplines, the mass can stay the same throughout the process. So far as I know, the amount of metal you start with when raising a pot is the same when you have finished. Although you can add to it if you want, the lump of clay you start with on the wheel is all you need to make the bowl you end up with. In glassblowing, you could produce a glass with only one gather from the furnace, but most often several gathers are required, certainly for large-scale pieces and for cased glass (see fig. 6). Also, as in ceramics, you might want to add handles, lips, feet, and other parts.

Wood is entirely different. The mass is reduced; wood shavings are taken away. Unlike its craft siblings, it is rather like carving. I should, however, mention that in ceramics, just to confuse things, traditional Southern potters call throwing "turning." In ceramics in general, there is a process quite close to wood turning: trimming. The greenware is affixed to the wheel by some wet clay, and the potter shaves the form with tools while the material turns. Theoretically, you could trim a pot out of leather-dry clay and thus turn it as in wood turning. In ceramics, except for work on the foot of the vessel, too much trimming—some think any trimming at all—is considered cheating. Most porcelain produced by Sèvres in France, I am told, is more trimmed than thrown, accounting for its lifeless precision.

Actual touch is another consideration. Although tools are sometimes used (little bits of wood and sharp instruments, sponges, bits of metal to smooth and shape), ceramics is very hands-on. Metal you touch while raising and planishing, but it is mostly tools that come in contact with the material. Glass, for obvious reasons, is not directly touched at all until cold-working, if it is necessary. Wood turning involves some touch. You have to grab the wood and screw it on; thereafter, it is gouges and chisels against the whirling material. Finishing and polishing, however, require more contact with the material.

Surface treatment varies. Ceramics can use glaze formed naturally in the wood-fired kiln or through the addition of salt or, of course, concocted glazes of all sorts. The clay can also be scored and marked before firing. Glass is glassy, but it can be engraved when it is cold and cut and sandblasted; color can permeate the form or be layered or added in bits. Metal can be decorated by the hammer marks and engraved and there are degrees of polish, but the preference is for metal as metal (see fig. 7). Wood is similar: the wood may be stained or highly oiled, but paint and carved configurations are rare. Unlike all the other media discussed, in turned wood, configurations are found in the wood and brought out by the turner. The centering of the wood on the lathe, the orientation of the vessel, the actual turning, can be used to discover rings, bark, branching, spalting (a kind of rot), holes, and other deformities, even worm holes. Thus, differentiation of surface and sometimes a great deal of the form itself is "found."

How is the turned-wood vessel like and unlike sculpture? Traditional sculpture has been divided into subtractive and additive techniques, the subtractive (carving away) being the most traditional, the additive encompassing welding and assemblage. Cast-

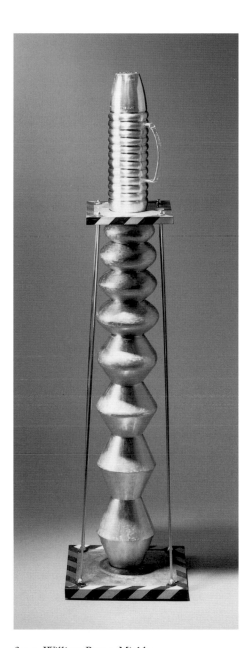

fig. 5. William Baran-Mickle
ENDLESS COLUMN: COFFEE
1996
Brass and wood, 51 × 12 × 12 in. (129.5 × 30.5 × 30.5 cm)
Collection of the artist. Photograph by Jeoffrey Tesch

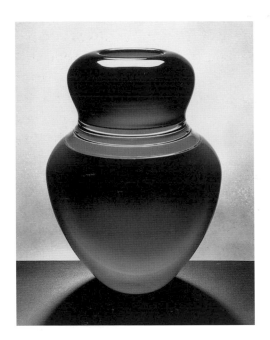

fig. 6. Sonja Blomdahl
SCARLET/CLEAR/TEAL

1994
Blown glass, 17 × 12 in. (43.2 × 30.5 cm)
Collection of the Seattle Water Department Portable Works.
Photograph by Lynn Hamrick

ing is also additive if one considers the handmade clay form the process might begin with, but it can also begin with a carved form or a found form as subjects for investment. Perhaps casting should be a third sculptural technique, and a fourth, finding or selecting. Modeling with clay can best be described as combining the additive and the subtractive methods.

Turning wood is a subtractive process, like stone carving, but it also participates in the finding mode since the qualities of the result depend on qualities found in the wood. So the turned-wood vessel is like traditional sculpture because of its similarity to carving and like Dada and postmodern sculpture because of its found-object aspect. In the latter case the difference hinges on the Dada/postmodern preference for cultural objects, whereas turning obviously chooses chunks of natural wood. When really unusual wood stock is used, such as wildly spalted or lightning-struck wood or grotesque burls, our new genre relates to the ancient Chinese art form of discovered rock formations claimed and prized as art.

Both the turned-wood vessel and sculpture are three dimensional. The former, however, is always made of wood and always turned, whereas sculpture can be made of almost anything—including wood—and can use any process except turning. The turned vessel, like all art vessels, is composed exclusively of curves and circles, convex and concave shapes, whereas sculpture is not (see fig. 8). One could say that the vessel is a smaller category within the larger one of sculpture. But one could also say that about jewelry and glass sculpture. I myself have done this in the past to make a rhetorical point, but now it seems more instructive to do the reverse. Although craft is art, it is not sculpture, for the aesthetic values are quite different. The same can be said of the turned-wood vessel. Like the ceramic vessel, it is less about manipulating space than it is about manipulating void. It does not call attention to the space around it; instead, it focuses the mind on the space within.

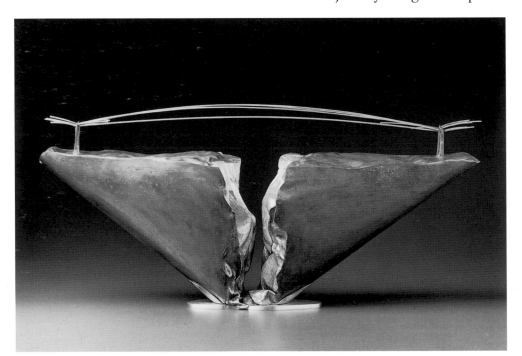

fig. 7. William Baran-Mickle
CANYON SONG

1987
Copper, brass, sterling, and nickel silver, 12 × 25½ × 6½ in.
(30.5 × 64.8 × 16.5 cm)
Collection of the Burchfield-Penney Art Center, Buffalo State College, Buffalo, New York, Gift of the artist, 1992.
Photograph by Jamey Stillings

THINKING IN CIRCLES (CONCLUSION)

This has been a circuitous journey, from the vessel to art, but I hope this small essay complements its subject in obvious but also in not-so-obvious ways. As in wood turning, in this text there are no straight lines. I mean instead to provide a map made up of many paths rather than a single path; it is a map where all boundaries end up composed of dotted lines. It is a map in motion. The dotted lines move. And, after all these arguments and odd descriptions, what is the return? Surprisingly, we come back to beauty. Beauty is central to the turned vessel, but beauty is found in what has been removed by metal tools pressed against the whirling chunk of wood as well as in what remains.

The beauty of turned-wooden vessels is not so much about proportion, although proportion has its rightful place. Proportion can be figured out with a compass and a

little solid geometry. It is instead about reaching for what cannot be reduced to mathematics. The proportions we are dealing with are too complex for ordinary mathematics, for there are at least a dozen aspects of the turned vessel that must be interrelated in some meaningful way. The beauty is in the polysemic employment of these traits. The beauty is in the relationship to all other vessels produced in the past or those that will be produced and in the relationships to the various art arguments and definitions that have been proposed. The beauty is in the references and the cross-references. The beauty is in the use, which is largely contemplative, and in the memory of the tree, as expressed by what the turner found and thus allows us to find. The beauty is in care and patience.

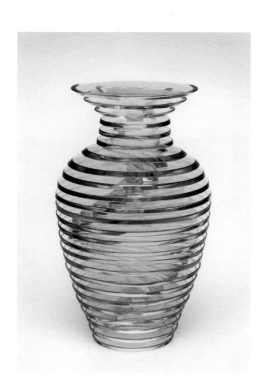

fig. 8. Sidney Hutter
PLATE GLASS VASE #26

1981
Plate glass, 11¾ × 7⅛ in. (29.8 × 18.1 cm)
The Toledo Museum of Art from the George and Dorothy
Saxe Collection, © Sidney Hutter. Photograph by Tim
Thayer and Robert Hensleigh

Edward S. Cooke, Jr.

Turning Wood in America
New Perspectives on the Lathe

For much of the twentieth century, wood turning has been a misunderstood process with a reputation closely linked to the Industrial Revolution. Many people have perceived the lathe as an active mechanical agent in the mass production of goods during the late nineteenth century, emphasizing speed and accuracy over flexibility and efficiency. Historians of technology have celebrated the invention of the Blanchard lathe and subsequent types of replicating lathes as examples of American ingenuity in the development of integrated systems of machine tools that virtually eliminated handwork. These scholars depict the lathe monolithically as a highly regulated piece of machinery that permitted the rapid, repetitive, and accurate manufacture of vast quantities of component parts. Design historians have also focused their attention on the lathe in the nineteenth century, but have taken a more critical view. They have linked the possibilities of such workmanship of certainty to a critique of Victorian aesthetics, denouncing the lathe for its contribution to the overvigorous and degraded turned ornament of nineteenth-century furniture and interior woodwork.[1]

Although wood turning was certainly well suited to some of the technical and aesthetic needs of the last half of the nineteenth century, it is important to recognize that American wood turning has a longer history and encompasses a wide variety of approaches differing in power (human, water, steam, or electricity), space (chair manufactory, turning mill, or small shop), product (gun stock, furniture part, architectural detail, rolling pin, treen [wooden plates and bowls], or hollow vessel), and market (national mail order, local custom work, or art gallery). Rather than focus on a specific type of lathe mechanism or certain products off the lathe, one needs to look at the lathe as a tool used toward a variety of ends and understand lathe technology as a social process, an interaction between maker, tool, and market. At different points in American history, specific cultural settings have contributed to specific technological choices. Understanding the various uses of the lathe sheds light on the pattern of these choices.[2]

For much of the colonial and early national period, furniture makers in urban and rural shops used human-powered pole, treadle, or wheel lathes to produce parts for chairs, bedsteads, tables, and even case furniture. As early as the seventeenth century, chairmakers in urban centers such as Boston turned batches of legs and stretchers, which they then could assemble to make sets of chairs for export. Relying on chairmaking as their sole means of making a living, these craftsmen set up their lathes and were able to turn parts consistently and quickly by using a strike pole, or marking stick, to lay out the proportions of the turned elements on the rough blank and by maximizing the rhythm of their turning tools and lathe. Urban cabinetmakers in the eighteenth century also used the lathe to turn legs and stretchers for common tables;

make columns, finials, and drops for case furniture; and shape the bottoms of the pad feet on crooked legs. Rural joiners also made effective use of the lathe to organize their work rhythms. Using one set of tools at a time to fabricate and stockpile parts always in demand was much more efficient than constantly juggling different sets of tools to produce individual parts as needed. Such a system permitted the yeoman-joiner to balance his chairmaking with case furniture construction, general woodwork, farming, and other activities. In a period characterized by local social economies and limited labor, the lathe permitted flexible, economical production in both urban and rural settings (fig. 1).[3]

In the early national period, deep social and economic changes such as population growth, the development of federal transportation and finance systems, increased interest in manufacturing, and intensified artisanal activity combined to alter the scale of lathe production and the extent of its markets. However, these changes occurred mainly in the number of makers, the advent of year-round production, the increased use of water power, and the specialization of their product, rather than in machinery (fig. 2). Rural turners in particular began to orient themselves toward new markets such as plank-seated furniture for urban retailers and spindles for the increasing number of textile manufactories. The rural craftsman simply intensified his existing lathe rhythms, turning out parts throughout the year and using template patterns and jigs such as strike poles not just to turn efficiently but also to meet external standards of the new markets. Most chairmakers apparently did not employ formal outwork systems common in crafts such as shoemaking and hatmaking, but rather used a variety of strategies: working with and for one another, renting lathe time to other woodworkers, exchanging batches of parts, and developing a network of interconnected sawmills, turning shops, and assembly shops. In short, turners maintained a certain fluidity in the organization of their work and experienced changes in degree more than in kind.[4]

In the last half of the nineteenth century, advances in the machine-tool industry and the emergence of national markets fostered certain developments in turning machinery. For example, specialized lathes with shearing knives cutting uniformly along the tangential surface of the wood blank in the lathe could provide thousands of identical balusters or columns (fig. 3). However, such function-specific machines were better suited for metal than for wood, with its inconsistent grain that was subject to tear out, and more successful in producing shapes that emphasized tapering and incised rings than balls and balusters. The unpredictable grain of the raw material, limited range of shapes, and the necessity of large output to offset high investment cost in very specialized cutting knives and carriage apparatus restricted the use of such lathes to the low end of the furniture- and home-building markets, where a high degree of fashionable decoration was not economically feasible. The most common applications were legs for tables and chairs and balusters for stairways, typically with simple shapes and abrupt transitions between elements. As a result, the new lathes did not really dominate the industry but rather gained a foothold only in the bulk or mass-

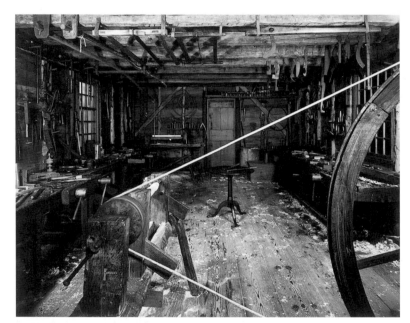

fig. 1. Interior view of the reconstructed Dominy Woodworking Shop, originally located in East Hampton, New York, and now at the Winterthur Museum. The shop itself was built around 1750 and remained in use until 1946. Measured drawings of the shop, oral histories, and surviving artifacts guided the placement of the various tools and equipment. Note the way in which the pole lathe, benches, and great wheel lathe were located around the edge of the room, permitting flexible linkage among the various stations. The placement of chisels, gouges, and other edge tools just above bench height and patterns, molding planes, and other guides or jigged tools just above head height speaks to a logic of efficient production. Such a shop would have two to four craftsmen working in it. Photograph courtesy, Winterthur Museum

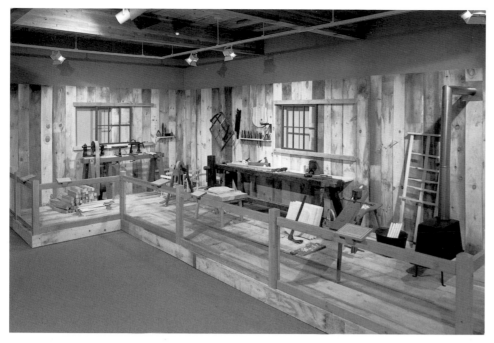

fig. 2. Vignettes of a chairmaker's shop at right and turning shop at left, re-created from inventories and records of northern Worcester County, Massachusetts, artisans, ca. 1820–50. To satisfy growing demand in urban markets, rural chairmakers intensified their turned-chair production by using water power and organizing the various stages efficiently. The technology itself changed very little, but its co-ordination changed significantly. Photograph courtesy, Old Sturbridge Village

fig. 3. Back-knife lathe. From W. A. Heath, *Illustrated Catalogue "A"* (Binghamton, N.Y.: by the company, 1889), p. 34. Such continuously running gouge lathes began to appear in the 1870s but only gained acceptance where thousands of an identical part were needed. It was costly to develop and cut new knives and patterns and difficult to produce intricately turned elements with flowing transitions. Photograph courtesy, Eleutherian Mills Historical Library

production sector, where low price, uniform character, and use of dedicated technology reinforced one another.[5]

Most of the furniture trade, and therefore much of the turning business, in the last half of the nineteenth century was instead characterized by custom or batch production in which product character and quality were as important as price. Such priorities placed greater emphasis on general-purpose machinery that permitted the skilled woodworker to draw on his dexterity and knowledge of materials to make informed use of jigs, patterns, or drawings and to make design adjustments or decisions while the work was on the lathe. The belt-driven lathe, with either steam or electric power, was ideally suited for this type of flexible, efficient work that balanced quantity and stylistic quality. In essence this was a period in which skilled turners were human machines who made maximum use of the versatile lathe. Through the end of the century, most furniture firms in the middle and upper levels of the market continued to cluster general-purpose machinery like lathes in certain areas of their shops and to depend on skilled craftsmen to apply their skills (fig. 4). Other furniture manufacturers or builders relied on production shops or turning mills to supply needed turnings. Firms such as the John Grass Wood Turning Company in Philadelphia (est. 1863) used belt-driven lathes and skilled turners to provide a wide variety of furniture parts, architectural woodwork, household wares such as rolling pins, and flagpoles (fig. 5). Together, specialized lathes and skilled turners in furniture manufactories, production shops, and small custom shops satisfied the growing American demand for furniture and building materials built from turned elements.[6]

In the early twentieth century, wood turning continued to play an important role in low-end furniture and architectural markets, but competitive ideals, technologies, and materials eroded its pervasiveness in other parts of the market. The aesthetic philosophies and craftsmanship ideals of the Arts and Crafts movement favored the display of structural integrity with honest construction and limited decoration. Such attitudes led to an explicit emphasis on sawn or hewn elements, straight lines, and restrained carving. Social and design reformers of this period linked the lathe to the impersonal industrialization that they railed against. The validity of wood turning became limited to variations of Windsor furniture, much of which was popular as low-end school and institutional furniture. The spectacular growth of the refined earthenware industry in New Jersey and Ohio further eroded the market for wood turning as ceramic bowls and platters replaced treenware in the kitchen.[7]

By the 1920s interest in the modern aesthetics of the Machine Age led to a greater concern with strong forms and modern materials such as tubular steel, chrome, or plastic. Lathes became increasingly linked to metalworking and milling and less identified with woodworking. A 1931 government publication intended to guide the

American public in the purchase of furniture discusses the properties of different types of woods, the benefits of veneered plywood, the strength of joinery techniques such as mortise-and-tenon or doweled construction, the importance of good carving, and the values of different styles, but makes no reference to the lathe or turning.[8]

By midcentury, the reputation of the lathe had reached a nadir even among woodworkers, who divided the furniture industry into two distinct camps: quantity production of mundane objects fabricated mechanically and custom work that clearly showcased the material and handwork. In a 1944 article Virgil Poling (b. 1908), head of the Dartmouth College shop where the School for American Craftsmen was first established, summarized the contemporary woodworker's opinion of the lathe:

> New machine tools can easily lead one far afield, also. . . . Some tools, like the lathe, can lead the craftsman astray in the direction of overdecoration. The facility of the tool can become so fascinating that the result is nothing more than an intricate series of spools and acorns. Let the tool guide you but don't let it run away with you. . . . This close combination of tools, materials, and craftsman leads to something beyond the machine and the man. I call it personality. This personality is a direct expression of the craftsman and what sets the hand made article aside from the machine.[9]

Accepting the technical and aesthetic critiques of Arts and Crafts reformers, Poling articulated a common view of the lathe as a machine that controlled or seduced the skilled craftsman. The lathe thus became a cliché of the crass materialism of the late nineteenth century when technology seemed to overwhelm good design. Woodworkers of the post–World War II period did use machinery such as table saws, mortising machines, and routers but employed them in the preparatory stages and toward a certain aesthetic that emphasized "quiet refinement of contour and proportion" derived from a "sculpted effect in solid wood." Cherry and walnut forms with edges rounded and shaped with hand tools such as shaves and rasps and finished in oil characterize much of the furniture from this period. The furniture of Wharton Esherick (1887–1970) and Sam Maloof (b. 1916) offers the clearest examples of these principles. Several chair and table forms by these woodworkers and others active in the 1940s and 1950s featured simple, slightly tapered legs lacking any turned ornament, but the craftsmen eschewed the lathe in preference for a more labor-intensive approach. They shaved and rounded their legs from squared stock. Perceptions of the lathe as evil and an obsession with hand-tooled surfaces determined such choices.[10]

Ironically, just as Poling expressed the furniture maker's disdain for the lathe, different sorts of people "rediscovered" the lathe for new purposes. Initially self-taught individuals who were not trained artisans found turning to be an accessible, affordable, accomplishable, and satisfying woodworking technique. The spread of home workshops and hobbyist woodworkers during the first half of the century, introduction of electric power for lathes, limited number of tools or other equipment required to turn objects, and widespread availability of materials encouraged non-professionals to try their hand at turning, particularly the making of treenware. In contrast to the cost of setting up a complete furniture-making shop—several pieces of power machinery such as a table saw; a variety of measuring, cutting, and shaping

fig. 4. "The Manufacture of Parlor Furniture—Factory of M. & H. Schrenkeisen, New York City," *Scientific American* 43, no. 15 (October 9, 1880). The engraving of the Schrenkeisen factory indicates that skilled turners working on belt-powered lathes continued to satisfy the demand for turnings in the middle-level market for parlor furniture. Oftentimes the multipurpose machines were located on the lower floors of a manufactory. Photograph courtesy, The Museum of Fine Arts, Houston, and Bettmann Archive, New York

fig. 5. View of two of the four turning stations on the second floor of the John Grass Wood Turning Company, located on 2nd Street in Philadelphia. Established in 1863, the Grass shop contained six workstations at the turning bench along the north wall on the first floor and four stations above that on the second floor. The adjustable headstocks and tailstocks permitted a wide variety of turning in this production shop. Note the location of the bench by windows with northern exposure, the racks for turning tools between the windows, and the drive shaft along the ceiling. Photograph courtesy, Wood Turning Center

fig. 6. Mark Sfirri
TABLE, MIRROR, AND BRACKETS

1996
Ash
For each leg of the table and each rail of the mirror, Sfirri employed different multiaxis turning. Photograph courtesy, Mark Sfirri

tools; and boards from the lumberyard—and the time required to master the various steps of furniture construction, the establishment of a turning shop was inexpensive and the learning period relatively brief. Sears offered a simple hobbyist bench lathe, appropriate for spindle turning, for about one hundred dollars. Other hobbyists purchased Delta and Walker Turner lathes, formerly used in school shop programs, on the secondary market for two to three hundred dollars. A kit of turning tools could be as simple as a single gouge, but often consisted only of a gouge, skew, and scraper. Fallen or scrap timber was all around.[11]

The emphasis of contemporary woodworking on pure forms that exploited the inherent warmth and figure of the material also provided aesthetic legitimacy for this exploration of wood turning. Pioneers such as James Prestini (1908–1993), Bob Stocksdale, Melvin Lindquist (b. 1911), and Rude Osolnik (b. 1915) became new versions of production turners. However, they were distinct in several key ways. They were detached from the traditional shop environment of their artisanal predecessors and earned reputations as much for their particular choices of specific exotic or figured woods as for their skill in shaping the material. Working by themselves out of their home shops, they pursued refined, simplified forms; turned quantities of bowls, plates, and candlesticks; and sold their wares at a variety of venues including department stores and craft shows.

The example of these early form and grain turners also inspired a new generation of turners, which emerged in the 1970s. These studio turners embraced the creative parameters offered by the flexible tool and enjoyed the speed and ease of realizing three-dimensional form in a relatively inexpensive and readily available material. As the metalsmith Charles Crowley (b. 1958) has explained, "I like to sketch on the lathe; it allows me to explore, change, and refine ideas quickly without losing my original inspiration." Such a proactive attitude distinguishes these studio turners from their immediate predecessors who strove to reveal the inherent beauty of the material. Studio turners perform much of their work on the lathe, but they also manipulate the objects off the lathe. As John Wooller (b. 1939), an Australian turner, explains, "Woodturning is just part of the process. My work is defined by the turning, but I don't want the turning to dominate it."[12]

As a result, the term *studio turner* includes a large number of personal styles, many of which are illustrated in this catalogue—the manipulated, constructed designs of Virginia Dotson and Robyn Horn, the thin-walled hollow vessels of David Ellsworth, the textured anthropological expressions of Todd Hoyer and Howard Werner, and the natural carvings of Michelle Holzapfel and Ron Fleming. Even in traditional furniture forms such as tables with turned legs, the contemporary studio turner can produce original work. Mark Sfirri (b. 1955) employs the lathe as a means to explore our notions of visual balance and symmetry, the foundation of traditional turning. Although he does sketch many of his ideas for forms, Sfirri depends on the physical activity of turning to achieve his intended results (fig. 6). The difficulty of planning multiaxis spindle turning is borne out by his study collection of turned elements from past work, his three-dimensional "sketchbook" that he uses for reference. The products of the studio turner, which can be functional or sculptural, serious or whimsical, highly finished or roughly textured, tend to be sold to galleries and collectors. Such

one-of-a-kind commodities are thus the direct opposite of the common perception of turned goods: they are unique, design- and labor-intensive objects made by an individual maker whose market is the rarefied gallery world rather than mass-produced parts produced in a factory or sweatshop for the building trade or furniture industry (fig. 7).[13]

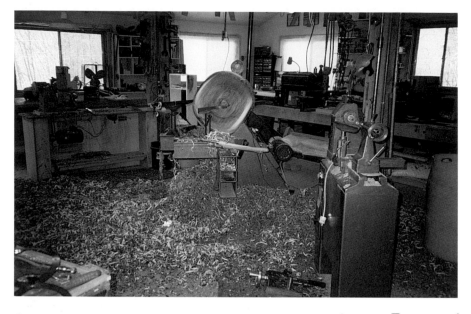

fig. 7. View of the shop of Rodger Jacobs, Newland, North Carolina. For many contemporary turners, the lathe stands in a dominant position in the middle of the shop, symbolizing that the lathe is no longer tied to larger processes but is the primary processural focus of the individual turner. Jacobs has five lathes in his shop, including a long-bed pattern-maker's lathe to turn lengthy elements (visible in the background on the right side), a lathe for production spindle work (on the left), and a lathe set up for faceplate turning of vessels (center).

In the past two decades the two new types of turners —nonprofessional serious hobbyists and studio turners—have provided mutual support for each other. Hobbyists, many of whom are older men with some previous woodworking experience, enthusiastically embrace wood turning, making up the bulk of the nearly six-thousand-member American Association of Woodturners, a ten-year-old organization with seventy-five local chapters. Able to commit money and time to their avocation, they eagerly follow the latest developments in lathe technology, chucks, and tools; provide important input to the development of new tools; and are often the first turners to purchase the latest equipment. For example, at the most recent annual meeting of the AAW, this cohort was responsible for the largest number of purchases of the newest lathe, a tool with improved stability and speed control ideally suited for large bowl and vessel turning, at a price of about four thousand dollars. The patronage of these hobbyists is thus critical to the vitality of machine and tool companies seeking a niche in the turning world. The same group contributes financial resources in other ways as well. They flock to turning workshops and demonstrations, subscribe to various publications such as *Fine Woodworking* and *Woodshop News,* and seek out exhibitions of turned work in galleries, regional craft shows, and museums. As a result, the hobbyist turners are often the most active buyers and collectors of turned objects. It is not mere coincidence, then, that Ron Wornick, a skilled self-taught turner attracted by the accessibility of turning—an "available and accomplishable" pursuit—and fascinated by new equipment developed for studio turners, is a member of the AAW, frequents exhibitions of turned work, and has collected the significant group of objects highlighted in this catalogue.[14]

Studio turners, for their part, benefit in many ways from the field's hobbyist foundation. The hobbyists' interest in new technologies and willingness to share experiences at demonstrations and workshops have expanded the technical knowledge for all practitioners. Such informal, collaborative learning is essential in a field in which there is no school or program offering a degree in turning. Graduates with degrees in furniture design and construction, ceramics, industrial design, and a variety of other majors can receive an education in turning by attending these conferences or demonstrations. The field's interest in bringing together hobbyist and studio turner, veteran and novice—seen in the symposia held from 1976 to 1981 at the George School in Newtown, Pennsylvania, and in the regional and national meetings of the AAW from 1985 to the present—also provides a forum for studio turners to interact with one another. Finally, the confidence gained from a knowledgeable support group has en-

abled studio turners to accept a leadership role in pushing the boundaries of turned expression. The Challenge shows and World Turning Conferences developed by the Wood Turning Center, based in Philadelphia, provide evidence of this thrust. The synergy between the hobbyist providing financial and energetic glue and the studio turner providing dynamic creative energy thus creates a large ecumenical turning community.[15]

At the end of the century, the lathe has become something quite different from its former identity. It has not retained an exclusively industrial character and has not led, in a Marxist line of argument, to the dominance of mechanized factory production. Rather, it has provided a means to retain and emphasize the skill and working knowledge of the individual maker.[16] No longer associated with industrial factories and responsible for aberrant taste, wood turning has been increasingly associated with basement shops and studios, hobbyists and artists, and exhibitions in galleries and museums. It has taken its place as a viable and important process in contemporary visual arts.

NOTES

I would like to acknowledge the invaluable support of Albert LeCoff, director of the Wood Turning Center, Philadelphia, who introduced me to the world of contemporary turning and who has taught me so much about the field over the past six years. His indefatigable commitment to wood turning, ecumenical sense of the field, and generous collegiality have been a source of inspiration. Residency at the 1996 International Turning Exchange, sponsored by the Wood Turning Center, provided me with important insights into the lathe and its uses. I would like to thank Michael Brolly, Jean-François Escoulen, Hugh McKay, Terry Martin, and Palmer Sharpless for sharing their vast turning experiences with me and for grounding me in the dexterity of the turner. Ben Cooke also provided valuable insights into the turning process.

1. For the pervasive view of the lathe, see David Hounshell, *From the American System to Mass Production, 1800–1932* (Baltimore: The Johns Hopkins University Press, 1984), esp. pp. 35–38; Carolyn Cooper, *Thomas Blanchard's Machinery and Patent Management in Nineteenth-Century America* (New York: Columbia University Press, 1991); and Berry Tracy et al., *Nineteenth-Century America: Furniture and Other Decorative Arts* (New York: The Metropolitan Museum of Art, 1970).

2. On the importance of recognizing technology, not as science applied to the craft tradition, but as a series of production choices, see David Pye, *The Nature and Art of Workmanship* (New York: Van Nostrand Reinhold, 1968). Helpful applications of this definition include Michael Ettema, "Technological Innovation and Design Economics in Furniture Manufacture," *Winterthur Portfolio* 16, nos. 2–3 (Summer–Autumn 1981): 197–223; Philip Scranton, "Diversity in Diversity: Flexible Production and American Industrialization, 1880–1930," *Business History Review* 65, no. 1 (Spring 1991): 27–90; and Thomas Misa, *A Nation of Steel: The Making of Modern America, 1865–1925* (Baltimore: The Johns Hopkins University Press, 1995).

3. On the lathe and its advantages during this period, see Charles Hummel, *With Hammer in Hand: The Dominy Craftsmen of East Hampton, New York* (Charlottesville: University Press of Virginia, 1968); and Edward S. Cooke, Jr., *Making Furniture in Preindustrial America: The Social Economy of Newtown and Woodbury, Connecticut* (Baltimore: The Johns Hopkins University Press, 1996).

4. Cooke, *Making Furniture in Preindustrial America;* Nancy Evans, *American Windsor Chairs* (New York: Hudson Hills Press, 1996), esp. pp. 71–73; Donna Baron and Frank White, " 'Cabinet Furniture and Chairs Cheap': Making and Selling Furniture in Central New England, 1790–1850" (Old Sturbridge Village, Mass., 1993; MS in possession of author); and Carolyn Cooper and Patrick Malone, "The Mechanical Woodworker in Early-Nineteenth-Century New England as a Spin-off from Textile Industrialization" (Old Sturbridge Village, Mass., 1990; MS in possession of author).

5. On the differences between bulk and batch production, see Scranton, "Diversity in Diversity." On the changes in woodworking technology, see Ettema, "Technological Innovation and Design Economics"; Polly Anne Earl, "Craftsmen and Machines: The Nineteenth-Century Furniture Industry," in Ian Quimby and Polly Anne Earl, eds., *Technological Innovation and the Decorative Arts* (Charlottesville: University Press of Virginia, 1974), pp. 307–29; and Hentie Louw, "The Mechanisation of Architectural Woodwork in Britain from the Late Eighteenth to the Early Twentieth Century, and Its Practical, Social, and Aesthetic Implications. Part III: The Retreat of the Handicrafts," *Construction History* 11 (1996): 51–71.

6. See Ettema, "Technological Innovation and Design Economics"; Earl, "Craftsmen and Machines"; Donald Pierce, "Mitchell and Rammelsberg, Cincinnati Furniture Manufacturers, 1847–1881," *Winterthur Portfolio* 13 (1979): 209–29; Catherine Hoover Voorsanger, "From the Bowery to Broadway: The Herter Brothers and the New York Furniture Trade," in Katherine Howe, Alice Cooney Frelinghuysen, Catherine Hoover Voorsanger, et al., *Herter Brothers: Furniture and Interiors for a Gilded Age* (New York: Harry N. Abrams, 1994), pp. 56–77; and John Bowie, "The John Grass Wood Turning Company" (MS of paper presented at the World Turning Conference, 1993; on file at the Wood Turning Center).

7. On woodwork in the Arts and Crafts movement, see Wendy Kaplan, ed., *"The Art that is Life": The Arts and Crafts Movement in America, 1875–1920* (Boston: Museum of Fine Arts, 1987); Edward S. Cooke, Jr., "Arts and Crafts Furniture: Process or Product?" in Janet Kardon, ed., *The Ideal Home* (New York: Harry N. Abrams, 1993), pp. 64–76; and Edward S. Cooke, Jr., "The Aesthetics of Craftsmanship and the Prestige of the Past: Boston Furniture-Making and Wood-Carving," in *Inspiring Reform: Boston's Arts and Crafts Movement* (New York: Harry N. Abrams, 1997).

8. On the changes in the 1920s, see Karen Davies, *At Home in Manhattan: Modern Decorative Arts, 1925 to the Depression* (New Haven: Yale University Art Gallery, 1983); Richard Guy Wilson et al., *The Machine Age in America, 1918–1941* (New York: Harry N. Abrams, 1986); Derek Ostergard, ed., *Bent Wood and Metal Furniture, 1850–1946* (New York: American Federation of Arts, 1987); and Janet Kardon, ed., *Craft in the Machine Age: The History of Twentieth-Century American Craft, 1920–1945* (New York: Knopf, 1995). The government publication that makes no reference to the lathe is U.S. Department of Commerce, *Furniture: Its Selection and Use* (Washington, D.C.: United States Printing Office, 1931).

9. Virgil Poling, "The Woodworker's Page," *Craft Horizons* 3, no. 7 (November 1944): 23.

10. The quotations are from Greta Daniel, "Furniture by Craftsmen," *Craft Horizons* 17, no. 2 (March–April 1957): 34–38. For additional discussion of the woodworkers' aesthetic of this period, see Michael Stone, *Contemporary American Woodworkers* (Salt Lake City: Peregrine Smith, 1986), esp. pp. 4–17 and 65–81; and Edward S. Cooke, Jr., *New American Furniture: The Second Generation of Studio Furnituremakers* (Boston: Museum of Fine Arts, 1989), esp. pp. 10–14. George Nakashima, who subcontracted out the turning of the spindles for his Windsor-like chairs, is a notable exception to the trend, but his use of an outside supplier suggests that he did not consider it a woodworker's skill worthy of the personal touch.

11. Trends for this period have been culled from the numerous articles on some of the early turners. Among the most helpful biographical works are Stone, *Contemporary American Woodworkers;* John Kelsey, "The Turned Bowl: The End of Infancy for a Craft Reborn," *Fine Woodworking* 32 (January–February 1982): 54–60; Mark Lindquist, *Sculpting Wood: Contemporary Tools and Techniques* (Worcester, Mass.: Davis Publications, 1986), pp. 211–29; and Robert Bruce Duncan, "Bob Stocksdale: Still on a Roll at 75," *Woodwork* 1 (Spring 1989): 16–21. Richard Raffan cites such accessibility as the main reason he became a self-taught turner in 1970: *Turning Wood with Richard Raffan* (Newtown, Conn: Taunton Press, 1985), p. 1. The approximate cost of a lathe at this time was suggested by Palmer Sharpless, in conversation with the author, July 1996. Even in 1996, a person can establish a decent turning shop for as little as $300 or spend as much as $6,000.

12. Charles Crowley, in conversation with the author, April 1990; and Wooller as quoted in Terry Martin, *Wood Dreaming: The Spirit of Australia Captured in Woodturning* (Sydney, Australia: Angus & Robertson, 1996), p. 175.

13. Mark Sfirri, in conversation with the author, July 1996; David Ellsworth's response to the author's questionnaire, July 1991. The questionnaire on trends in production and collecting in studio furniture and wood turning, sent to several prominent makers and dealers, served as an important source for the author's essay "Wood in the 1980s: Expansion or Commodification?" in Davira S. Taragin et al., *Contemporary Crafts and the Saxe Collection* (Toledo: The Toledo Museum of Art, in association with Hudson Hills Press, 1993), pp. 149–58.

14. The broad generalizations presented here were culled from conversations with various turners in July 1996. Ron Wornick, in conversation with the author, June 1996, explained his attraction to turning and discussed his shop.

15. On the developments in the field in the past two decades and its catholic membership, see Cooke, "Wood in the 1980s: Expansion or Commodification?"; and Stephen Loar, "We're Not in Kansas Anymore," *American Woodturner* 10, no. 4 (December 1995): 44 and 46. Among the important publications produced by the Wood Turning Center are *Lathe-Turned Objects: An International Exhibition* (1988); *Challenge IV: International Lathe-Turned Objects* (1991); and *Challenge V: International Lathe-Turned Objects* (1993). Forthcoming is a volume of essays from the 1993 World Turning Conference.

16. For a typical Marxist approach, see John Rule, "The Property of Skill in the Period of Manufacture," in Patrick Joyce, ed., *The Historical Meanings of Work* (Cambridge: Cambridge University Press, 1987), pp. 99–118. On the value of skill and working knowledge, see Douglas Harper, *Working Knowledge: Skill and Community in a Small Shop* (Chicago: University of Chicago Press, 1987).

Artists' Biographies and Works

Derek Bencomo

Born: Torrence, California, October 4, 1962
Studio: Lahaina, Hawaii

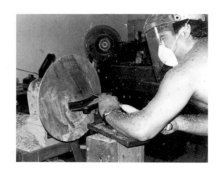

DEREK BENCOMO is a true California spirit. Born in the Los Angeles area in the early 1960s, as a youth he spent much of his time at the beach, surfing or swimming. The move to Hawaii in his early twenties was an easy transition. Although several years in the making, Bencomo's interest in the exotic woods found in antique Hawaiian furniture propelled him into the field of woodturning. He purchased a lathe and then simply figured it out one step at a time. Bencomo cites the islands as the catalyst to his aesthetic interests. Ultimately, however, he follows the dictates of the wood. According to the artist, he "never fights the wood because it has too loud a voice." To this end, Bencomo carries forward the traditions of master artists like Bob Stocksdale and Ed Moulthrop.

EDUCATION

Harbor Community College, Wilmington, California, studies in business, 1982–83

PROFESSIONAL EXPERIENCE

Independent woodturner, 1988–present

SELECTED EXHIBITIONS

1996 Maui Cultural Center, Maui, Hawaii, *Art Maui*
1995 Carleton College, Northfield, Minnesota, *Nature Turning into Art: The Ruth and David Waterbury Collection of Turned-Wood Bowls*
1994 Alamoaana Center, Honolulu, *Woods of Hawaii*
1993 Honolulu Academy of Arts, *The Hawaiian Craftsmen Exhibition*
1992 Young Presidents Organization, Maui, Hawaii, *Celebration of Life*

SELECTED COLLECTIONS

Bishop Museum, Honolulu
State Historical Foundation of Culture and Arts, Honolulu
Yale University Art Gallery, New Haven, Connecticut

SELECTED BIBLIOGRAPHY

Edward Jacobson, *Nature Turning into Art: The Ruth and David Waterbury Collection of Turned-Wood Bowls* (Northfield, Minn.: Carleton College, 1995), unpaginated.

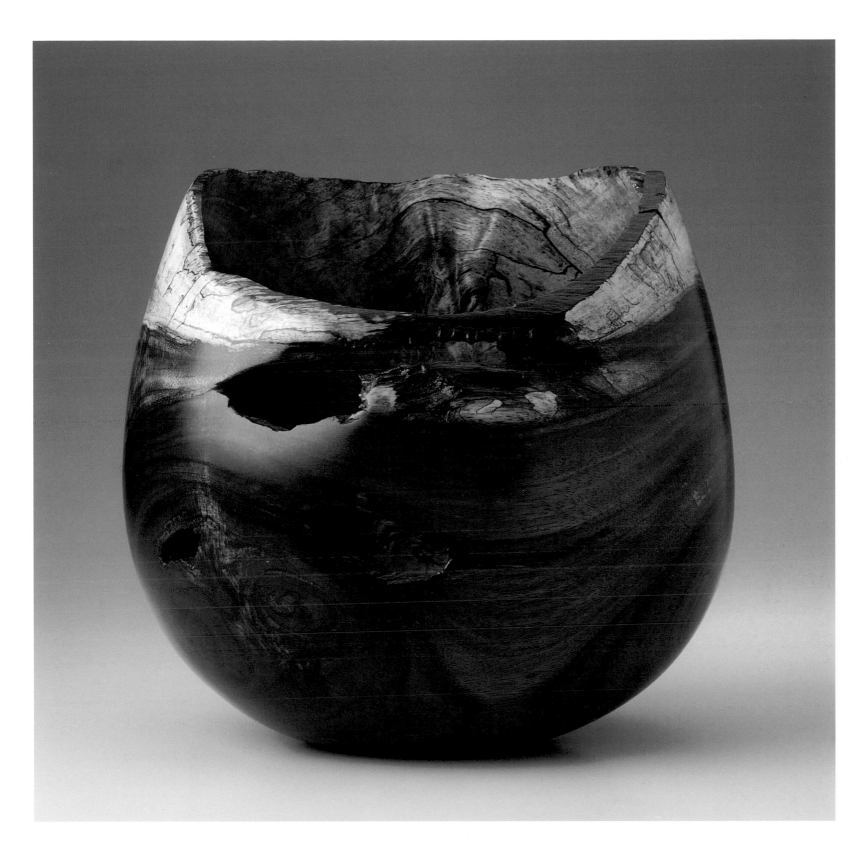

Derek Bencomo

UNTITLED (Vessel), 1993

Turned koa
9⅝ × 9⅞ × 10 in. (24.4 × 25.1 × 25.4 cm)

Edward Bosley

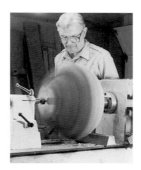

Born: Schenectady, New York, March 25, 1917
Studio: Berwyn, Pennsylvania

LIKE MANY ARTISTS in the woodturning field, Edward Bosley had an earlier career completely unrelated to the arts. In Bosley's case, he spent thirty-five years in the aircraft and space industries. During the early 1940s, his significant formal education was as a mechanical engineer. It was not until after he retired in the early 1970s that he developed an interest in wood. At first Bosley assisted his younger son, Arthur, in the production of what he calls "free-form furniture." Vessel forms off the lathe came shortly thereafter when he became involved with the Wood Turning Center in Philadelphia through studio-arts courses he was taking at the Pennsylvania Academy of the Fine Arts. Since focusing on woodturning more than fifteen years ago, Bosley now feels that his postretirement studies in painting and sculpture are the over-riding factors influencing what he calls his "attention to color as well as the rhythm and movement in the marks in the wood." Now, at seventy-nine, however strong his passion for wood might be, he is leaving the field to pursue other interests.

EDUCATION

Pennsylvania Academy of the Fine Arts, Philadelphia, studies in painting and sculpture, 1973–75

University of Wisconsin, Madison, B.S. in mechanical engineering, 1943

PROFESSIONAL EXPERIENCE

Independent woodturner, 1974–present

General Electric, Valley Forge, Pennsylvania, various positions including manager of manufacturing for space division, 1939–74

SELECTED EXHIBITIONS

1996 Pennsylvania State University, Media, *Friends of the Tim Mark Endowment*

1995 The Valley Forge Historical Society, Valley Forge, Pennsylvania, *Annual Fine Arts Exhibition*

1994 Philip and Muriel Berman Museum of Art, Collegeville, Pennsylvania, *Challenge V: International Lathe-Turned Objects*

1993 The Hagley Museum, Wilmington, Delaware, *Art from the Lathe*

1992 Florida Craftsmen Gallery, St. Petersburg, *The Turners Dance*

1990 Woodmere Art Museum, Philadelphia, *Pennsylvania Lathe Objects: Trends, Transitions, Traditions*

SELECTED COLLECTION

Price Waterhouse Corporation

SELECTED BIBLIOGRAPHY

Albert LeCoff, *Challenge V: International Lathe-Turned Objects* (Philadelphia: Wood Turning Center, 1993), p. 7.

———, *Lathe-Turned Objects: An International Exhibition* (Philadelphia: Wood Turning Center, 1988), pp. 6, 139.

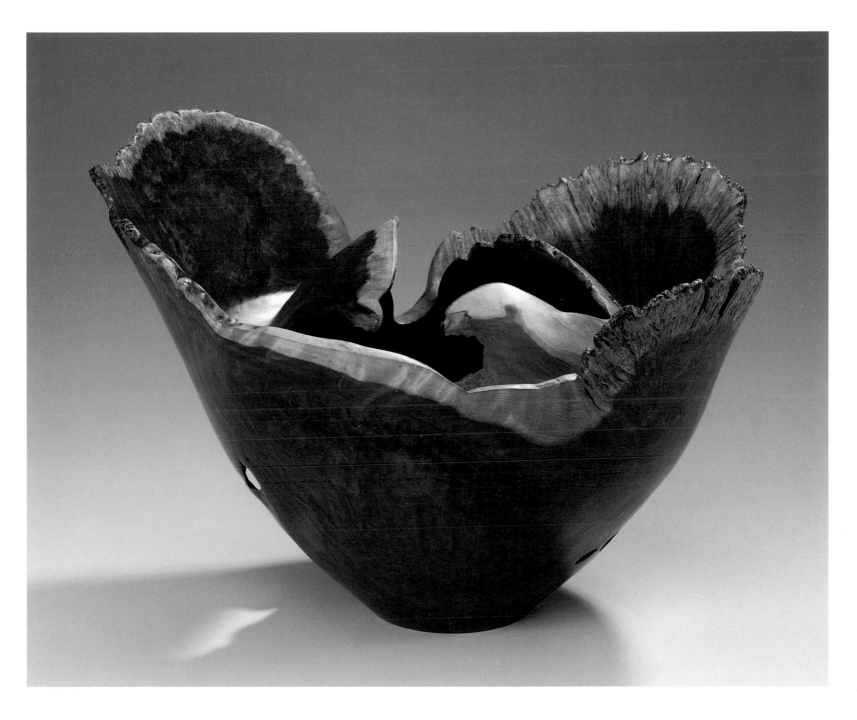

Edward Bosley

#2 CANYON SUNSET, 1987

Turned redwood lace burl

9⅞ × 12¼ × 14⅛ in. (25.1 × 32.4 × 35.9 cm)

Christian Burchard

Born: Hamburg, Germany, February 12, 1955
Studio: Ashland, Oregon

CHRISTIAN BURCHARD has written an excellent account of his own wood sculpture and vessels called "Learning to Speak." In it he provides personal insight into his struggles to overcome an early period during which he was ostracized for producing work that apparently relied on the ideas of other woodturners. Looking at his work today, it hardly seems possible that this could have been the case. Burchard maintains two distinct facets of his art, reasonably large-scale and abstractly "figurative" wood sculpture as well as thematically driven vessels. He describes his work in this way: "On the one hand I make small vessels and for the time being have limited myself to one shape. This allows me to thoroughly explore and understand this shape, to delve into all the subtle relationships within it, and to experiment with small changes. On the other hand is my sculptural work, with all the freedom that I can handle."

EDUCATION
Emily Carr College of Art and Design, Vancouver, British Columbia, studies in studio arts, 1978–79
School of the Museum of Fine Arts, Boston, studies in studio arts, 1977–78
Apprenticeship with Halvor Gutchow in furniture making, Hamburg, Germany, 1974–76

PROFESSIONAL EXPERIENCE
Independent sculptor, 1982–present
Toymaker and furniture restorer, Steiermark, Austria, 1976–77

SELECTED EXHIBITIONS
1996 Del Mano Gallery, Los Angeles, *Turned Wood: Small Treasures*
1995 Carleton College, Northfield, Minnesota, *Nature Turning into Art: The Ruth and David Waterbury Collection of Turned-Wood Bowls*
1994 Philip and Muriel Berman Museum of Art, Collegeville, Pennsylvania, *Challenge V: International Lathe-Turned Objects*
1993 Galeria Mesa, Mesa, Arizona, *15th Annual Vahki Exhibition*
1992 Art Museum, Arizona State University, Tempe, *Turning Plus: Redefining the Lathe-Turned Object*
1991 Port of History Museum, Philadelphia, *Challenge IV: International Lathe-Turned Objects*
1990 Arrowmont School of Arts and Crafts, Gatlinburg, Tennessee, *Woodturning: Vision and Concept II*

SELECTED COLLECTIONS
Royal Cultural Center, Jedda, Saudi Arabia
Craft & Folk Art Museum, Los Angeles
Presbyterian Seminary, Louisville, Kentucky
Wood Turning Center, Philadelphia
Oregon Arts Commission, Salem

SELECTED BIBLIOGRAPHY
Arnold Brickman, *Turned Wood: Small Treasures* (Los Angeles: Del Mano Gallery, 1996), unpaginated.
Christian Burchard, "Learning to Speak," *American Woodturner* 9, no. 1 (March 1994): 26–27.
Edward Jacobson, *Nature Turning into Art: The Ruth and David Waterbury Collection of Turned-Wood Bowls* (Northfield, Minn.: Carleton College, 1995), unpaginated.
Albert LeCoff, *Challenge V: International Lathe-Turned Objects* (Philadelphia: Wood Turning Center, 1993), pp. 8–9.
Eileen Silver et al., *Challenge IV: International Lathe-Turned Objects* (Philadelphia: Wood Turning Center, 1991), pp. 36, 63.
Kevin Wallace, *Turned Wood '96* (Los Angeles: Del Mano Gallery, 1996), unpaginated.

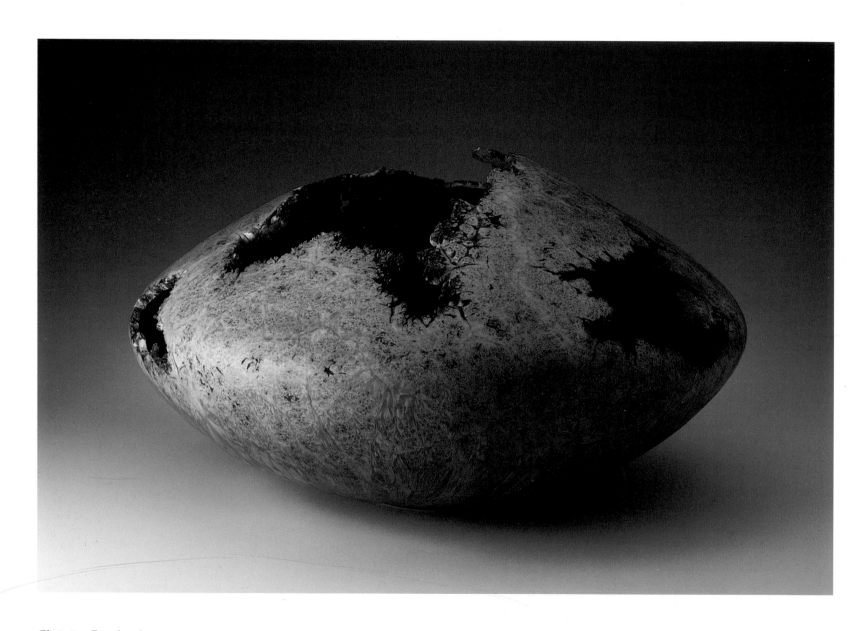

Christian Burchard
UNTITLED (Vessel), 1987

Turned maple burl
13 × 22¾ × 22¾ in. (33 × 57.8 × 57.8 cm)

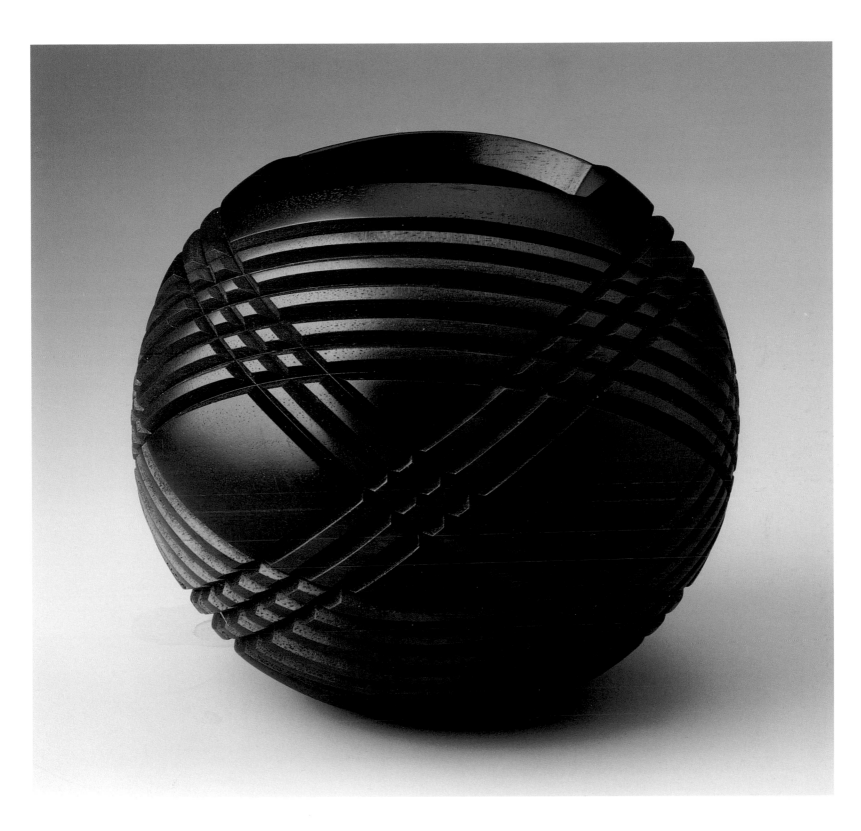

Christian Burchard

UNTITLED (Vessel), 1995

Old Earth series
Turned black walnut
5¾ × 6⅜ in. (14.6 × 16.2 cm)

M. Dale Chase

Born: Grand Rapids, Michigan, May 12, 1934
Studio: Grass Valley, California

"YES," SAYS M. Dale Chase, "the question of identity is important." Chase describes his accomplishments: "I began making turned, exotic hardwood boxes twenty years ago as a medium upon which to explore ornamental turning. The form of the boxes evolved, in the last seven years, from cylindrical with external ornament to hand-turned forms with smooth surfaces and internal rose engine ornamentation." Chase's statement identifies two points of reference, his constant interest in box forms and an almost exclusive use of the lathe-carving technique known as rose engine. Chase and those who have held his lidded vessels report a strong "sensual pleasure" from the experience. Amazing as this may sound, there is no question that his pieces offer an inexplicably tactile magic.

EDUCATION

University of California Medical Center, San Francisco, M.D., 1960
University of California, Berkeley, B.A. in zoology, 1956

PROFESSIONAL EXPERIENCE

Ornamental turner, 1976–present
Vascular surgeon in private practice, Chico, California, 1972–92
Stanford University, Palo Alto, California, clinical faculty, 1968–72
Vascular surgeon in private practice, Palo Alto and Redwood City, California, 1968–72

SELECTED EXHIBITIONS

1996 Del Mano Gallery, Los Angeles, *Turned Wood: Small Treasures*
1995 Carleton College, Northfield, Minnesota, *Nature Turning into Art: The Ruth and David Waterbury Collection of Turned-Wood Bowls*
1994 Philip and Muriel Berman Museum of Art, Collegeville, Pennsylvania, *Challenge V: International Lathe-Turned Objects*
1993 The Hagley Museum, Wilmington, Delaware, *Art from the Lathe*
1992 Craft Alliance Gallery, St. Louis, *One Hundred Ornamented Containers*
1991 Port of History Museum, Philadelphia, *Challenge IV: International Lathe-Turned Objects*
1990 Society of Arts and Crafts, Boston, *Lathe-Turned Objects Defined*

SELECTED COLLECTIONS

The Gernot Schluifer Collection, Kitzbühel, Austria
Wood Turning Center, Philadelphia
Art Museum, Arizona State University, Tempe
Collection of Prince and Princess Takamada, Tokyo

SELECTED BIBLIOGRAPHY

Arnold Brickman, *Turned Wood: Small Treasures* (Los Angeles: Del Mano Gallery, 1996), unpaginated.

Edward Jacobson, *Nature Turning into Art: The Ruth and David Waterbury Collection of Turned-Wood Bowls* (Northfield, Minn.: Carleton College, 1995), unpaginated.

Albert LeCoff, *Challenge V: International Lathe-Turned Objects* (Philadelphia: Wood Turning Center, 1993), pp. 10–11.

————, *Lathe-Turned Objects: An International Exhibition* (Philadelphia: Wood Turning Center, 1988), pp. 10, 139.

Eileen Silver et al., *Challenge IV: International Lathe-Turned Objects* (Philadelphia: Wood Turning Center, 1991), p. 11.

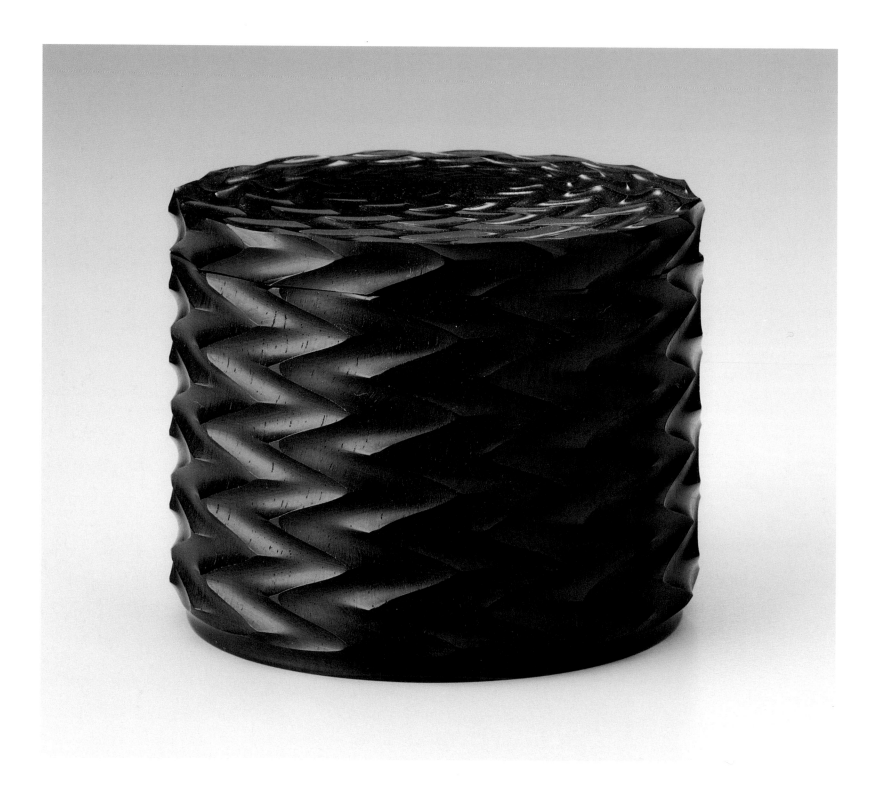

M. Dale Chase

UNTITLED (Lidded Box), ca. 1986

Turned Mozambique ebony
2½ × 2⅜ × 2⅜ in. (6.4 × 6 × 6 cm)

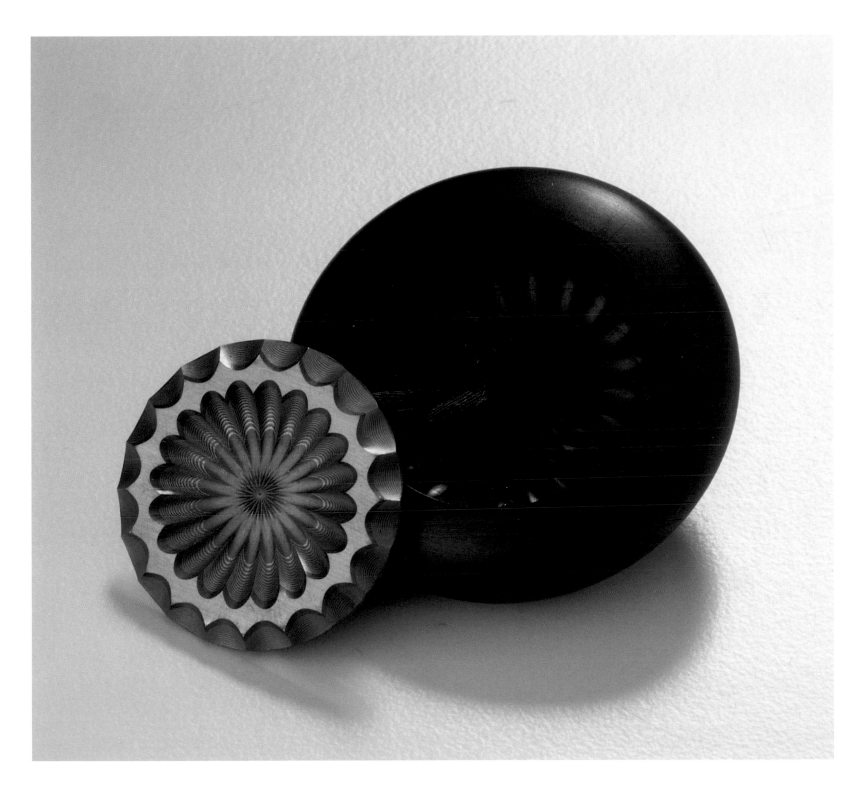

M. Dale Chase

KAGAMIBUTA, ca. 1988

Turned macassar ebony, bronze, and silk
⅝ × 1¼ in. (1.6 × 4.5 cm)

Rod Cronkite

Born: Kalamazoo, Michigan, June 1, 1954
Studio: Burlington, Wisconsin

ALTHOUGH HE MAJORED in woodworking during his under-graduate education in the mid-1970s, Rod Cronkite's involvement in turning began when he sought out Dale Nish at the Arrowmont School of Arts and Crafts in 1984. According to Cronkite, Nish provided him with the "awareness of fine techniques in contemporary woodturning." That experience set him on his current path. Cronkite is actually one of the few artists in the woodturning field who credits his peers with being his mentors. David Ellsworth is cited as the "master of the hollow-form vessel." Michael Peterson is said to have made a profound impact by encouraging Cronkite to work with natural formations in burled woods. And then there is Norm Sartorius, whose compelling "sculptural vessels," according to Cronkite, "are elegant statements of free-form carving." With all these influences, Cronkite now sees himself as someone who "will try just about anything."

EDUCATION

National College of Education, Evanston, Illinois, M. Ed., 1986

Arrowmont School of Arts and Crafts, Gatlinburg, Tennessee, studies in woodturning, 1984

Western Michigan University, Kalamazoo, B.S. in technology education with woodworking major, 1977

PROFESSIONAL EXPERIENCE

Independent woodturner, 1987–present

Case High School, Racine, Wisconsin, instructor in woodworking, 1978–87

SELECTED EXHIBITIONS

1994 Philip and Muriel Berman Museum of Art, Collegeville, Pennsylvania, *Challenge V: International Lathe-Turned Objects*

1993 Highlight Gallery, Mendocino, California, *National Turned Object Exhibition*

1992 Del Mano Gallery, Los Angeles, *Turned Wood '92*

1991 Port of History Museum, Philadelphia, *Challenge IV: International Lathe-Turned Objects*

1990 Arrowmont School of Arts and Crafts, Gatlinburg, Tennessee, *Woodturning: Vision and Concept II*

SELECTED COLLECTIONS

numerous private collections

SELECTED BIBLIOGRAPHY

Paul Bertorelli et al., *Fine Woodworking Design Book Four* (Newtown, Conn.: Taunton Press, 1987), p. 114.

———, *Fine Woodworking Design Book Five* (Newtown, Conn.: Taunton Press, 1990), p. 89.

Albert LeCoff, *Challenge V: International Lathe-Turned Objects* (Philadelphia: Wood Turning Center, 1993), p. 12.

———, *Lathe-Turned Objects: An International Exhibition* (Philadelphia: Wood Turning Center, 1988), pp. 15, 40.

Eileen Silver et al., *Challenge IV: International Lathe-Turned Objects* (Philadelphia: Wood Turning Center, 1991), p. 38.

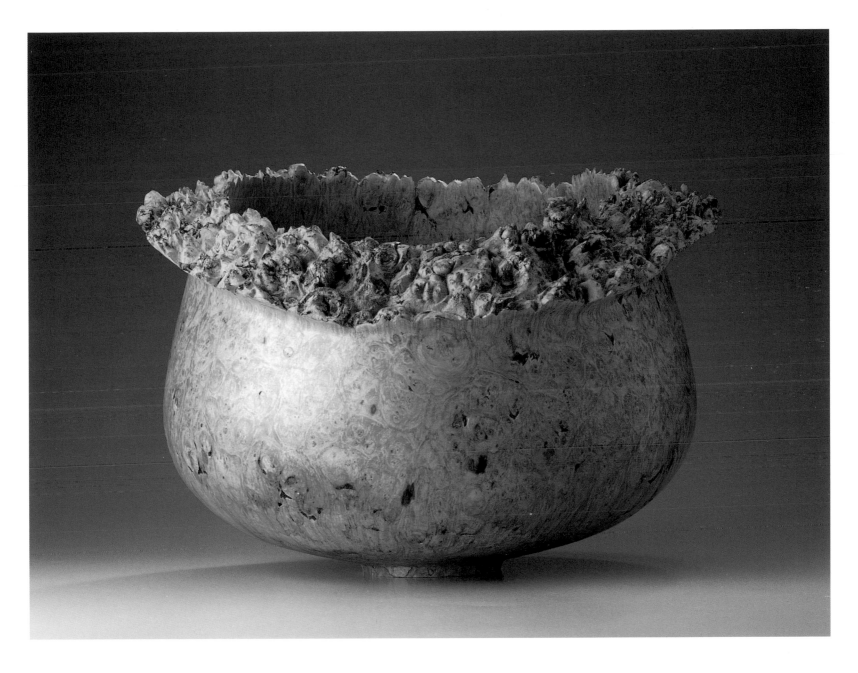

Rod Cronkite

UNTITLED (Vessel), 1991

Turned western maple burl
12⅜ × 16½ × 16⅜ in. (31.4 × 41.9 × 41.6 cm)

Mike Darlow

Born: Birmingham, England, December 19, 1943
Studio: Sydney, Australia

MIKE DARLOW is one of the dominant artists in Australian woodturning. After nearly twenty years in the field, Darlow's contributions come in many forms. Perhaps his greatest voice, aside from his work, is his extensive writings. Darlow has more than fifty articles to his credit, which have appeared in at least ten national and international publications, and he is the author of *The Practice of Woodturning*, a standard reference that has been reprinted in the United States. He has also operated his own school for turning while concurrently directing a large-scale studio equipped with eighteen lathes run by five assistants. On top of this, Darlow maintains an extensive lecture schedule throughout Australia, New Zealand, and England. His real mission is to spread the word about woodturning.

EDUCATION

Sydney Technical College, Sydney, Australia, studies in woodturning and cabinetmaking, 1975–79

Loughborough University, Loughborough, England, M.S. in construction management, 1968

Birmingham University, Birmingham, England, B.S. in civil engineering, 1965

PROFESSIONAL EXPERIENCE

Independent woodturner, 1979–present

Magazine columnist, *The Woodworker*, 1993–95

Mike Darlow Woodturning School, Sydney, Australia, 1992–95

SELECTED EXHIBITION

1993 Woodworkers' Association of New South Wales, New South Wales, Australia, *Wood for Tomorrow*

SELECTED COLLECTIONS

Rockhampton Art Gallery, Queensland, Australia

Powerhouse Museum, Sydney, Australia

SELECTED BIBLIOGRAPHY

Mike Darlow, "Criticism and Heritage," *Woodworker* 98, no. 6 (June 1994): 83–85.

———, "Perception," *New Zealand Woodworker*, no. 19 (June 1989): 24–26.

———, *The Practice of Woodturning*, 2d ed. (New York: Sterling Publishing, 1996).

John Kelsey et al., *Fine Woodworking Design Book Three* (Newtown, Conn.: Taunton Press, 1983), p. 80.

Albert LeCoff, *Lathe-Turned Objects: An International Exhibition* (Philadelphia: Wood Turning Center, 1988), pp. 17, 140.

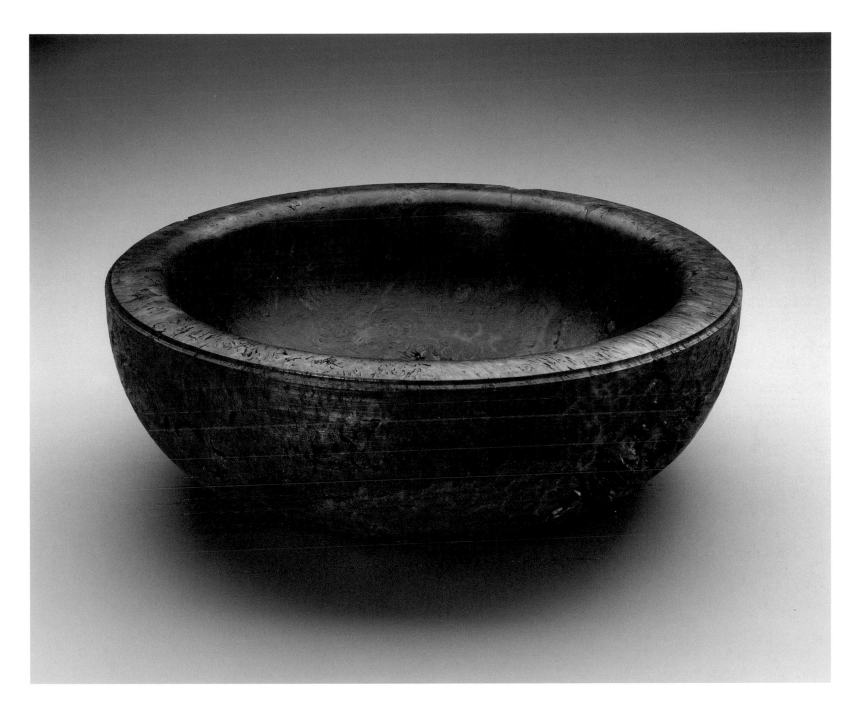

Mike Darlow
UNTITLED (Vessel), 1987
Turned jarrah burl
6¼ × 18 in. (15.9 × 45.7 cm)

Virginia Dotson

Born: Newton, Massachusetts, September 1, 1943
Studio: Scottsdale, Arizona

NOMENCLATURE, classifications, value systems, self-identities, critical perspectives, philosophical positions, and of course hierarchies are all part of the greater mechanism of the academic arena and consumer market for works of art. Although her work is still subject to these forces, Virginia Dotson enthusiastically embraces her activities as part of the contemporary studio crafts movement. "It has inspired me and enriched my life. I love to look at work in other media and talk about common concerns with weavers, quilters, metal and glass artists. This type of interaction has provided many insights for the personal involvement I have with my work." As a woodturner, Dotson continues to seek a formal vocabulary that is taken directly from the variety of landscapes found in the southwestern United States. She sees her laminated wooden bowls as aesthetic reflections of layered geological patterns that explore changing states of light and shadow.

EDUCATION
Arizona State University, Tempe, B.F.A. in wood, 1985
Wellesley College, Wellesley, Massachusetts, studies in psychology, 1961–63

PROFESSIONAL EXPERIENCE
Independent woodturner, 1985–present

SELECTED EXHIBITIONS
1996 Del Mano Gallery, Los Angeles, *Turned Wood '96*
1995 Renwick Gallery, National Museum of American Art, Smithsonian Institution, Washington, D.C., *The White House Collection of American Crafts*
1994 Philip and Muriel Berman Museum of Art, Collegeville, Pennsylvania, *Challenge V: International Lathe-Turned Objects*
1993 Galerie für Angewandte Kunst des Bayerischen Kunstgewerbe-Vereins, Munich, Germany, *Holzschalen* (The Art of Wooden Bowls)
1992 Fine Arts Museum of the South, Mobile, Alabama, *Out of the Woods: Turned Wood by American Craftsmen*
1991 Port of History Museum, Philadelphia, *Challenge IV: International Lathe-Turned Objects*
1990 Arrowmont School of Arts and Crafts, Gatlinburg, Tennessee, *Woodturning: Vision and Concept II*

SELECTED COLLECTIONS
Dowse Art Museum, Lower Hutt, New Zealand
Fine Arts Museum of the South, Mobile, Alabama
Wood Turning Center, Philadelphia
Art Museum, Arizona State University, Tempe
The White House Collection of American Crafts, Washington, D.C.

SELECTED BIBLIOGRAPHY
Virginia Dotson, "Laminated Turnings: From Landscape to Vessels," *American Woodturner* (June 1995): 8–11.

———, "Polychromatic Turning: Cross Winds," *Woodturner* (December 1989): 2.

Albert LeCoff, *Challenge V: International Lathe-Turned Objects* (Philadelphia: Wood Turning Center, 1993), p. 17.

Michael Monroe, *The White House Collection of American Crafts* (New York: Harry N. Abrams, 1995), pp. 96, 114, 118.

Eileen Silver et al., *Challenge IV: International Lathe-Turned Objects* (Philadelphia: Wood Turning Center, 1991), p. 14.

Martha Stamm-Connell, *Out of the Woods: Turned Wood by American Craftsmen* (Mobile, Ala.: Fine Arts Museum of the South, 1992), pp. 27–28.

Kevin Wallace, *Turned Wood '96* (Los Angeles: Del Mano Gallery, 1996), unpaginated.

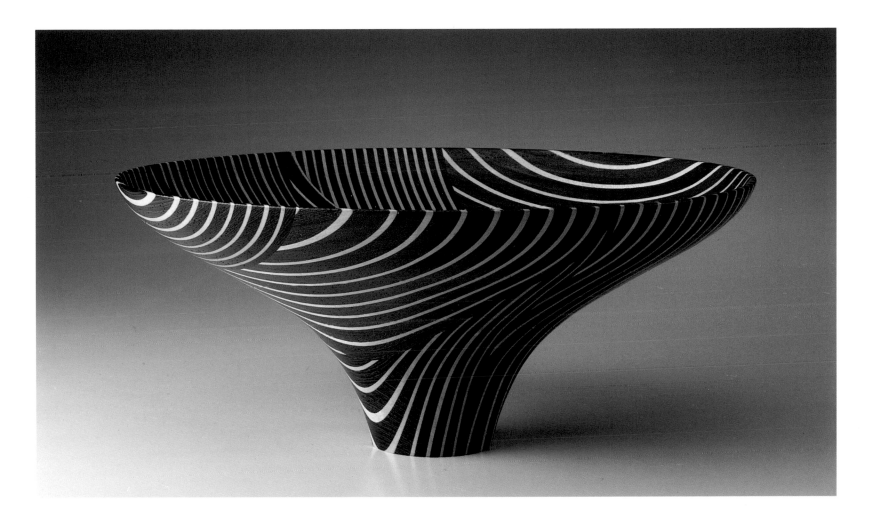

Virginia Dotson

CROSS WINDS, 1989

Laminated and turned wenge and maple
5¾ × 13⅛ × 13⅛ in. (14.6 × 33.3 × 33.3 cm)

Dennis Elliott

Born: London, England, August 18, 1950
Studio: Sherman, Connecticut

HOW DENNIS ELLIOTT made the transition from playing in the London-based rock band Foreigner to being a woodturner in New England is a story yet to be told. Elliott has done just this, however, and his success as a turner is substantial. Since the late 1980s, he has amassed an exhibition, collection, and publication record that makes it appear as though he has been at this endeavor for a lifetime. On the other hand, Elliott will quickly point out that he is only now "finding himself in the midst of the beginning of his future." And why is he at this threshold in life? "I feel a tremendous importance and responsibility each time I begin a new piece. Pondering a burl that was once a living part of a tree, I treat the cutting as though it were a diamond. Knowing the piece of wood was and can be again a thing of beauty, I am obliged to the wood; it is not obliged to me." For those who want to know more, contact Elliott's homepage on the Internet at http://www.denniselliott.com.

EDUCATION
Life experience

PROFESSIONAL EXPERIENCE
Independent woodturner, 1989–present
Drummer with the rock band Foreigner, London, 1976–89

SELECTED EXHIBITIONS
1996 Del Mano Gallery, Los Angeles, *Turned Wood '96*
1995 American Craft Museum, New York, *The Banquet*
1994 Art Museum, Arizona State University, Tempe, *Turning Plus: Redefining the Lathe-Turned Object III*
1993 Fuller Museum of Art, Brockton, Massachusetts, *The Domestic Object: Articles for Everyday Living*
1992 Lyman Allyn Art Museum, New London, Connecticut, *Containers*
1991 Port of History Museum, Philadelphia, *Challenge IV: International Lathe-Turned Objects*
1990 Arrowmont School of Arts and Crafts, Gatlinburg, Tennessee, *Woodturning: Vision and Concept II*

SELECTED COLLECTIONS
Museum of Fine Arts, Boston
Craft & Folk Art Museum, Los Angeles
Yale University Art Gallery, New Haven, Connecticut
American Craft Museum, New York
Renwick Gallery, National Museum of American Art, Smithsonian Institution, Washington, D.C.

SELECTED BIBLIOGRAPHY
Paul Bertorelli et al., *Fine Woodworking Design Book Five* (Newtown, Conn.: Taunton Press, 1990), p. 89.
Heather Sealy Lineberry, *Turning Plus: Redefining the Lathe-Turned Object III* (Tempe: Art Museum, Arizona State University, 1994), unpaginated.
Andy Schultz et al., *Fine Woodworking Design Book Six* (Newtown, Conn.: Taunton Press, 1992), p. 139.
Eileen Silver et al., *Challenge IV: International Lathe-Turned Objects* (Philadelphia: Wood Turning Center, 1991), p. 43.
Kevin Wallace, *Turned Wood '88* (Los Angeles: Del Mano Gallery, 1988), unpaginated.
————, *Turned Wood '96* (Los Angeles: Del Mano Gallery, 1996), unpaginated.

Dennis Elliott

UNTITLED (Vessel), 1990

Turned and carved big-leaf maple burl
6 × 19⅝ × 18½ in. (15.2 × 49.8 × 47 cm)

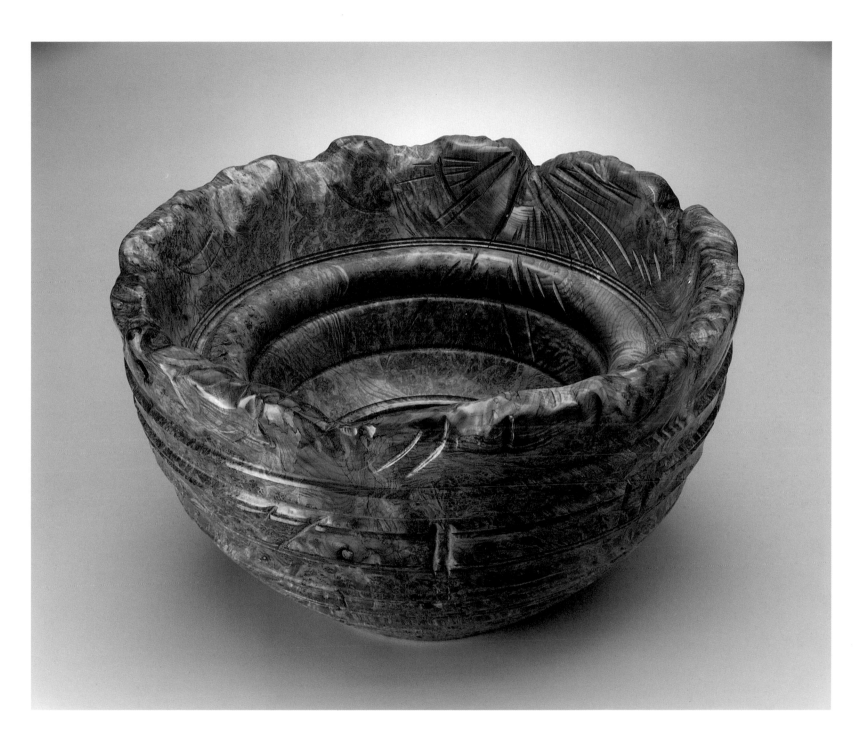

Dennis Elliott

UNTITLED (Vessel), 1994

Turned and carved big-leaf maple burl

14⅜ × 23⅝ × 24 in. (36.5 × 60 × 61 cm)

David Ellsworth

Born: Iowa City, Iowa, June 25, 1944
Studio: Quakertown, Pennsylvania

IN A RECENT interview, David Ellsworth disclosed an important element in his search for creative energy. Having come from what he calls an "academic family," Ellsworth has always felt a need to balance the act of making with the rigors of teaching as a means to further artistic development. In 1990 he opened his own school for woodturning to substantiate his approach. Ellsworth also cites three mentors who contributed to his outlook as an artist: Mary Frank, for her perspective on how "to see"; Paul Soldner, for his "work ethic"; and James Prestini, for the "dimension of his creativity." As for his work, Ellsworth believes the process of vessel making should be one in which the "heart, not the head, is in charge. The vessel is the language of self, expressed, but not overwhelmed, by one's material or technique."

EDUCATION

University of Colorado, Boulder, M.F.A. in sculpture, 1973

University of Colorado, Boulder, B.F.A. in studio arts, 1971

New School for Social Research, New York, studies in studio and liberal arts, 1966–70

Washington University, St. Louis, studies in architecture, 1965–66

PROFESSIONAL EXPERIENCE

David Ellsworth School of Woodturning, Quakertown, Pennsylvania, 1990–present

Independent studio woodturner, 1974–present

SELECTED EXHIBITIONS

1996 Del Mano Gallery, Los Angeles, *Turned Wood: Small Treasures*

1995 Renwick Gallery, National Museum of American Art, Smithsonian Institution, Washington, D.C., *The White House Collection of American Crafts*

1994 Joanne Rapp Gallery, Scottsdale, Arizona, *David Ellsworth*

1993 American Craft Museum, New York, *New Acquisitions*

1992 Trenton City Museum, Trenton, New Jersey, *The Forest Refined*

1991 Port of History Museum, Philadelphia, *Challenge IV: International Lathe-Turned Objects*

1990 High Museum of Art, Atlanta, *By the Hand: Twentieth-Century Craft*

SELECTED COLLECTIONS

Museum of Fine Arts, Boston

Denver Art Museum

American Craft Museum, New York

Philadelphia Museum of Art

Renwick Gallery, National Museum of American Art, Smithsonian Institution, Washington, D.C.

SELECTED BIBLIOGRAPHY

Arnold Brickman, *Turned Wood: Small Treasures* (Los Angeles: Del Mano Gallery, 1996), unpaginated.

Edward Jacobson, *The Art of Turned-Wood Bowls* (New York: E. P. Dutton, 1985), pp. 22–25.

Dona Meilach, *Woodworking: The New Wave* (New York: Crown Publishers, 1981), p. 11.

Michael Monroe, *The White House Collection of American Crafts* (New York: Harry N. Abrams, 1995), pp. 103, 114, 118.

Katherine Pearson, *American Crafts: A Source Book for the Home* (New York: Stewart, Tabori & Chang, Publishers, 1983), pp. 186–87.

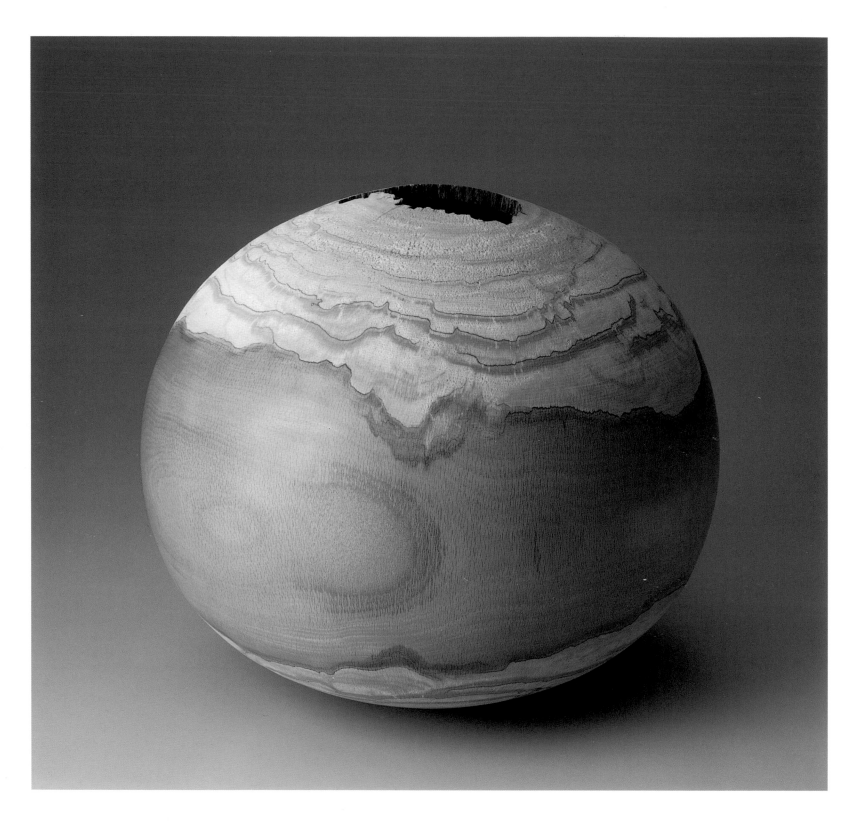

David Ellsworth

SOLSTICE SERIES #1, 1987

Turned spalted beech
11⅜ × 13 × 13⅛ in. (28.9 × 33 × 33.3 cm)

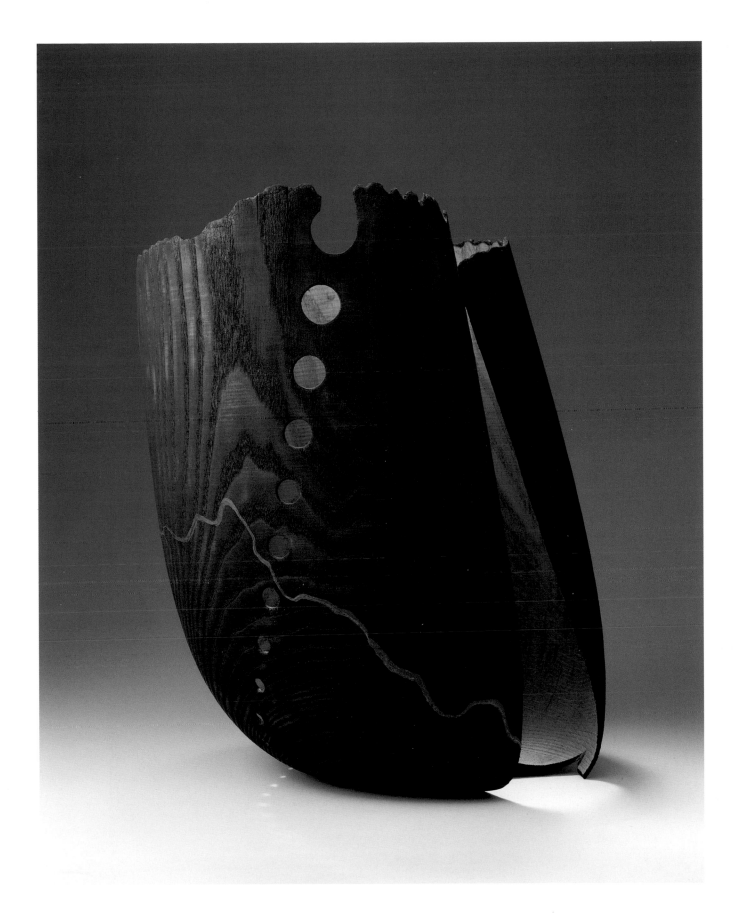

David Ellsworth

MACHEL, 1991

Turned, cut, and painted ash
18 × 13 × 14⅞ in. (45.7 × 33 × 37.8 cm)

J. Paul Fennell

Born: Beverly, Massachusetts, October 12, 1938
Studio: Scottsdale, Arizona

J. PAUL FENNELL cites David Pye's book, *The Nature and Art of Workmanship,* as having made a significant contribution to the way in which he approaches creating his turned-wood vessels. Fennell has always held to a strict vessel aesthetic, one that is "inspired by the timelessness and universality of such forms." The continuum of workmanship in his pieces, as he sees it, is therefore the "cutting across of diverse civilizations and cultures of the world, past and present." Fennell is also greatly concerned with issues involving conservation, which is another reason he focuses on clean vessels. Never cutting a live tree, he salvages his wood and then transforms it into exceptionally thin-walled, primarily closed forms. They are truly visually delicious.

EDUCATION

University of Southern California, Los Angeles, M.S. in aeronautical and astronomical engineering, 1965

Ohio State University, Columbus, B.S. in engineering, 1961

PROFESSIONAL EXPERIENCE

Independent woodturner, 1984–present

Rockwell International, Apollo Program, Downey, California, re-entry specialist, 1962–73

SELECTED EXHIBITIONS

1996 Del Mano Gallery, Los Angeles, *Turned Wood: Small Treasures*

1995 Carleton College, Northfield, Minnesota, *Nature Turning into Art: The Ruth and David Waterbury Collection of Turned-Wood Bowls*

1994 Art Museum, Arizona State University, Tempe, *Turning Plus: Redefining the Lathe-Turned Object III*

1993 Museum of Art, Rhode Island School of Design, Providence, *Conservation by Design*

1992 Northwest Gallery of Fine Woodworking, Seattle, *Rain Forest Safe*

1991 Port of History Museum, Philadelphia, *Challenge IV: International Lathe-Turned Objects*

1990 Worcester Center for Crafts, Worcester, Massachusetts, *Woodturners of the Northeast 1990*

SELECTED COLLECTIONS

Craft & Folk Art Museum, Los Angeles

Wood Turning Center, Philadelphia

SELECTED BIBLIOGRAPHY

Arnold Brickman, *Turned Wood: Small Treasures* (Los Angeles: Del Mano Gallery, 1996), unpaginated.

Albert LeCoff, *Lathe-Turned Objects: An International Exhibition* (Philadelphia: Wood Turning Center, 1988), pp. 26, 141.

Heather Sealy Lineberry, *Turning Plus: Redefining the Lathe-Turned Object III* (Tempe: Art Museum, Arizona State University, 1994), unpaginated.

Andy Schultz et al., *Fine Woodworking Design Book Six* (Newtown, Conn.: Taunton Press, 1992), p. 158.

Eileen Silver et al., *Challenge IV: International Lathe-Turned Objects* (Philadelphia: Wood Turning Center, 1991), p. 27.

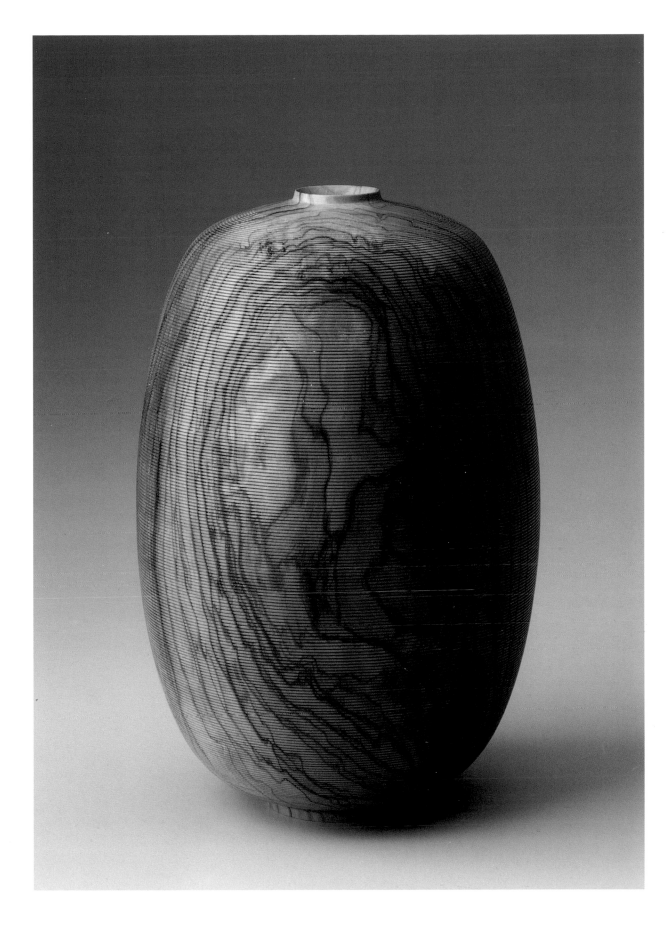

J. Paul Fennell

UNTITLED (Vessel), 1995

Turned olive
6⅛ × 4 in. (15.6 × 10.2 cm)

Ron Fleming

Born: Oklahoma City, Oklahoma, September 20, 1937
Studio: Tulsa, Oklahoma

IN THE ARTIST'S WORDS: "I love nature. For many years I watched my father and grandfather work in wood—observing and learning, thinking and searching for a way to express the feelings and thoughts I have about nature, its beauty, and its passages. Woodturning is a natural way for me to combine my capabilities as an artist and a craftsman. Whether it is the remains of a burned and charred forest transformed into a statement of new beginnings or a single flower bud unfolding in spring, each piece gives me an opportunity to make a delicate expression about the never-ending rituals of nature's evolution. Never taking a living tree but using only given woods, each turned and carved example of wood becomes a captured moment in time. Every form gives me a way to unfold my deep feelings about the things I see around me in our natural world."

EDUCATION

Oklahoma City University, studies in civil engineering, 1955–59

PROFESSIONAL EXPERIENCE

Independent sculptor and illustrator, 1985–present

Independent graphic illustrator, 1960–85

Oklahoma State Bridge Department, Oklahoma City, engineering draftsman, 1955–59

SELECTED EXHIBITIONS

1996 Del Mano Gallery, Los Angeles, *Turned Wood: Small Treasures*

1995 Craft & Folk Art Museum, Los Angeles, *Points of View: Collectors and Collecting*

1994 Philip and Muriel Berman Museum of Art, Collegeville, Pennsylvania, *Challenge V: International Lathe-Turned Objects*

1993 Art Museum, Arizona State University, Tempe, *Turning Plus: Redefining the Lathe-Turned Object II*

1992 The Arkansas Arts Center Decorative Arts Museum, Little Rock, *Regional Crafts Biennial*

1991 Port of History Museum, Philadelphia, *Challenge IV: International Lathe-Turned Objects*

1990 Museum of Fine Arts, Santa Fe, New Mexico, *Southwest '90*

SELECTED COLLECTIONS

The Arkansas Arts Center Decorative Arts Museum, Little Rock

Neutrogena Corporation, Los Angeles

Kirkpatrick Center Museum Complex, Oklahoma City

State Arts Council, Tulsa, Oklahoma

The White House Collection of American Crafts, Washington, D.C.

SELECTED BIBLIOGRAPHY

Paul Bertorelli et al., *Fine Woodworking Design Book Five* (Newtown, Conn.: Taunton Press, 1990), p. 91.

Arnold Brickman, *Turned Wood: Small Treasures* (Los Angeles: Del Mano Gallery, 1996), unpaginated.

Albert LeCoff, *Challenge V: International Lathe-Turned Objects* (Philadelphia: Wood Turning Center, 1993), pp. 18–19.

Michael Monroe, *The White House Collection of American Crafts* (New York: Harry N. Abrams, 1995), pp. 95, 107, 114, 118.

Andy Schultz et al., *Fine Woodworking Design Book Six* (Newtown, Conn.: Taunton Press, 1992), p. 136.

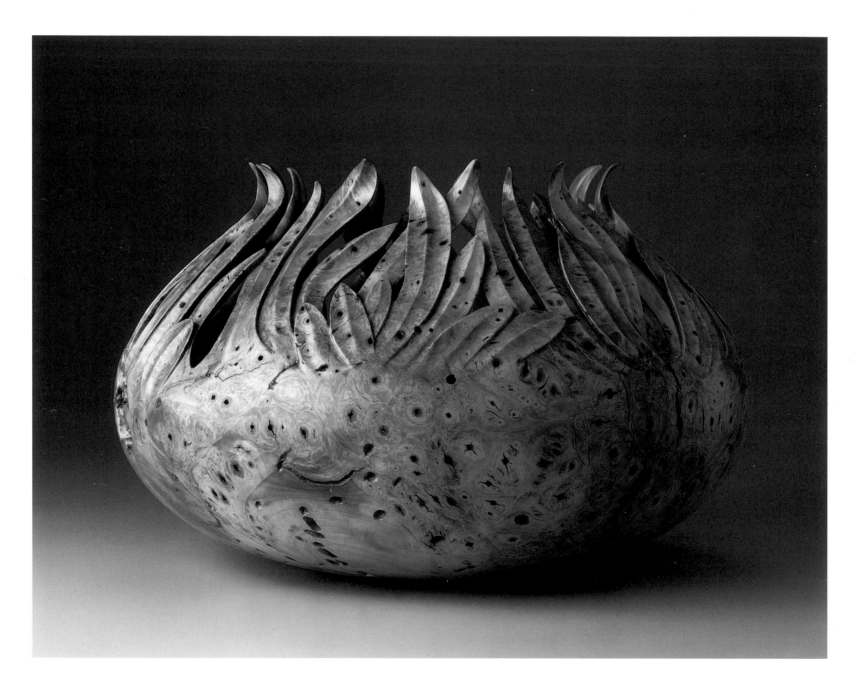

Ron Fleming

REEDS IN THE WIND, 1988

Turned and carved box elder burl
8⅜ × 13 × 13 in. (21.3 × 33 × 33 cm)

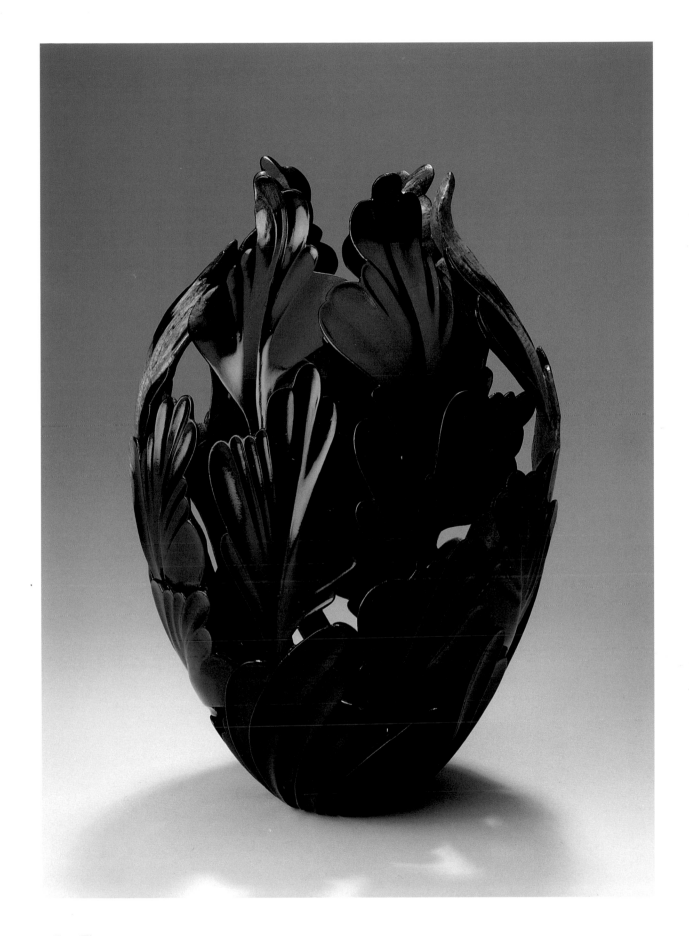

Ron Fleming

EMBRACE, 1994

Turned and carved South African black ivory
12 × 7⅞ × 7⅞ in. (30.5 × 20 × 20 cm)

Giles Gilson

Born: Philadelphia, July 19, 1942
Studio: Schenectady, New York

GILES GILSON is a power player in the field of woodturning, but he is also considered to be somewhat on the aesthetic fringe. As Gilson has put it, he wandered in "through the front door," and after that, "don't ask." While many of his forms and surface embellishments are innovative, such as his concentrated efforts to produce lacquered finishes, a great number of his works disregard the wood and instead focus on those attributes that disguise any visual relationship to the primary material. So why use wood? In defense, if one is needed, Gilson comes from a rogue background as a jazz musician, and the name of his game has always been improvisation. When combining his wooden vessels with various metals, plastics, and myriad synthetic surface treatments, he notes: "There are times when a piece has more to do with just plain fun than anything else."

EDUCATION
Independent studies in studio and industrial arts, music, drama, and art history

PROFESSIONAL EXPERIENCE
Independent studio artist, 1973–present
Independent jazz musician, 1968–73

SELECTED EXHIBITIONS
1996 Del Mano Gallery, Los Angeles, *Turned Wood: Small Treasures*
1995 Craft & Folk Art Museum, Los Angeles, *Points of View: Collectors and Collecting*
1994 Philip and Muriel Berman Museum of Art, Collegeville, Pennsylvania, *Challenge V: International Lathe-Turned Objects*
1993 Mendelson Gallery, Washington Depot, Connecticut, *Master Woodturners*
1992 Fine Arts Museum of the South, Mobile, Alabama, *Out of the Woods: Turned Wood by American Craftsmen*
1991 Port of History Museum, Philadelphia, *Challenge IV: International Lathe-Turned Objects*
1990 Arrowmont School of Arts and Crafts, Gatlinburg, Tennessee, *Woodturning: Vision and Concept II*

SELECTED COLLECTIONS
Fine Arts Museum of the South, Mobile, Alabama
The Metropolitan Museum of Art, New York
Wood Turning Center, Philadelphia
Schenectady Museum, Schenectady, New York
Art Museum, Arizona State University, Tempe

SELECTED BIBLIOGRAPHY
Arnold Brickman, *Turned Wood: Small Treasures* (Los Angeles: Del Mano Gallery, 1996), unpaginated.
Edward Jacobson, *The Art of Turned-Wood Bowls* (New York: E. P. Dutton, 1985), pp. 26–28.
Albert LeCoff, *Challenge V: International Lathe-Turned Objects* (Philadelphia: Wood Turning Center, 1993), p. 21.
Dona Meilach, *Woodworking: The New Wave* (New York: Crown Publishers, 1981), pp. 5, 21, 108, 199, 246–47.
Dale Nish, *Artistic Woodturning* (Provo, Utah: Brigham Young University Press, 1980), p. 217.

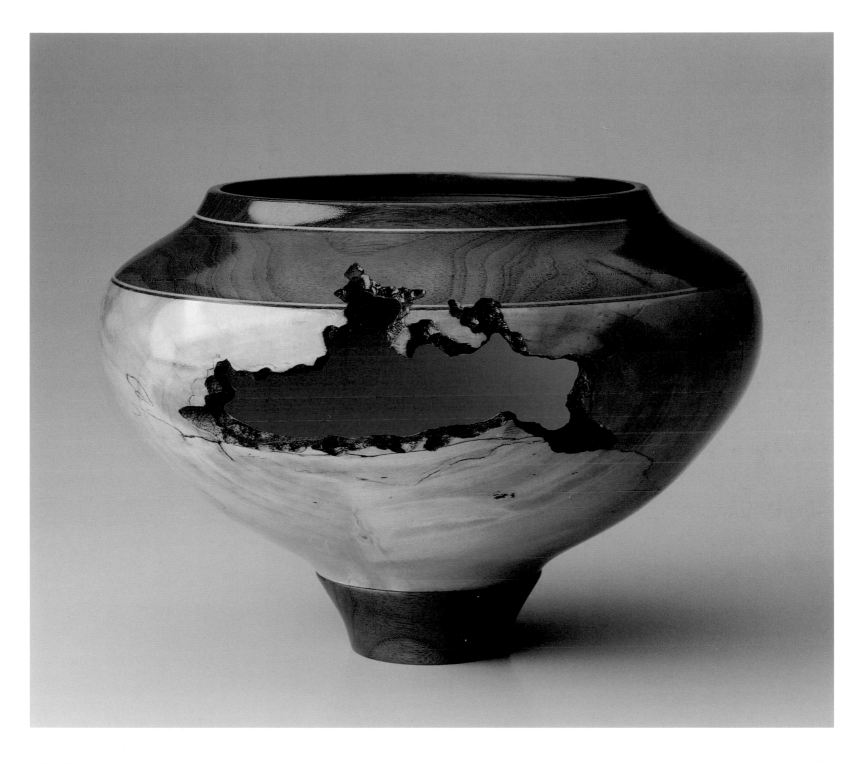

Giles Gilson

POINT OF VIEW, 1989

Laminated, turned, and painted cocobolo, holly, ebony, walnut, and elder
6 × 8½ in. (15.2 × 21.6 cm)

David Groth

Born: Scotia, California, June 6, 1950
Studio: Trinidad, California

DAVID GROTH maintains an exceptionally deep philosophical approach to his work in wood. Participating in an exhibition selected by the painter Morris Graves called *From the Center* (1989, at the Humboldt Cultural Center in Eureka, Calif.), Groth made the statement, "my intellect only knows the things it knows. The part of me that sees beyond what the intellect is able to see is interesting to me and when I bring it into three-dimensional form is what allows that part of my brain, my intellect, to say, 'I begin to understand.'" With each object he creates, Groth expresses states of consciousness outside the general normal senses perceived by the intellect. To this end, he selected a secluded part of Northern California in which to live and make his art. The relationship of environment to every aspect of his existence is crucial, for Groth turns to his natural surroundings as the catalyst for thought and action.

EDUCATION

Humboldt State University, Arcata, California, B.A. in studio arts, 1973

PROFESSIONAL EXPERIENCE

Independent gemstone cutter, 1993–present

Independent sculptor, 1975–present

Independent construction worker, 1977–91

SELECTED EXHIBITIONS

1993 Humboldt Arts Council, Eureka, California, *25th Anniversary Exhibition*

1989 Humboldt Arts Council, Eureka, California, *From the Center*

SELECTED COLLECTION

Humboldt Arts Council, Eureka, California

SELECTED BIBLIOGRAPHY

John Kelsey et al., *Fine Woodworking Design Book Three* (Newtown, Conn.: Taunton Press, 1983), p. 17.

Lydia Matthews, *From the Center* (Eureka, Calif.: Humboldt Arts Council, 1989), unpaginated.

Connie Mississippi, "Collectors—Roles and Responsibilities," *Turning Points* 8, no. 2 (Spring 1995): 9.

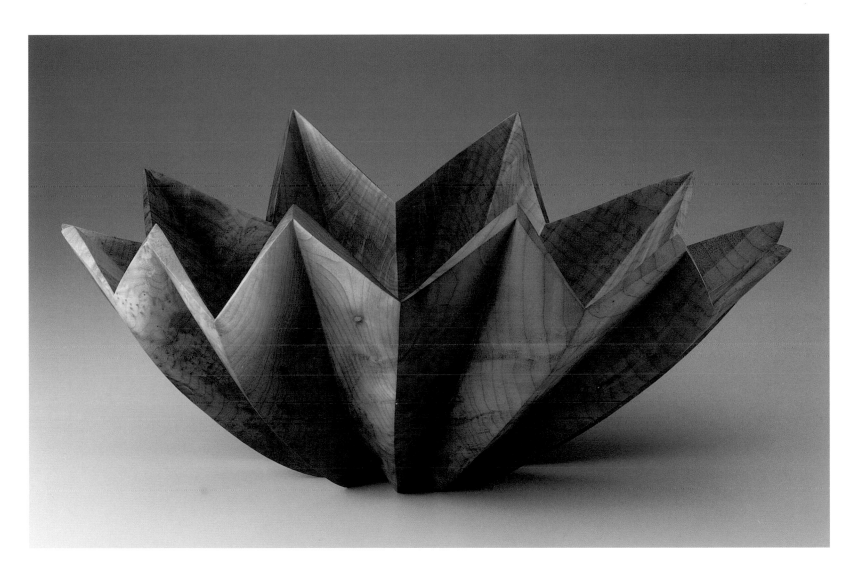

David Groth

#2, 1984

Cock's Comb Oyster series
Carved myrtlewood
8⅞ × 19½ × 12⅝ in. (22.5 × 49.5 × 32.1 cm)

Michelle Holzapfel

Born: Woonsocket, Rhode Island, December 9, 1951
Studio: Marlboro, Vermont

MICHELLE HOLZAPFEL is one of a handful of artists working in turned-wood vessels who have written extensively about their approach. She has published articles on personal creativity, wood as a material as it relates to beauty versus concept, wood as an environmental issue, and ideas of vessel versus sculpture. Holzapfel's combined writings offer exceptional insight into one artist's singular development, which speaks also for the larger field of artistic endeavor. Her aesthetic results are equally compelling, providing a broad display of shaping and turning wood into vessel forms. One recurring theme, however abstract it may be, is the notion of the piece being conceptually derived from a utilitarian object. For Holzapfel, daily life and her art cannot be separated; the two are what she calls the "reconciliation of passion and reason."

EDUCATION

Norwich University, Brattleboro, Vermont, B.A. in studio and liberal arts, 1995

Marlboro College, Marlboro, Vermont, studies in studio arts and mathematics, 1969–70

PROFESSIONAL EXPERIENCE

Independent sculptor and woodworker, 1977–present

SELECTED EXHIBITIONS

1996 Marlboro College, Marlboro, Vermont, *50th Anniversary Exhibition*

1995 Connell Gallery, Atlanta, *Three Generations of Studio Woodturners: The Making of an Art Form*

1994 Peter Joseph Gallery, New York, *Circling the Square*

1993 De Cordova Museum and Sculpture Park, Lincoln, Massachusetts, *11 Artists/11 Visions 1993*

1992 Fine Arts Museum of the South, Mobile, Alabama, *Out of the Woods: Turned Wood by American Craftsmen*

1991 Port of History Museum, Philadelphia, *Challenge IV: International Lathe-Turned Objects*

1990 Oxford Gallery, Oxford, England, *Wood for the Trees*

SELECTED COLLECTIONS

Museum of Fine Arts, Boston

Fine Arts Museum of the South, Mobile, Alabama

Du Pont Corporation, Philadelphia

Wood Turning Center, Philadelphia

Museum of Art, Rhode Island School of Design, Providence

SELECTED BIBLIOGRAPHY

Paul Bertorelli et al., *Fine Woodworking Design Book Four* (Newtown, Conn.: Tauton Press, 1987), p. 118.

Michelle Holzapfel, *Michelle Holzapfel* (New York: Peter Joseph Gallery, 1991).

Albert LeCoff, *A Gallery of Turned Objects* (Provo, Utah: Brigham Young University Press, 1981), p. 23.

————, *Lathe-Turned Objects: An International Exhibition* (Philadelphia: Wood Turning Center, 1988), pp. 42–43, 142.

Eileen Silver et al., *Challenge IV: International Lathe-Turned Objects* (Philadelphia: Wood Turning Center, 1991), p. 25.

Kevin Wallace, *Turned Wood '88* (Los Angeles: Del Mano Gallery, 1988), unpaginated.

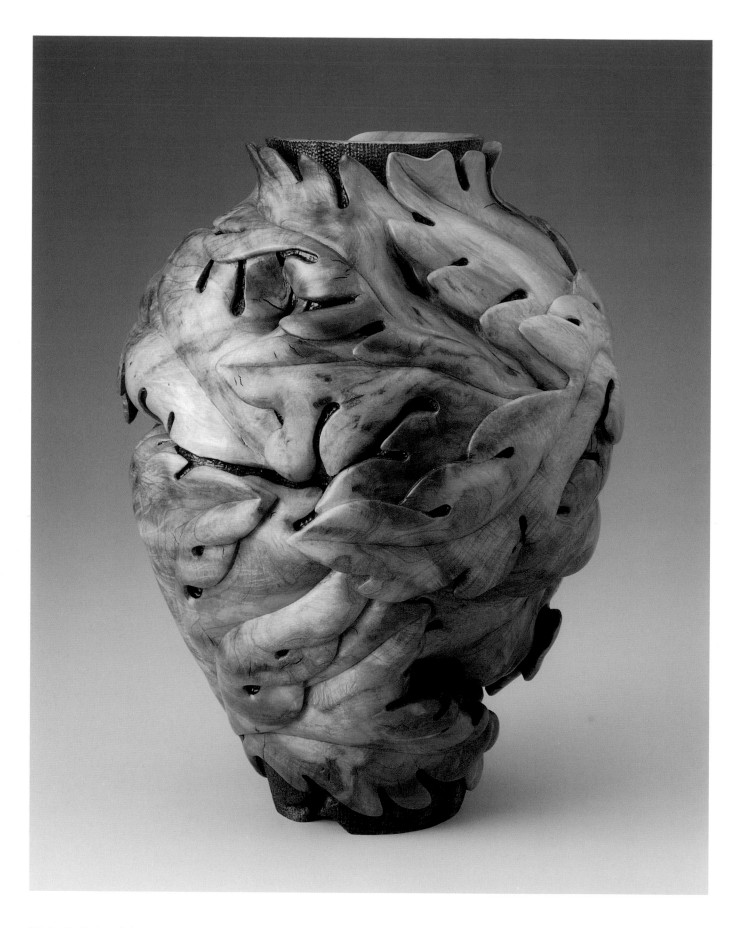

Michelle Holzapfel

OAK LEAF VASE, 1991

Turned and carved maple burl
13⅜ × 9⅝ × 9⅞ in. (34 × 24.4 × 25.1 cm)

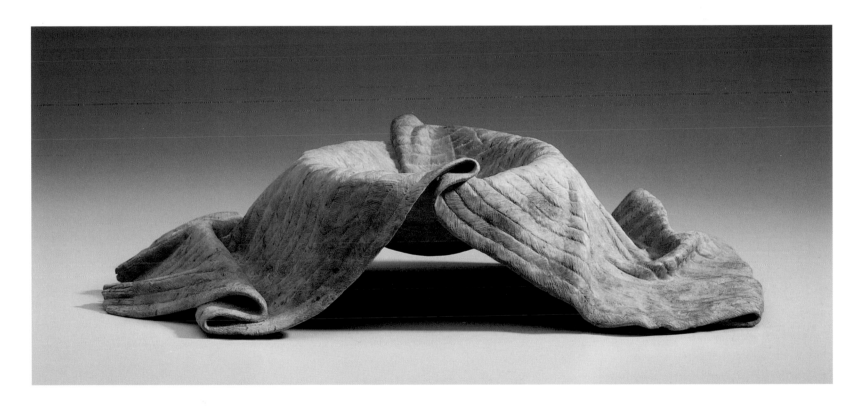

Michelle Holzapfel

SCARF BOWL, 1992

Turned and carved yellow birch burl
4 × 15½ × 7⅝ in. (10.2 × 39.4 × 19.4 cm)

Robyn Horn

Born: Fort Smith, Arkansas, November 3, 1951
Studio: Little Rock, Arkansas

FORMALLY TRAINED in painting and sculpture and coming from a family of painters, Robyn Horn was introduced to turned and shaped wood by yet another family member. During the early 1980s Horn felt tremendous enthusiasm for the work of such sculptors as Isamu Noguchi and Barbara Hepworth. When her brother-in-law Sam Horn came to her studio with examples of turned wood he had made at the Arrowmont School of Arts and Crafts, she instantly felt the expressive power those pieces conveyed. Horn found "truth in wood as a material," an idea that Hepworth promoted as a sculptor. For Horn, "the look and feel of wood lends itself to a warmer feeling than stone, which adds to the intrinsic value of this material." Horn adds, "the process of wood materializing into stone shapes is the basis of what I am trying to accomplish creatively."

EDUCATION

Arrowmont School of Arts and Crafts, Gatlinburg, Tennessee, workshop studies with Del Stubbs, John Jordan, and Steve Loar, 1990

Hendrix College, Conway, Arkansas, B.A. in studio arts, 1973

PROFESSIONAL EXPERIENCE

Independent sculptor, 1973–present

Arkansas Park and Tourism Department, commercial photographer, Little Rock, 1977–84

SELECTED EXHIBITIONS

1996 Del Mano Gallery, Los Angeles, *Turned Wood: Small Treasures*

1995 Renwick Gallery, National Museum of American Art, Smithsonian Institution, Washington, D.C., *The White House Collection of American Crafts*

1994 Banaker Gallery, San Francisco, *Women in Wood*

1993 Hunter Museum of Art, Chattanooga, Tennessee, *Hand of a Craftsman, Eye of an Artist*

1992 Fine Arts Museum of the South, Mobile, Alabama, *Out of the Woods: Turned Wood by American Craftsmen*

1991 Society of Arts and Crafts, Boston, *Lathe-Turned Objects Defined*

1990 Arrowmont School of Arts and Crafts, Gatlinburg, Tennessee, *Woodturning: Vision and Concept II*

SELECTED COLLECTIONS

Arrowmont School of Arts and Crafts, Gatlinburg, Tennessee

The Arkansas Arts Center Decorative Arts Museum, Little Rock

Fine Arts Museum of the South, Mobile, Alabama

Wood Turning Center, Philadelphia

The White House Collection of American Crafts, Washington, D.C.

SELECTED BIBLIOGRAPHY

Paul Bertorelli et al., *Fine Woodworking Design Book Five* (Newtown, Conn.: Taunton Press, 1990), p. 88.

Albert LeCoff, *Challenge V: International Lathe-Turned Objects* (Philadelphia: Wood Turning Center, 1993), p. 28.

————, *Lathe-Turned Objects: An International Exhibition* (Philadelphia: Wood Turning Center, 1988), pp. 44–45, 142.

Michael Monroe, *The White House Collection of American Crafts* (New York: Harry N. Abrams, 1995), pp. 112, 114, 119.

Andy Schultz et al., *Fine Woodworking Design Book Six* (Newtown, Conn.: Taunton Press, 1992), p. 130.

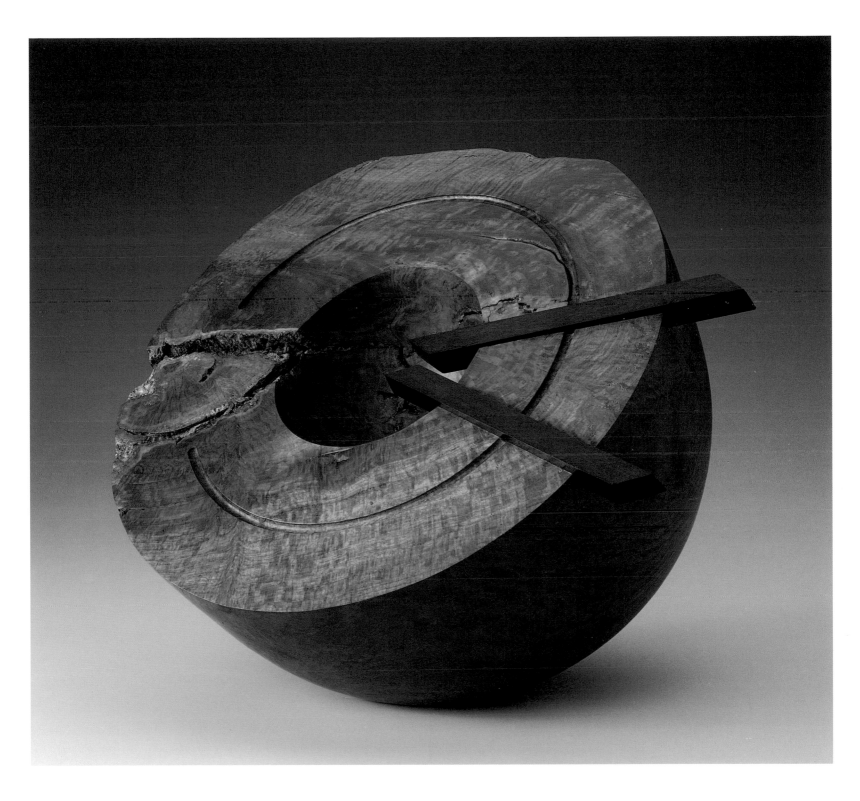

Robyn Horn

PIERCED GEODE, 1990

Turned and constructed jarrah burl and ebony
12¼ × 15 × 12¾ in. (31.1 × 38.1 × 32.4 cm)

Todd Hoyer

Born: Beaverdam, Wisconsin, January 22, 1952
Studio: Bisbee, Arizona

THE NOTION THAT artists involved in craft media have a "history of creating" that is human-oriented, particularly through the sense of touch, characterizes the work of Todd Hoyer on a number of levels. The tactility of his wooden vessels, an attribute present in turned wood in general, is augmented by the personal relevance that Hoyer brings to each piece, resulting in a powerful statement of human experience. The formal attributes, for example, that you see in his X series are actually a personal iconography for him that represents "anger, frustration, and the sense of helplessness when caught in struggles beyond one's control, with no solution in sight." In Hoyer's Passages series, he used solid forms to represent "obstacles that must be either continually circumvented or passed through. The outer black rings are fears or restrictions. The passage is the only way through the obstacle to the beyond." In these series and others Hoyer literally worked through the personal trauma of divorce and a death in the family.

EDUCATION

Arizona State University, Tempe, studies in design technology and manufacturing engineering, 1970–75

PROFESSIONAL EXPERIENCE

Independent woodworker, 1977–present

SELECTED EXHIBITIONS

1996 Del Mano Gallery, Los Angeles, *Turned Wood: Small Treasures*

1995 Philip and Muriel Berman Museum of Art, Collegeville, Pennsylvania, *Challenge V: International Lathe-Turned Objects*

1994 Art Museum, Arizona State University, Tempe, *Turning Plus: Redefining the Lathe-Turned Object III*

1993 Tucson Museum of Art, *Arizona Biennial*

1992 Art Museum, Arizona State University, Tempe, *Turning Plus: Redefining the Lathe-Turned Object*

1991 Port of History Museum, Philadelphia, *Challenge IV: International Lathe-Turned Objects*

1990 Society of Arts and Crafts, Boston, *Lathe-Turned Objects Defined*

SELECTED COLLECTIONS

Wood Turning Center, Philadelphia

Museum of Art, Rhode Island School of Design, Providence

Art Museum, Arizona State University, Tempe

SELECTED BIBLIOGRAPHY

Arnold Brickman, *Turned Wood: Small Treasures* (Los Angeles: Del Mano Gallery, 1996), unpaginated.

Edward Jacobson, *The Art of Turned-Wood Bowls* (New York: E. P. Dutton, 1985), pp. 32–35.

John Kelsey et al., *Fine Woodworking Design Book Three* (Newtown, Conn.: Taunton Press, 1983), p. 17.

Albert LeCoff, *Challenge V: International Lathe-Turned Objects* (Philadelphia: Wood Turning Center, 1993), p. 29.

Albert LeCoff et al., *Revolving Techniques: Clay, Glass, Metal, Wood* (Doylestown, Pa.: James A. Michener Art Museum, 1992), pp. 10–11.

Eileen Silver et al., *Challenge IV: International Lathe-Turned Objects* (Philadelphia: Wood Turning Center, 1991), p. 65.

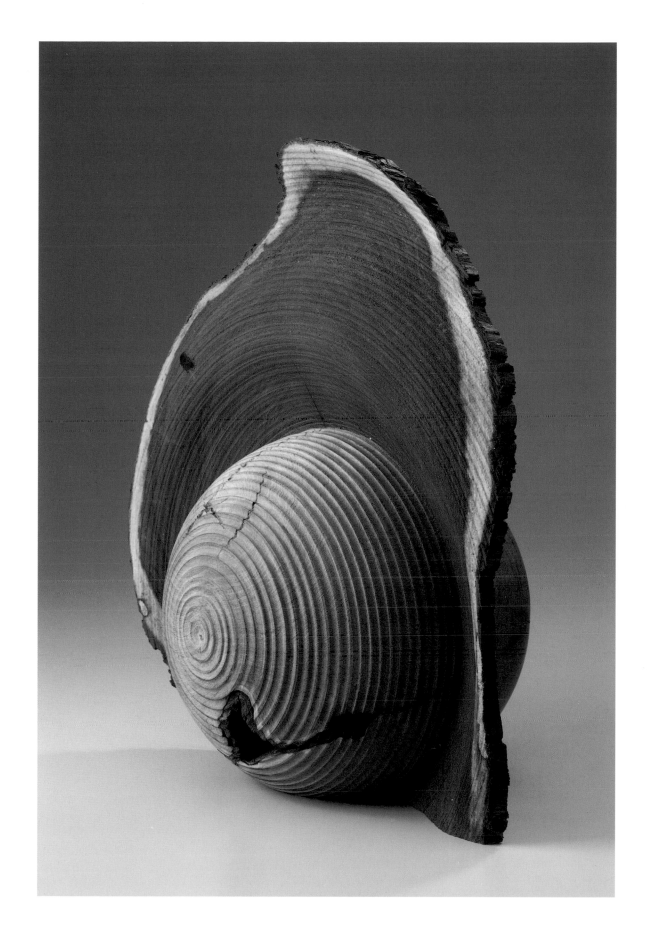

Todd Hoyer

PEELING ORB, 1987

Turned mesquite
14¼ × 13¼ × 8 in. (36.2 × 33.7 × 20.3 cm)

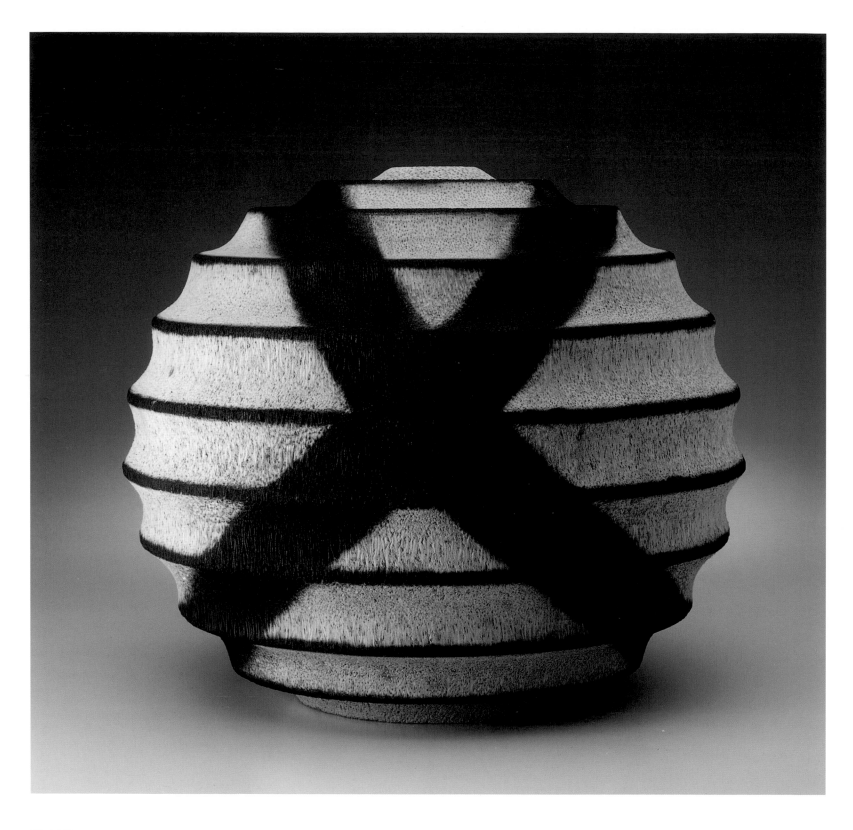

Todd Hoyer

UNTITLED (Vessel), 1990

Ringed series
Turned and burned palm
13⅝ × 16⅛ in. (34.6 × 41 cm)

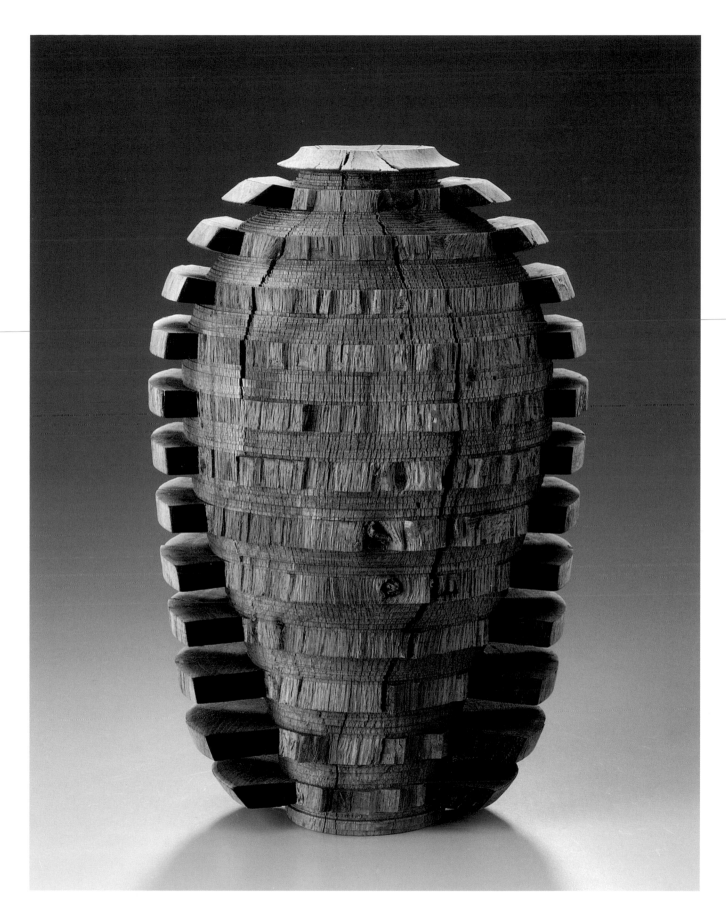

Todd Hoyer

UNTITLED (Vessel), 1994

Turned and burned emery oak
11¼ × 7¼ × 6½ in. (28.6 × 18.4 × 16.5 cm)

Stephen Hughes

Born: Melbourne, Australia, December 20, 1958
Studio: Aspendale Gardens, Victoria, Australia

STEPHEN HUGHES is a woodturner who is always looking for ways to develop new aesthetic concepts in his vessel forms. Although he has had formal training in woodturning, having studied with Vic Wood, Hughes feels that he is much more responsive on an instinctive level to the range of qualities that exist in Australian timber. First, he starts from the vantage point that wood is an organic material linked to all other natural elements. Hughes is particularly interested in relating his wooden vessels to the landscape and the ocean. With this in mind, however, he does admit that his education guides him to promote his work as sculpture, with the desire to place it in a greater art-historical context. To this end, Hughes almost always makes preliminary sketches before executing a piece, although he notes that the wood has the final say.

EDUCATION

Melbourne State College, Melbourne, Australia, B.Ed. in secondary arts and crafts, 1980

PROFESSIONAL EXPERIENCE

Woodturner and sculptor, 1981–present

Karingal Secondary College, Frankston, Victoria, Australia, instructor in wood design and technology, 1981–present

SELECTED EXHIBITIONS

1996 Del Mano Gallery, Los Angeles, *Turned Wood: Small Treasures*

1995 Art Museum, Arizona State University, Tempe, *Turning Plus: Redefining the Lathe-Turned Object IV*

1994 Philip and Muriel Berman Museum of Art, Collegeville, Pennsylvania, *Challenge V: International Lathe-Turned Objects*

1993 Bendigo Art Gallery, Bendigo, Victoria, Australia, *Enchanted Wood*

1992 Society of Arts and Crafts, Boston, *Lathe-Turned Objects Defined III*

1991 Port of History Museum, Philadelphia, *Challenge IV: International Lathe-Turned Objects*

1990 The Blackwood Street Gallery, Melbourne, Australia, *Extremities*

SELECTED COLLECTIONS

Museum of Arts and Sciences, Darwin, Northern Territory, Australia

Shire of Eltham Art Collection, Eltham, Victoria, Australia

Moomba Trophy Collection, Melbourne, Australia

Reserve Bank of Australia Art Collection, Melbourne, Australia

SELECTED BIBLIOGRAPHY

Arnold Brickman, *Turned Wood: Small Treasures* (Los Angeles: Del Mano Gallery, 1996), unpaginated.

Albert LeCoff, *Challenge V: International Lathe-Turned Objects* (Philadelphia: Wood Turning Center, 1993), p. 31.

Heather Sealy Lineberry, *Turning Plus: Redefining the Lathe-Turned Object III* (Tempe: Art Museum, Arizona State University, 1994), unpaginated.

Terry Martin, *Wood Dreaming: The Spirit of Australia Captured in Woodturning* (Sydney, Australia: Angus & Robertson, 1996), pp. 106–10, 122, 128, 151.

Eileen Silver et al., *Challenge IV: International Lathe-Turned Objects* (Philadelphia: Wood Turning Center, 1991), p. 25.

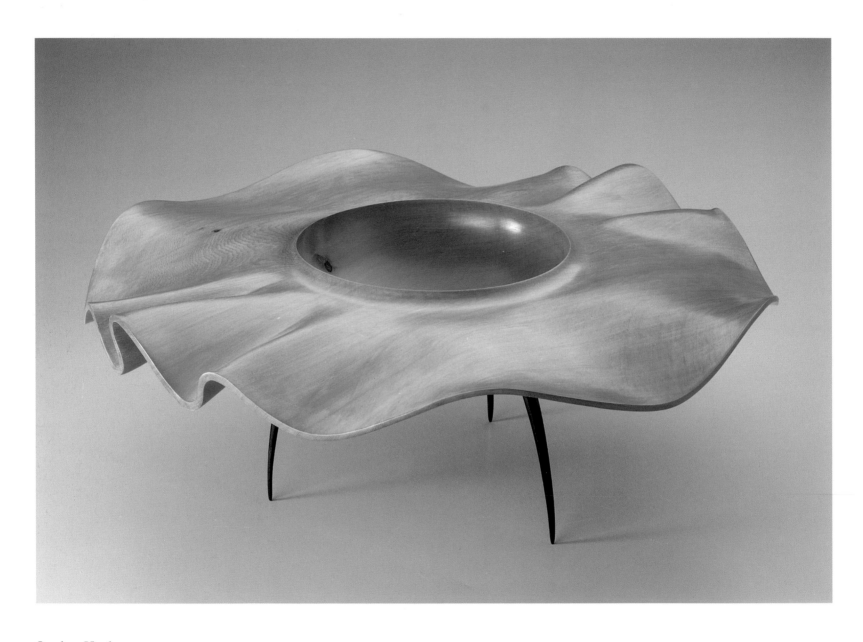

Stephen Hughes

MANTA, 1991

Turned and carved Huon pine and Indian ebony
17¼ × 18⅝ × 18⅝ in. (43.8 × 47.3 × 47.3 cm)

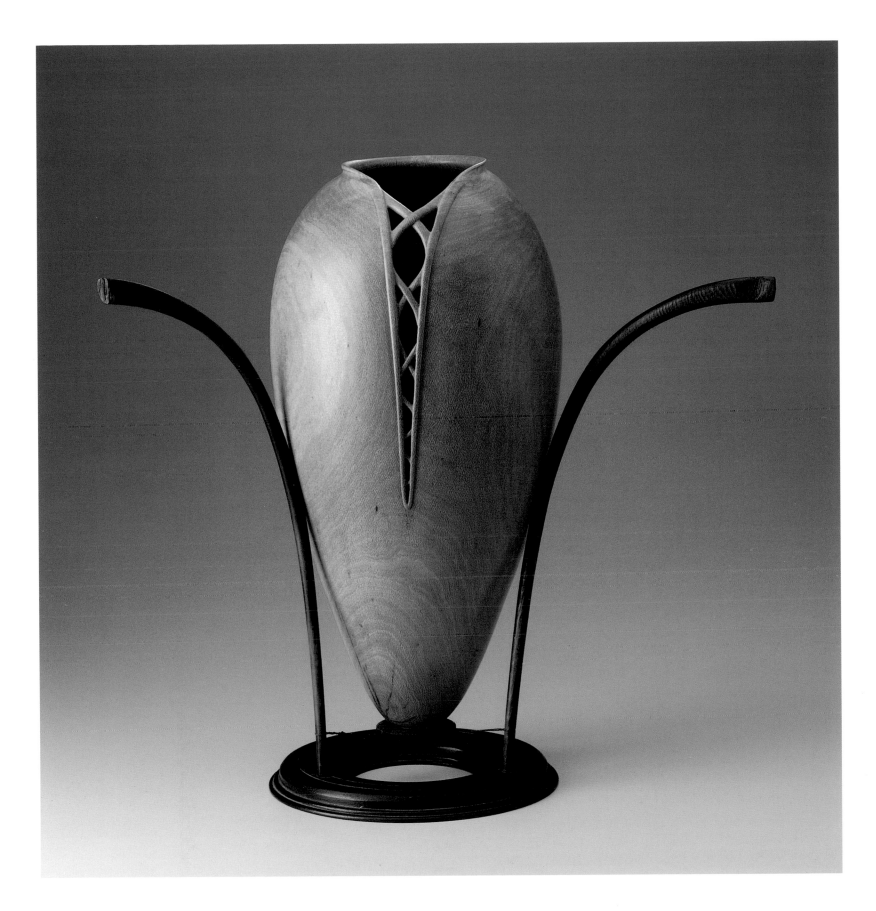

Stephen Hughes

THE PROTECTOR, 1993

Turned, carved, pigmented, and burned New South Wales ivory needlewood,
Huon pine, and medium-density fiberboard stand
17⅝ × 14 × 17 in. (44.8 × 35.6 × 43.2 cm)

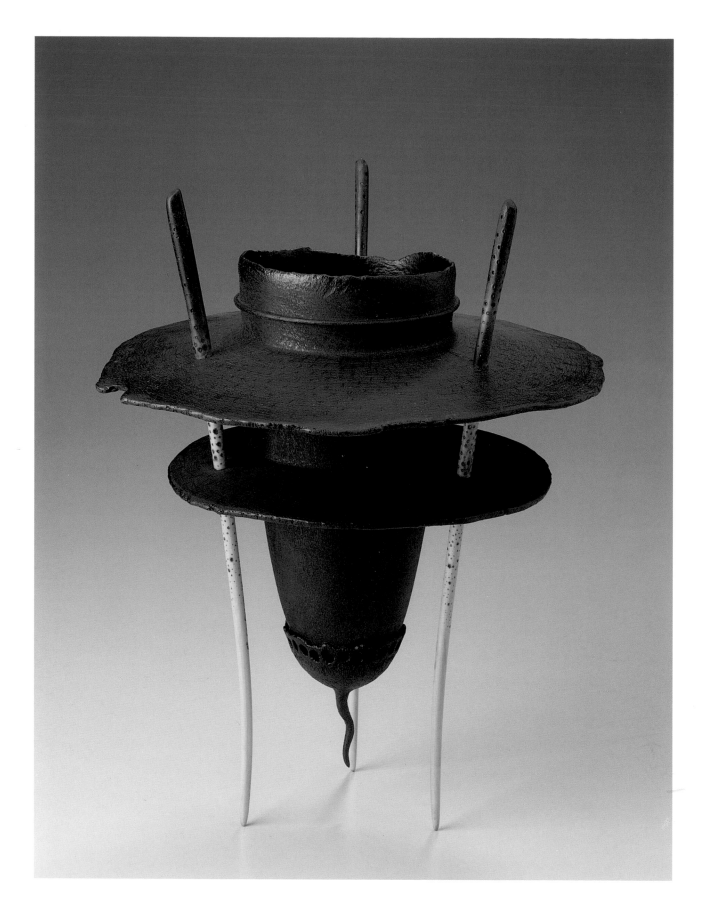

Stephen Hughes

ZANTHOREAN OFFERING VESSEL, 1993

Turned, carved, burned, and formed Western Australian grass tree and Huon pine
15½ × 12¼ × 11¾ in. (39.4 × 31.1 × 29.8 cm)

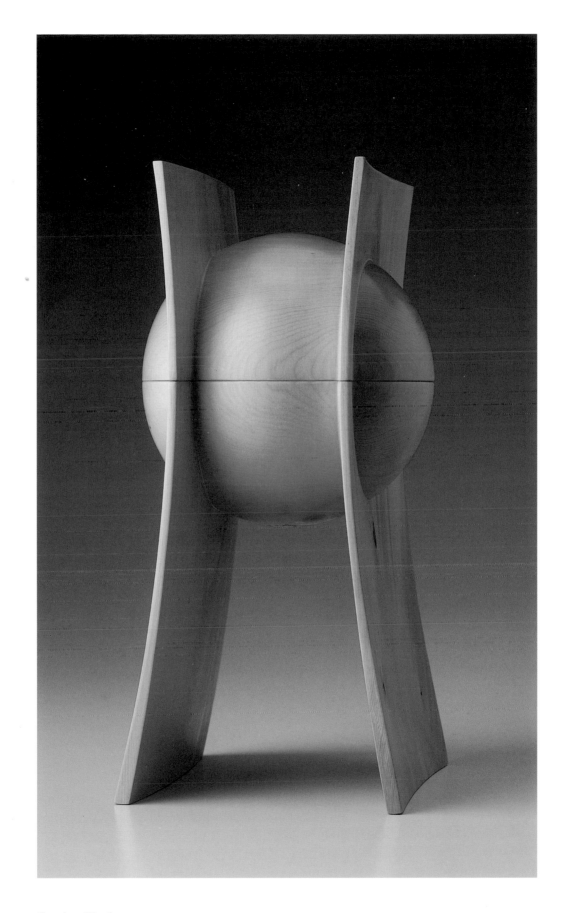

Stephen Hughes

VADER BOX 1, 1994

Turned Huon pine
9⅝ × 5⅜ × 4½ in. (24.4 × 13.7 × 11.4 cm)

William Hunter

Born: Long Beach, California, October 15, 1947
Studio: El Portal, California

MUCH IN THE WAY that hot-blown glass has attracted a broader range of active artists only since the 1960s, turned and shaped wood has a relatively short history in the United States as an artistic medium. Bill Hunter is one of the few artists in the United States who entered this field during its formative stage. As of 1970, the year in which he began to sell his vessels, Hunter found his way as a self-taught artist. He knew then and he knows now that turning wood is his passion, his lifelong commitment. Working primarily in exotic woods Hunter draws his creativity from the entire history of art, specifically as it relates to wood, but also from various disciplines of science. Perhaps even more inspirational are the natural surroundings of his home near Yosemite. He sees the forms he creates as a new language of movement and balance, a contribution of elegance to our lives.

EDUCATION

California State Dominguez Hills, Carson, B.A. in sociology, 1972

Santa Monica City College, Santa Monica, California, A.A. in fire science, 1968

PROFESSIONAL EXPERIENCE

Independent studio artist, 1970–present

SELECTED EXHIBITIONS

1995 Craft & Folk Art Museum, Los Angeles, *Points of View: Collectors and Collecting*

1994 Philip and Muriel Berman Museum of Art, Collegeville, Pennsylvania, *Challenge V: International Lathe-Turned Objects*

1993 The Hagley Museum, Wilmington, Delaware, *Art from the Lathe*

1992 California Crafts Museum, San Francisco, *Wood: Form and Function*

1991 Snyderman Gallery, Philadelphia, *William Hunter*

1990 Arrowmont School of Arts and Crafts, Gatlinburg, Tennessee, *Woodturning: Vision and Concept II*

SELECTED COLLECTIONS

Museum of Fine Arts, Boston

Fine Arts Museum of the South, Mobile, Alabama

American Craft Museum, New York

Oakland Museum of California

Renwick Gallery, National Museum of American Art, Smithsonian Institution, Washington, D.C.

SELECTED BIBLIOGRAPHY

Edward Jacobson, *The Art of Turned-Wood Bowls* (New York: E. P. Dutton, 1985), pp. 36–38.

John Kelsey et al., *Fine Woodworking Design Book Three* (Newtown, Conn.: Taunton Press, 1983), p. 17.

Albert LeCoff, *Lathe-Turned Objects: An International Exhibition* (Philadelphia: Wood Turning Center, 1988), pp. 52–53, 142.

———, *Challenge V: International Lathe-Turned Objects* (Philadelphia: Wood Turning Center, 1993), p. 23.

Martha Stamm-Connell, *Out of the Woods: Turned Wood by American Craftsmen* (Mobile, Ala.: Fine Arts Museum of the South, 1992), pp. 40–41.

Kevin Wallace, *Turned Wood '95* (Los Angeles: Del Mano Gallery, 1995), unpaginated.

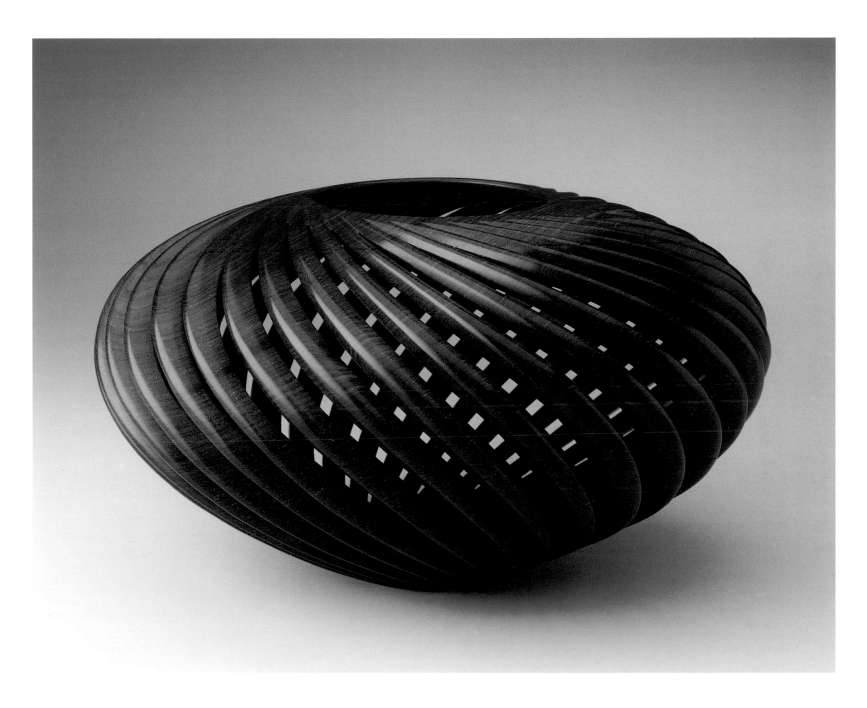

William Hunter

CYCLONE BASKET, 1994

Turned cocobolo
5⅞ × 10½ × 10½ in. (14.9 × 26.7 × 26.7 cm)

John Jordan

Born: Nashville, February 28, 1950
Studio: Antioch, Tennessee

ACCORDING TO John Jordan, the refined characteristics of his turned and carved vessels, which embrace "order, restraint, and detail," occur as direct responses to his otherwise chaotic and frequently disorganized life. Ironically or appropriately, depending on one's perspective, Jordan likes to find much of his initial lumber from timber that has been thrown away (i.e., from log dumps or construction sites). He truly enjoys the idea that his wooden vessels were initially "destined to be buried or burned." From the discarded, Jordan enters into a labor-intensive process of "manipulating colors and patterns in the wood to complement the forms, and texturing and carving to create visual and tactile contrasts." Although originally involved in making furniture forms, once he began turning wooden vessels Jordan knew that "everything clicked." His interests in the field have always been driven by an immediate sense of what feels right.

EDUCATION
Life experience

PROFESSIONAL EXPERIENCE
Independent woodturner and maker of objects, 1987–present
Service engineer in the banking field for computer systems troubleshooting, 1971–87

SELECTED EXHIBITIONS

1996 Del Mano Gallery, Los Angeles, *Turned Wood: Small Treasures*

1995 Carleton College, Northfield, Minnesota, *Nature Turning into Art: The Ruth and David Waterbury Collection of Turned-Wood Bowls*

1994 Philip and Muriel Berman Museum of Art, Collegeville, Pennsylvania, *Challenge V: International Lathe-Turned Objects*

1993 Hunter Museum of Art, Chattanooga, Tennessee, *Hand of a Craftsman, Eye of an Artist*

1992 Art Museum, Arizona State University, Tempe, *Turning Plus: Redefining the Lathe-Turned Object*

1991 Port of History Museum, Philadelphia, *Challenge IV: International Lathe-Turned Objects*

1990 Arrowmont School of Arts and Crafts, Gatlinburg, Tennessee, *Woodturning: Vision and Concept II*

SELECTED COLLECTIONS

High Museum of Art, Atlanta

Arrowmont School of Arts and Crafts, Gatlinburg, Tennessee

Fine Arts Museum of the South, Mobile, Alabama

American Craft Museum, New York

The White House Collection of American Crafts, Washington, D.C.

SELECTED BIBLIOGRAPHY

Arnold Brickman, *Turned Wood: Small Treasures* (Los Angeles: Del Mano Gallery, 1996), unpaginated.

Edward Jacobson, *Nature Turning into Art: The Ruth and David Waterbury Collection of Turned-Wood Bowls* (Northfield, Minn.: Carleton College, 1995), unpaginated.

Albert LeCoff, *Challenge V: International Lathe-Turned Objects* (Philadelphia: Wood Turning Center, 1993), p. 34.

Albert LeCoff et al., *Revolving Techniques: Clay, Glass, Metal, Wood* (Doylestown, Pa.: James A. Michener Art Museum, 1992), p. 14.

Michael Monroe, *The White House Collection of American Crafts* (New York: Harry N. Abrams, 1995), pp. 108, 114, 119.

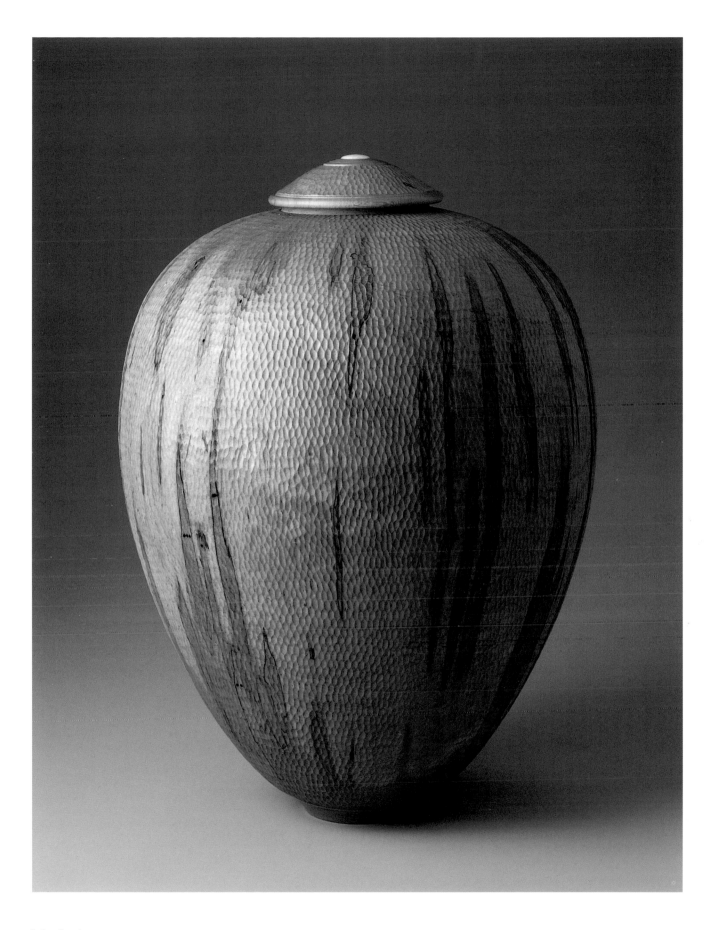

John Jordan

UNTITLED (Lidded Jar), 1992

Turned and chiseled red maple and bone
18⅛ × 13 × 13 in. (46 × 33 × 33 cm)

Ron Kent

Born: Chicago, May 18, 1931
Studio: Honolulu

IF THERE IS a signature to Ron Kent's turned-wood vessels it is that nearly every one is made from Norfolk Island pine. However, aside from the wood itself it is the way in which Kent takes a raw log and transforms it into what he calls a "graceful silhouette." The truth of his statement is undeniable. Each vessel form is an interplay of the inherent properties of the wood and of light as it is capable of dramatizing those "whorls, grains, colors, and patterns that nature has provided." Light, whether natural or artificial, is a necessary component in the visual and subsequent tactile responses of those who experience his work. Philosophically speaking, while positive and negative space has been an interest of modernist sculptors for most of this century, Kent reveals a spatial concern in a vessel format that is neither negative nor positive. What is it?

EDUCATION

University of California, Los Angeles, B.S. in mechanical engineering, 1957

PROFESSIONAL EXPERIENCE

Independent stockbroker and president of Leahi Tax-Free Mutual Fund, 1987–present

Woodturner and sculptor, 1967–present

New York Stock Exchange broker for various firms, including vice president with Prudential-Bache and Paine-Webber, 1959–87

SELECTED EXHIBITIONS

1996 Del Mano Gallery, Los Angeles, *Turned Wood: Small Treasures*

1995 Carleton College, Northfield, Minnesota, *Nature Turning into Art: The Ruth and David Waterbury Collection of Turned-Wood Bowls*

1994 High Museum of Art, Atlanta, *The Art of the Woodturner*

1993 Carlyn Gallery, Dallas, *Second Annual Turned-Wood Show*

1992 Fine Arts Museum of the South, Mobile, Alabama, *Out of the Woods: Turned Wood by American Craftsmen*

1991 Honolulu Academy of Arts, *Artists of Hawaii*

1990 Banaker Gallery, Walnut Creek, California, *Contemporary Wood '90*

SELECTED COLLECTIONS

Museum of Fine Arts, Boston

The Detroit Institute of Arts

American Craft Museum, New York

The Metropolitan Museum of Art, New York

Renwick Gallery, National Museum of American Art, Smithsonian Institution, Washington, D.C.

SELECTED BIBLIOGRAPHY

Arnold Brickman, *Turned Wood: Small Treasures* (Los Angeles: Del Mano Gallery, 1996), unpaginated.

Phyllis George, *Craft in America: Celebrating the Creative Work of the Hand* (Fort Worth, Tex.: Summit Group, 1993), pp. 142–43.

Edward Jacobson, *The Art of Turned-Wood Bowls* (New York: E. P. Dutton, 1985), pp. 39–41.

Dona Meilach, *Woodworking: The New Wave* (New York: Crown Publishers, 1981), p. 42.

Kevin Wallace, *Turned Wood '95* (Los Angeles: Del Mano Gallery, 1995), unpaginated.

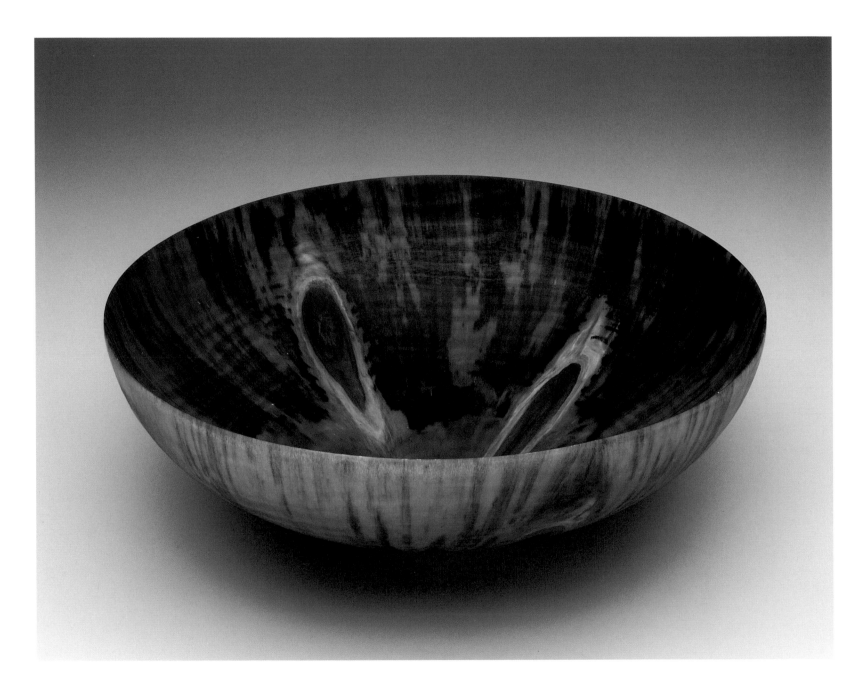

Ron Kent

UNTITLED (Translucent Vessel), 1986

Turned Norfolk Island pine
5⅞ × 15½ in. (14.9 × 39.4 cm)

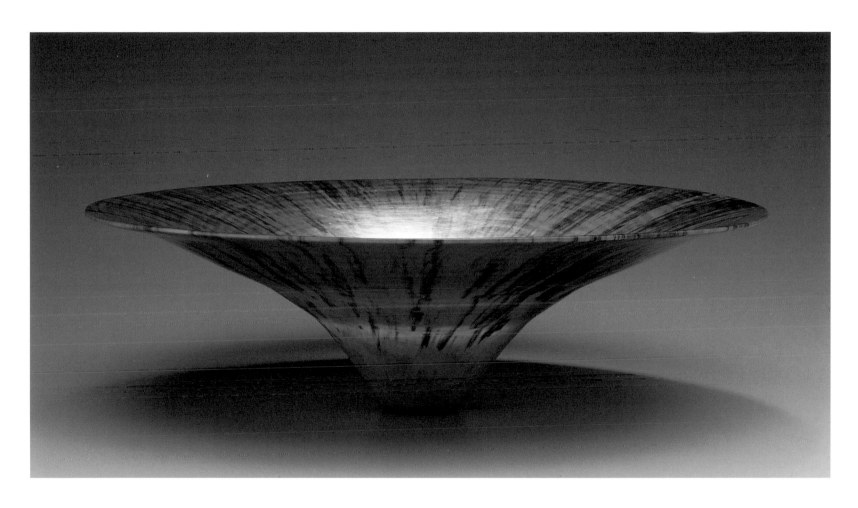

Ron Kent

UNTITLED (Vessel), 1992

Turned Norfolk Island pine
6⅝ × 21⅜ in. (16.8 × 54.3 cm)

Dan Kvitka

Born: Los Angeles, June 13, 1958
Studio: Portland, Oregon

THE IDEA OF revealing the beauty in woods is Dan Kvitka's continual challenge in creating his turned vessels. Simple, reductive forms, therefore, are the necessary means for conveying his notion of beauty. Kvitka tries to translate physical properties of wood into abstract concepts, in many examples utilizing grain patterns to express a dramatic landscape. Whether we know it or not, he presents us with a dichotomy between an elitist activity and our own basic desires to fall in love with an inanimate object. We all want to catch the exhilaration of being confronted by the power of beauty from something that at the same time is easily accessible to us. Kvitka does an outstanding job of providing this opportunity.

EDUCATION
Art Center College of Design, Pasadena, California, B.S. in industrial design, 1980

PROFESSIONAL EXPERIENCE
Independent woodturner, 1985–present
Editor-in-chief, *American Woodturner*, Corvallis, Oregon, 1986–88

SELECTED EXHIBITIONS
1996 Del Mano Gallery, Los Angeles, *Turned Wood: Small Treasures*
1995 Art Museum, Arizona State University, Tempe, *Turning Plus: Redefining the Lathe-Turned Object IV*
1994 The Sybaris Gallery, Royal Oak, Michigan, *Summer Pleasures*
1993 Maveety Gallery, Salishan, Oregon, *Dan Kvitka and Judith Lazelere*
1992 Kornbluth Gallery, Fair Lawn, New Jersey, *24th Annual Crafts Invitational*
1991 Gallery Eight, La Jolla, California, *Tapestry, Wood, Clay*
1990 Mendelson Gallery, Washington Depot, Connecticut, *Five Rising Stars*

SELECTED COLLECTIONS
Museum of Fine Arts, Boston
American Craft Museum, New York

SELECTED BIBLIOGRAPHY
Paul Bertorelli et al., *Fine Woodworking Design Book Four* (Newtown, Conn.: Taunton Press, 1987), p. 130.
————, *Fine Woodworking Design Book Five* (Newtown, Conn.: Taunton Press, 1990), p. 77.
Arnold Brickman, *Turned Wood: Small Treasures* (Los Angeles: Del Mano Gallery, 1996), unpaginated.
Albert LeCoff, *Lathe-Turned Objects: An International Exhibition* (Philadelphia: Wood Turning Center, 1988), pp. 73, 144.
Heather Sealy Lineberry, *Turning Plus: Redefining the Lathe-Turned Object III* (Tempe: Art Museum, Arizona State University, 1994), unpaginated.
Kevin Wallace, *Turned Wood '94* (Los Angeles: Del Mano Gallery, 1994), unpaginated.

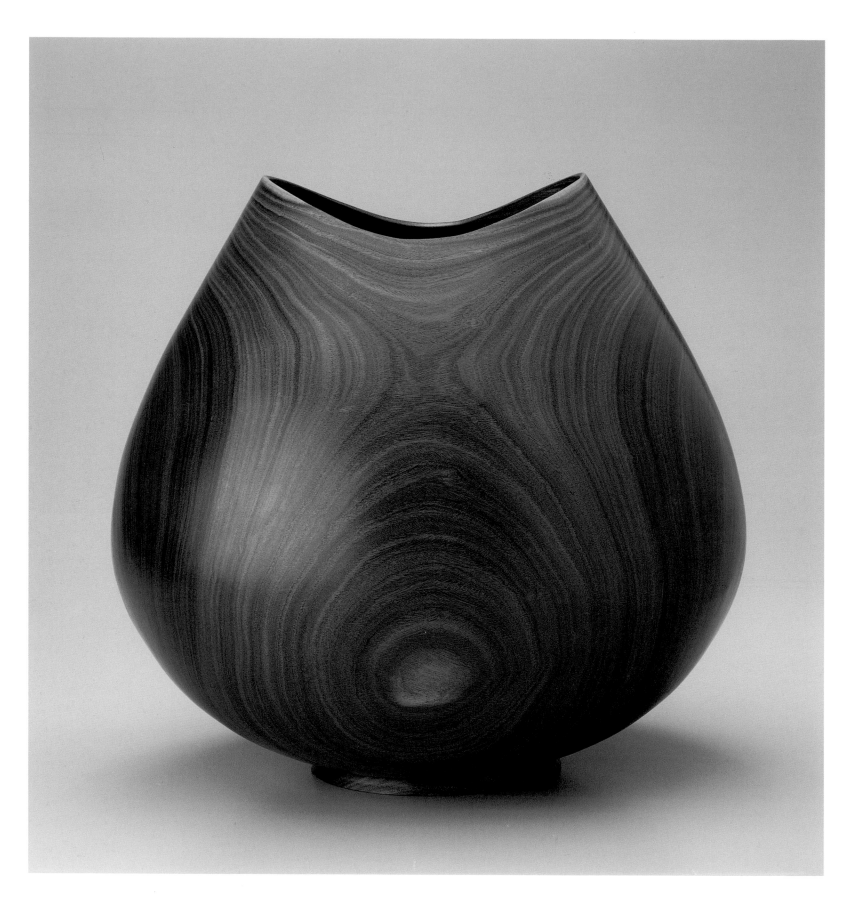

Dan Kvitka

NODE, 1986

Turned verawood
12⅜ × 12⅞ × 13⅜ in. (31.4 × 32.7 × 34 cm)

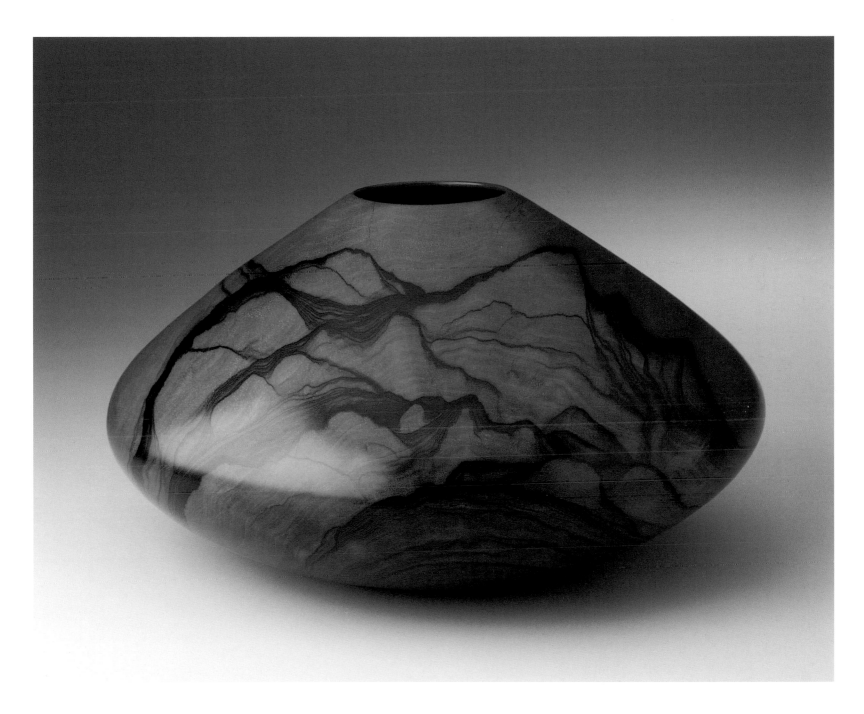

Dan Kvitka

RIVER ROCK, 1986

Turned macassar ebony
6⅜ × 11½ × 11½ in. (16.2 × 29.2 × 29.2 cm)

Bob (Bud) Latven

Born: Philadelphia, April 25, 1949
Studio: Tajique, New Mexico

BOB LATVEN, better known as Bud, calls himself an eccentric. No elaboration. Latven also states that he found his way to the field of woodturning only by chance. Again, no elaboration. On the other hand, looking at the formal qualities in the wooden vessels he creates and his extensive exhibition record, it is easy to see someone who is exceedingly well grounded and in control, giving clear definition to his work. Perhaps those woodturners who view themselves as being loose cannons have a greater need to be exceptionally disciplined for championing a strict vessel aesthetic. Interestingly enough, Latven is another woodturner who is captivated by modernism. Among other stylistic motivations, he has cited the Italian Memphis Group, with its leader Ettore Sottsass, as a crucial impetus for his work.

EDUCATION
University of New Mexico, Albuquerque, studies in philosophy, 1972–73
Delaware County College, Philadelphia, general studies, 1970–72

PROFESSIONAL EXPERIENCE
Independent studio woodturner, 1982–present
Independent studio furniture maker, 1973–82

SELECTED EXHIBITIONS
1996 Del Mano Gallery, Los Angeles, *Turned Wood: Small Treasures*
1995 Connell Gallery, Atlanta, *Three Generations of Studio Woodturners: The Making of an Art Form*
1994 Philip and Muriel Berman Museum of Art, Collegeville, Pennsylvania, *Challenge V: International Lathe-Turned Objects*
1993 High Museum of Art, Atlanta, *The Art of the Woodturner*
1992 Fine Arts Museum of the South, Mobile, Alabama, *Out of the Woods: Turned Wood by American Craftsmen*
1991 Charles A. Wustum Museum of Fine Art, Racine, Wisconsin, *Craft: The Discerning Eye*
1990 Society of Arts and Crafts, Boston, *Lathe-Turned Objects Defined*

SELECTED COLLECTIONS
Albuquerque Museum, New Mexico
High Museum of Art, Atlanta
Hunter Museum of Art, Chattanooga, Tennessee
Fine Arts Museum of the South, Mobile, Alabama
Renwick Gallery, National Museum of American Art, Smithsonian Institution, Washington, D.C.

SELECTED BIBLIOGRAPHY
Paul Bertorelli et al., *Fine Woodworking Design Book Four* (Newtown, Conn.: Taunton Press, 1987), p. 125.
Arnold Brickman, *Turned Wood: Small Treasures* (Los Angeles: Del Mano Gallery, 1996), unpaginated.
Albert LeCoff, *Challenge V: International Lathe-Turned Objects* (Philadelphia: Wood Turning Center, 1993), p. 40.
———, *Lathe-Turned Objects: An International Exhibition* (Philadelphia: Wood Turning Center, 1988), pp. 75, 144.
Heather Sealy Lineberry, *Turning Plus: Redefining the Lathe-Turned Object III* (Tempe: Art Museum, Arizona State University, 1994), unpaginated.

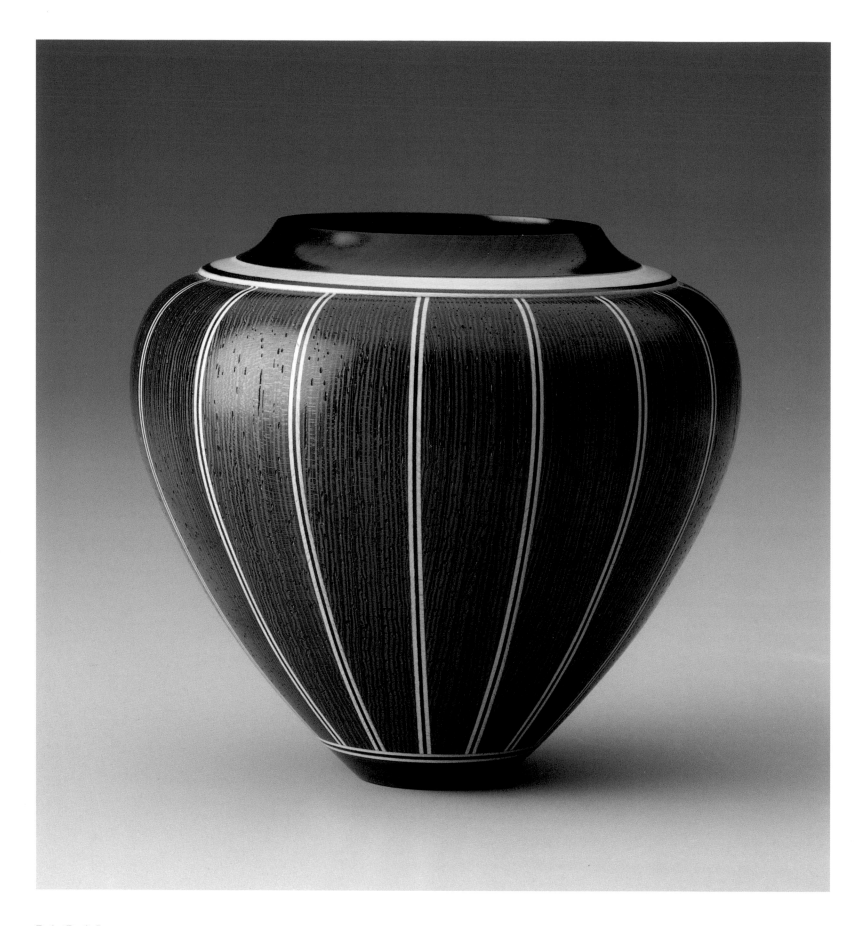

Bob (Bud) Latven

UNTITLED (Vessel), 1987

Laminated and turned wenge and maple
3¾ × 4 × 4 in. (9.5 × 10.2 × 10.2 cm)

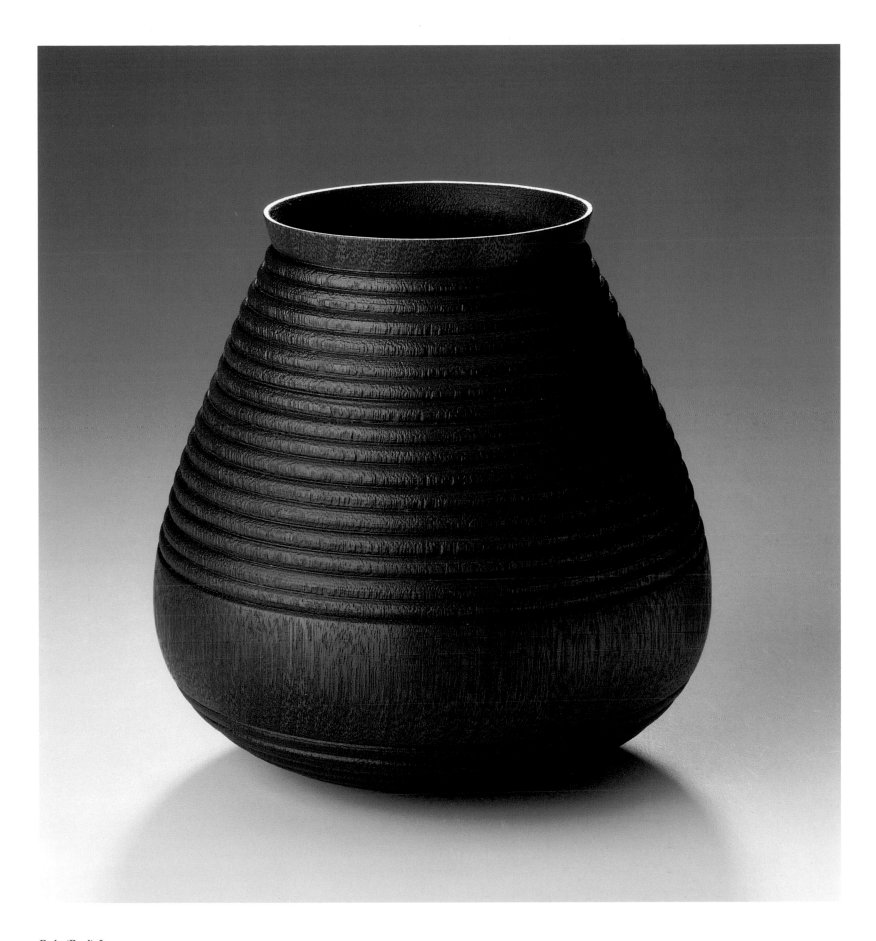

Bob (Bud) Latven

TEXTURED ANASAZI, 1988

Turned and stained Honduran mahogany and shoe polish
7⅛ × 7⅛ × 7⅛ in. (18.1 × 18.1 × 18.1 cm)

Mark Lindquist

Born: Oakland, California, May 16, 1949
Studio: Quincy, Florida

MARK LINDQUIST has been a significant driving force behind establishing woodturning as a nationally recognized and accepted art form. He began working in wood, primarily on the lathe, at age ten under his father's guidance. Lindquist views his art as a continuum of ancient ceramic ideals, precepts of Japanese Heian-period art, and modernist sculpture of the early twentieth century. For many years he has found motivation for his large-scale sculpture in his study of the art and philosophy of Japanese Buddhism and the totemic sculptures of primitive peoples, as well as the writings of such postmodernist literary figures as Jean-François Lyotard. Recently given a twenty-five-year retrospective by the Hand Workshop Art Center in Richmond, Virginia, he is known for having introduced the use of spalted wood and the acceptance of natural faults, realizing the aesthetic possibilities of celebrating the textural structure of wood. After many years of working with wood as his primary artistic medium, Lindquist believes that the material has only two constants: "Its absolutely unpredictable inconsistency and its innate nobility."

EDUCATION

Florida State University, Tallahassee, M.F.A. in sculpture, 1990

Pratt Institute of Fine Arts, Brooklyn, graduate studies in studio arts, 1971

New England College, Henniker, New Hampshire, B.A. in studio arts, 1971

Apprenticeship with ceramic artist Darr Collins, Henniker, New Hampshire, 1969–71

Apprenticeship with his father, master woodturner Melvin Lindquist, 1959–69

PROFESSIONAL EXPERIENCE

Sculptor, 1969–present

Florida A & M University, Tallahassee, visiting associate professor in the School of Architecture, 1988–89

MacDowell Colony, Peterborough, New Hampshire, resident fellow, 1979

Worcester Craft Center, Worcester, Massachusetts, chair of woodworking department, 1977–78

SELECTED EXHIBITIONS

1995–96 Hand Workshop Art Center, Richmond, Virginia, and Renwick Gallery, National Museum of American Art, Smithsonian Institution, Washington, D.C., *Mark Lindquist: Revolutions in Wood*

1995 Renwick Gallery, National Museum of American Art, Smithsonian Institution, Washington, D.C., *The White House Collection of American Crafts*

1994 Lowe Art Museum, University of Miami, Coral Gables, Florida, *Eight Contemporary Sculptors: Beyond Nature, Wood into Art*

1993 The Toledo Museum of Art, *Contemporary Crafts and the Saxe Collection*

1992 Fine Arts Museum of the South, Mobile, Alabama, *Out of the Woods: Turned Wood by American Craftsmen*

1991 Museum of Fine Arts, Boston, *Collecting American Decorative Arts and Sculpture*

1990 Florida State University, Tallahassee, *NEA Artists*

SELECTED COLLECTIONS

Museum of Fine Arts, Boston

Dallas Museum of Art

The Metropolitan Museum of Art, New York

Virginia Museum of Fine Arts, Richmond

Renwick Gallery, National Museum of American Art, Smithsonian Institution, Washington, D.C.

SELECTED BIBLIOGRAPHY

Edward S. Cooke, Jr., "Wood in the 1980s: Expansion or Commodification?" in *Contemporary Crafts and the Saxe Collection*, ed. Davira S. Taragin (Toledo, Ohio: The Toledo Museum of Art, in association with Hudson Hills Press, 1993), pp. 149, 151, 154, 156.

Josephine Gear, *Eight Contemporary Sculptors: Beyond Nature, Wood into Art* (Coral Gables, Fla.: Lowe Art Museum, University of Miami, 1994), pp. 6–9, 33.

Robert Hobbs, *Mark Lindquist: Revolutions in Wood* (Seattle: University of Washington Press, 1995).

Mark Lindquist, *Sculpting Wood: Contemporary Tools and Techniques* (Worcester, Mass.: Davis Publications, 1986).

Michael Monroe, *The White House Collection of American Crafts* (New York: Harry N. Abrams, 1995), pp. 98–99, 115, 120.

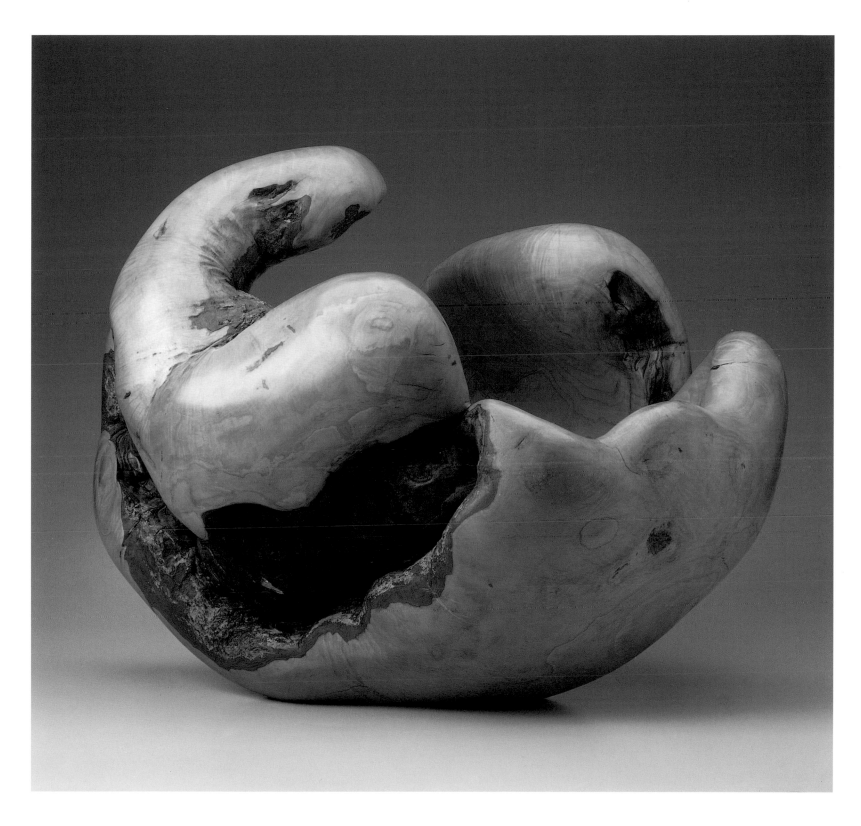

Mark Lindquist

SCULPTURAL VESSEL, 1979

Carved white ash burl
24 × 20 × 26 in. (61 × 50.8 × 66 cm)

Bert Marsh

Born: Brighton, East Sussex, England, September 10, 1932
Studio: Brighton, East Sussex, England

THE OBJECTS CREATED by Bert Marsh are delicate vessel forms with sensuous curves, graceful lines, and stunningly fine surfaces. Each example is a celebration of the wood from which it is made. At times it seems that Marsh has encouraged the wood to even greater responsibilities of beauty by transforming every organic property into a visually seductive element. Whether the point of departure is areas of decay or discoloration or the more formal components of grain pattern, Marsh tries to bring out the hidden revelation in the natural growth. "There's a lot of philosophy in art and I don't feel my work has a lot of philosophy in it. I turn for the love of the wood. I'm trying in some humble way to show the qualities of wood, which are fabulous."

EDUCATION

Buckingham College of Higher Education, Buckingham, Institute of Wood, Advanced Examination in Wood Science, 1978

High Wycombe College of Technology and Art, Buckingham, studies in wood science, 1976–77

Worthing College of Further Education, West Sussex, City and Guilds Licentiateship in Wood Machining, 1972

London College of Furniture, Licentiateship Certificate in Furniture Making, 1970

Brighton Technical College, East Sussex, Certificate in Timber Technology, 1967

Brighton College of Art, East Sussex, City and Guilds Full Technology Certificate in Cabinetmaking, 1960

Apprenticeship, Cakebread Cabinetry, Brighton, East Sussex, 1946–50

PROFESSIONAL EXPERIENCE

Independent woodturner, Brighton, East Sussex, 1983–present

Brighton Polytechnic, East Sussex, instructor in furniture and wood sciences, 1971–83

Brighton College of Art, East Sussex, instructor in furniture and wood sciences, 1965–71

Jordan & Cook Furniture, Brighton, East Sussex, cabinetmaker, 1955–65

Brighton Cabinets, East Sussex, cabinetmaker, 1954–55

Coachbuilder, Brighton, East Sussex, 1953–54

Jack Cohen Cabinetry, Brighton, East Sussex, woodcarver, 1953

SELECTED EXHIBITIONS

1996 Del Mano Gallery, Los Angeles, *Turned Wood: Small Treasures*

1995 Royal Festival Hall, London, *Homeworks*

1994 Bonhams, London, *Decorative Arts Today*

1993 Barbican Arts Centre, London, *Three Woodturners*

1992 Chelsea Old Town Hall, London, *Creative Eye*

1991 Dixon Gallery, London, *Two Views*

1990 Royal Pavilion, Brighton, East Sussex, *Objects of Desire*

SELECTED COLLECTIONS

Leeds City Art Gallery and Museum, Leeds

Guild of Master Craftsmen, Lewes, East Sussex

The Worshipful Company of Turners, London

Nature in Art, Twigworth

South East Arts, Turnbridge Wells

SELECTED BIBLIOGRAPHY

Tony Boase, *Woodturning Masterclass* (Lewes, East Sussex: Guild of Master Craftsman Publications, 1995), pp. 62–73.

Arnold Brickman, *Turned Wood: Small Treasures* (Los Angeles: Del Mano Gallery, 1996), unpaginated.

Bert Marsh, *Bert Marsh: Woodturner* (Lewes, East Sussex: Guild of Master Craftsman Publications, 1995).

Keith Rowley, *Woodturning—A Foundation Course* (Lewes, East Sussex: Guild of Master Craftsman Publications, 1990), p. vii.

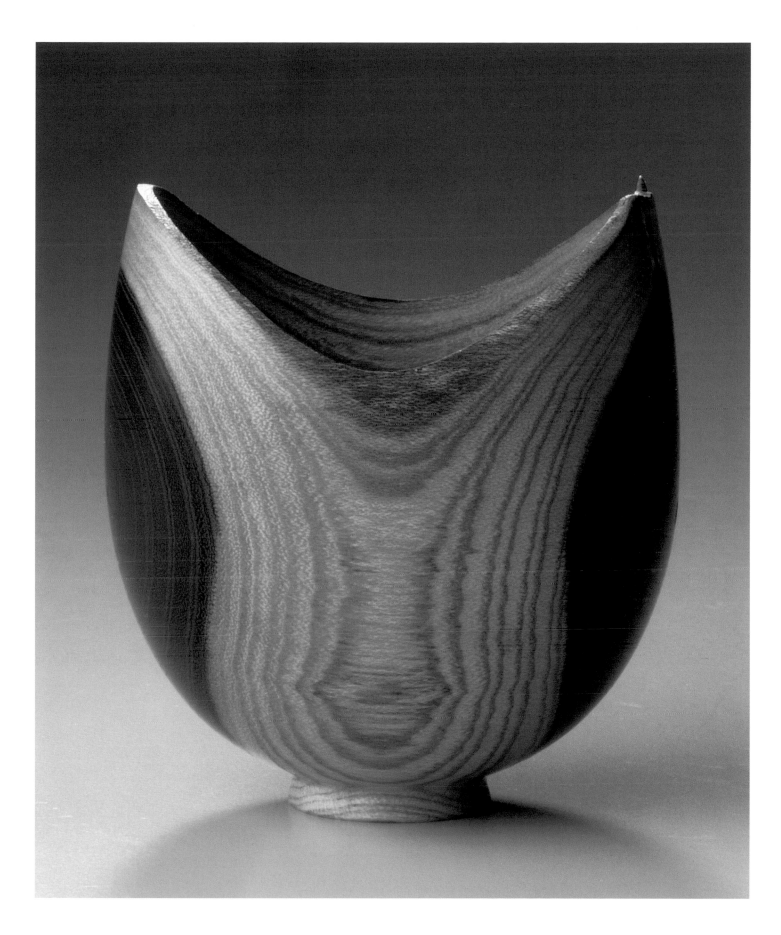

Bert Marsh

LABURNUM VASE, 1987

Turned laburnum
2⅞ × 2¼ in. (7.3 × 5.7 cm)

Bruce Mitchell

Born: San Rafael, California, May 12, 1949
Studio: Point Reyes, California

THE PROCESS OF woodturning, according to Bruce Mitchell, is "a dialogue, an exchange of ideas and possibilities between an artist and his wood." Mitchell allows for improvisational freedom when turning his wooden vessels, accepting the fact that initial designs nearly always change during hands-on creativity. Aside from his almost exclusive use of stumps and burls, attached to their chaotic shapes, Mitchell quickly credits one source for the direction in his work. The California wood sculptor J. B. Blunk, whose large-scale tree-root sculptural seating established a vanguard threshold for functional work during the 1960s, accepted Mitchell as an apprentice for several years. From that formative experience, Mitchell continues his primary aesthetic focus on objects that relate to function as an abstract rather than a literal concept for those who see and touch his pieces.

EDUCATION

University of California, Santa Barbara, studies in studio arts, 1970–71

Apprenticeship with wood sculptor J. B. Blunk, Inverness, California, 1969–77

Laney Community College, Oakland, California, studies in photography and art history, 1967–69

PROFESSIONAL EXPERIENCE

Independent sculptor, 1977–present

SELECTED EXHIBITIONS

1996 Del Mano Gallery, Los Angeles, *Turned Wood: Small Treasures*

1995 Carleton College, Northfield, Minnesota, *Nature Turning into Art: The Ruth and David Waterbury Collection of Turned-Wood Bowls*

1994 Del Mano Gallery, Los Angeles, *Turned Wood '94*

1993 Okun Gallery, Santa Fe, *Bruce Mitchell*

1992 Renwick Gallery, National Museum of American Art, Smithsonian Institution, Washington, D.C., *American Crafts: The Nation's Collections*

1991 Banaker Gallery, Walnut Creek, California, *Contemporary Wood '91*

1990 Society of Arts and Crafts, Boston, *Lathe-Turned Objects Defined*

SELECTED COLLECTIONS

High Museum of Art, Atlanta

The Arkansas Arts Center Decorative Arts Museum, Little Rock

Oakland Museum of California

Art Museum, Arizona State University, Tempe

Renwick Gallery, National Museum of American Art, Smithsonian Institution, Washington, D.C.

SELECTED BIBLIOGRAPHY

Paul Bertorelli et al., *Fine Woodworking Design Book Four* (Newtown, Conn.: Taunton Press, 1987), p. 116.

Arnold Brickman, *Turned Wood: Small Treasures* (Los Angeles: Del Mano Gallery, 1996), unpaginated.

Edward Jacobson, *The Art of Turned-Wood Bowls* (New York: E. P. Dutton, 1985), pp. 50–52.

John Kelsey et al., *Fine Woodworking Design Book Three* (Newtown, Conn.: Taunton Press, 1983), p. 15.

Albert LeCoff, *Lathe-Turned Objects: An International Exhibition* (Philadelphia: Wood Turning Center, 1988), pp. 86, 144.

———, *A Gallery of Turned Objects* (Provo, Utah: Brigham Young University Press, 1981), p. 48.

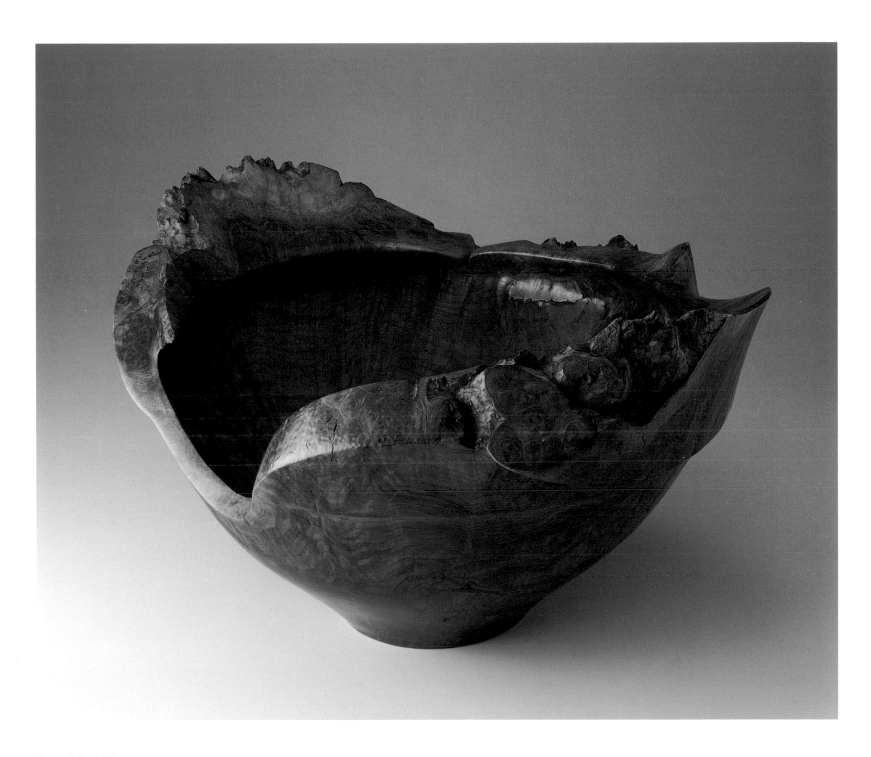

Bruce Mitchell

STAR CHAMBER, 1987

Turned claro walnut lace burl
11⅝ × 21⅝ × 17¾ in. (29.5 × 54.9 × 45.1 cm)

William Moore

Born: Arlington, Virginia, February 28, 1945
Studio: Hillsboro, Oregon

AS A SCULPTOR, William Moore sees himself as a protégé of the modernists. From Jean Arp to Henry Moore and Gaston Lachaise to Isamu Noguchi, Moore feels comfortably aligned with the interests of early- to mid-twentieth-century manifestos of style and philosophical approaches. His formal training in an M.F.A. program developed his conviction that he could reach beyond the early modern masters. Although he has always been involved with wood as a material, even before his university training, his intense focus on turned vessels came much later. For this, he credits masters such as Bob Stocksdale, Sam Maloof, and Wendell Castle (despite the latter two being furniture makers). In his current approach to turning, Moore designs his ideas on paper. He believes in a strict form-follows-function concept, which he states is a "very important part of my thinking and designing."

EDUCATION

University of Michigan, Ann Arbor, M.F.A. in sculpture, 1971
University of Michigan, Ann Arbor, B.S. in design, 1967

PROFESSIONAL EXPERIENCE

Pacific Northwest College of Art, Portland, Oregon, various positions including instructor and chairman of the sculpture department, 1972–present
Sculptor, 1971–present

SELECTED EXHIBITIONS

1996 Del Mano Gallery, Los Angeles, *Turned Wood: Small Treasures*

1994 Art Museum, Arizona State University, Tempe, *Turning Plus: Redefining the Lathe-Turned Object III*

1993 Laura Russo Gallery, Portland, Oregon, *William Moore Sculpture*

1992 Erie Art Museum, Erie, Pennsylvania, *Woodturning as an Art Form: The Irving Lipton Collection*

1991 Port of History Museum, Philadelphia, *Challenge IV: International Lathe-Turned Objects*

1990 James A. Michener Art Museum, Doylestown, Pennsylvania, *Revolving Techniques: Thrown, Blown, Spun, and Turned*

SELECTED COLLECTIONS

Mt. Angel Abbey, Mt. Angel, Oregon
Washington State Arts Commission, Olympia
Metropolitan Arts Commission, Portland, Oregon
Portland Development Commission, Portland, Oregon
Oregon Arts Commission, Salem

SELECTED BIBLIOGRAPHY

Arnold Brickman, *Turned Wood: Small Treasures* (Los Angeles: Del Mano Gallery, 1996), unpaginated.

John Kelsey et al., *Fine Woodworking Design Book Two* (Newtown, Conn.: Taunton Press, 1979), pp. 277, 284.

Heather Sealy Lineberry, *Turning Plus: Redefining the Lathe-Turned Object III* (Tempe: Art Museum, Arizona State University, 1994), unpaginated.

Eileen Silver et al., *Challenge IV: International Lathe-Turned Objects* (Philadelphia: Wood Turning Center, 1991), pp. 29, 60.

Kevin Wallace, *Turned Wood '90* (Los Angeles: Del Mano Gallery, 1990), unpaginated.

———, *Turned Wood '96* (Los Angeles: Del Mano Gallery, 1996), unpaginated.

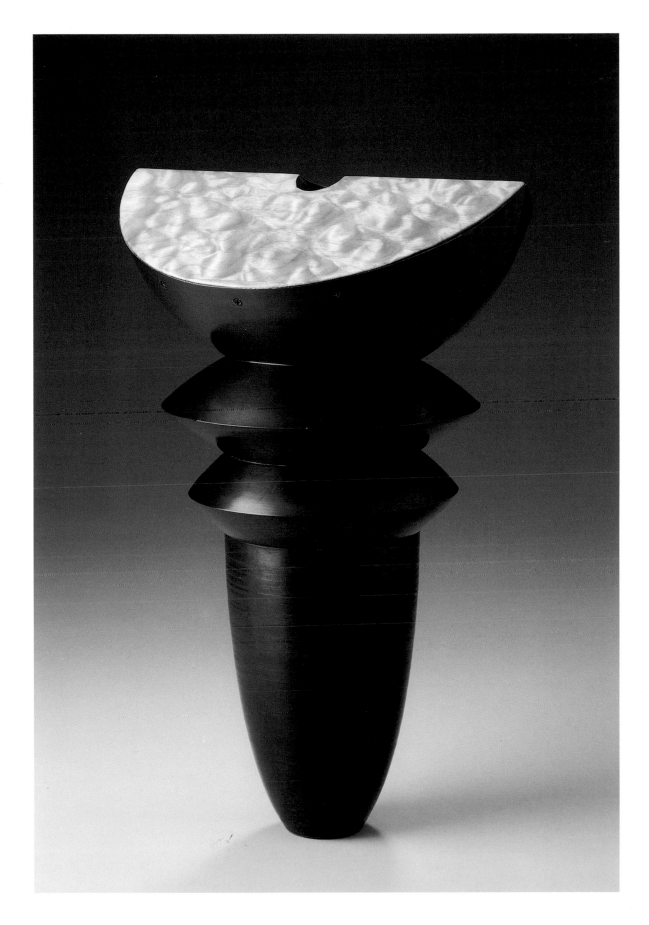

William Moore

CUMULUS, 1990

Turned western curly maple with spun copper
13⅝ × 9⅛ × 6⅞ in. (34.6 × 23.2 × 17.5 cm)

Philip Moulthrop

Born: Atlanta, November 12, 1947
Studio: Marietta, Georgia

IN AN ARTICLE in the *New York Times* entitled "Making Art, Making a Living" (December 23, 1993), Philip Moulthrop is quoted as saying, "I don't get caught up in naming what I do. I like the form of these bowls, and you don't need a two-paragraph explanation for what they are." In a subsequent two-paragraph artist's statement, Moulthrop explains his work this way: "I think of my woodturning as a way to reveal the beauty and texture that are found in the wood. The wood I use comes from trees that are native to the southeastern United States. These are not considered to be exotic woods; however, they possess a richness in the grain and figure that is too often overlooked.

"I create pieces using simple shapes and forms that will best display the colors and patterns that are inherent in the wood. My use of smooth, curving surfaces and lack of carvings or other surface embellishments are intended to better display the wood and not compete with it. The finish enables the observer to get a feel of the warmth of the wood while allowing intricacies to be imparted." In all fairness, this could not be said any better.

EDUCATION
Woodrow Wilson College of Law, Atlanta, LL.D., 1978
West Georgia College, Carrolton, B.A. in biology, 1969

PROFESSIONAL EXPERIENCE
Woodturner, 1979–present
Claims, Georgia Surety Company, Atlanta, 1973–present
Photographer, 1970–83

SELECTED EXHIBITIONS
1996 Del Mano Gallery, Los Angeles, *Turned Wood: Small Treasures*
1995 Craft & Folk Art Museum, Los Angeles, *Points of View: Collectors and Collecting*
1994 Philip and Muriel Berman Museum of Art, Collegeville, Pennsylvania, *Challenge V: International Lathe-Turned Objects*
1993 Hunter Museum of Art, Chattanooga, Tennessee, *Hand of a Craftsman, Eye of an Artist*
1992 Fine Arts Museum of the South, Mobile, Alabama, *Out of the Woods: Turned Wood by American Craftsmen*
1991 Mississippi Museum of Art, Jackson, *Spotlight '91*
1990 Huntsville Museum of Art, Huntsville, Alabama, *Contemporary Works in Wood, Southern Style*

SELECTED COLLECTIONS
High Museum of Art, Atlanta
Huntsville Museum of Art, Huntsville, Alabama
Fine Arts Museum of the South, Mobile, Alabama
Art Museum, Arizona State University, Tempe
Renwick Gallery, National Museum of American Art, Smithsonian Institution, Washington, D.C.

SELECTED BIBLIOGRAPHY
Arnold Brickman, *Turned Wood: Small Treasures* (Los Angeles: Del Mano Gallery, 1996), unpaginated.
Edward Jacobson, *The Art of Turned-Wood Bowls* (New York: E. P. Dutton, 1985), pp. 57–58.
Albert LeCoff, *Challenge V: International Lathe-Turned Objects* (Philadelphia: Wood Turning Center, 1993), p. 53.
———, *Lathe-Turned Objects: An International Exhibition* (Philadelphia: Wood Turning Center, 1988), pp. 89, 145.
Michael Monroe, *The White House Collection of American Crafts* (New York: Harry N. Abrams, 1995), pp. 106, 121–22.
Martha Stamm-Connell, *Out of the Woods: Turned Wood by American Craftsmen* (Mobile, Ala.: Fine Arts Museum of the South, 1992), pp. 56–57.

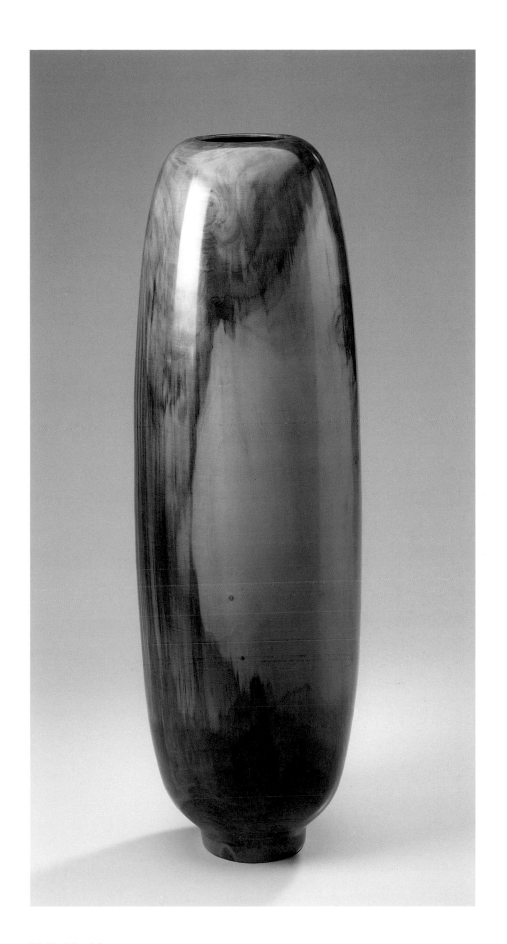

Philip Moulthrop

UNTITLED (Vessel), 1987

Turned figured tulipwood
31 × 9½ in. (78.7 × 24.1 cm)

Jim Partridge

Born: Leeds, England, June 29, 1953
Studio: Oswestry, Shropshire, England

TWO MASTERS in the field of wood set into place the direction that Jim Partridge would take as an artist, but for two entirely different reasons. John Makepeace and his school were Partridge's initial sounding board. He sought out Makepeace's school to learn furniture making as one of its first students. According to the art critic Ralph Turner, however, Partridge found himself at odds with the "privileged" working environment and "reacted against the assumption that furniture makers should pander to the luxurious aspirations of rich patrons." While studying with Makepeace, Partridge had the good fortune to meet the San Francisco Bay Area woodturner Bob Stocksdale, who had been invited by Makepeace to teach a workshop. Stocksdale's straightforward and unworried approach, as well as his gutsy relationship to the technology and material, clicked with Partridge. Asked if these experiences established the direct links to his current work, he replied: "Does the size of your feet influence the size of your shoes?"

EDUCATION

John Makepeace School of Craftsmen in Wood, Dorset, England, 1977–79

PROFESSIONAL EXPERIENCE

Independent woodworker, 1979–present

Crewe and Alsager College of Higher Education, Alsager, England, resident fellow in wood, 1983–84

SELECTED EXHIBITIONS

1996 Victoria and Albert Museum, London, *Jim Partridge*

1995 Contemporary Applied Arts, Covent Garden, London, *Greenwood*

1993 Ruthin Craft Centre, Ruthin, Clwyd, North Wales, *Jim Partridge: Woodworker*

1992 Contemporary Applied Arts, Covent Garden, London, *25th Anniversary Exhibition*

1991 Galerie Ra, Amsterdam, Netherlands, *The Banqueting Table*

1990 The Scottish Gallery, Edinburgh, *Jim Partridge: New Woodworks*

SELECTED COLLECTIONS

Museum of Fine Arts, Boston

National Museum of Modern Art, Kyoto

Contemporary Arts Society, London

Crafts Council, London

Southern Arts Association, Winchester, England

SELECTED BIBLIOGRAPHY

Albert LeCoff, *Lathe-Turned Objects: An International Exhibition* (Philadelphia: Wood Turning Center, 1988), pp. 96, 145.

Jim Partridge, *Greenwood* (London: Contemporary Applied Arts, 1995).

———, *High Weald Design Project* (Lewes, East Sussex: High Weald, 1994).

Ralph Turner, *Jim Partridge* (Ruthin, Clwyd, North Wales: Ruthin Craft Centre, 1993).

Ralph Turner et al., *Jim Partridge: Woodworker* (London: Crafts Council, 1989).

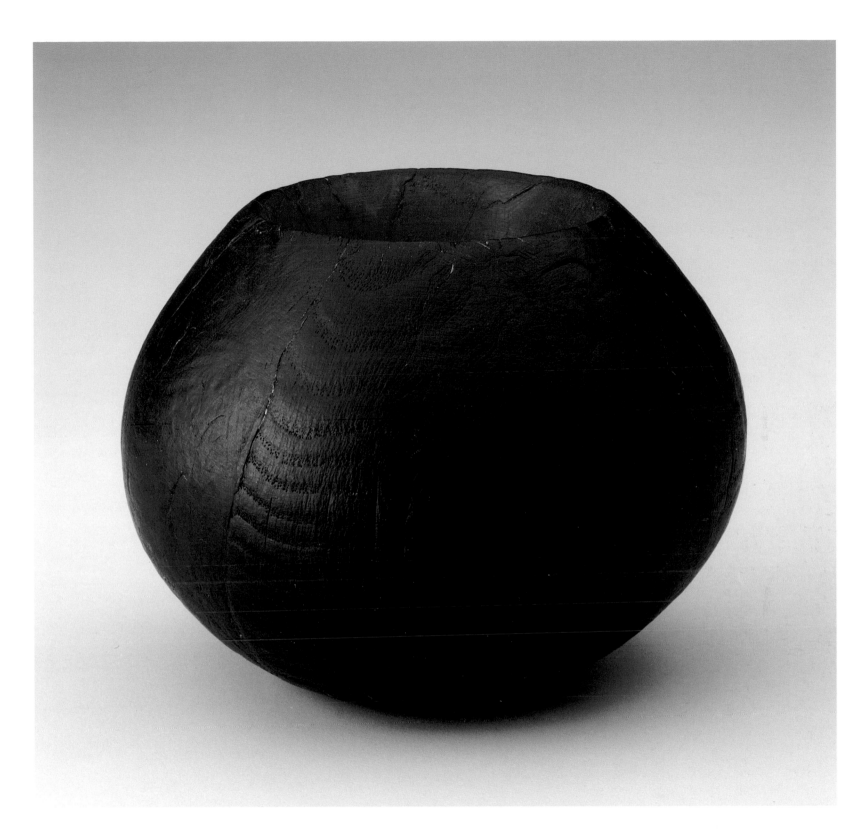

Jim Partridge
UNTITLED (Vessel), 1988

Turned, carved, and painted oak
3½ × 4⅜ × 4½ in. (8.9 × 11.1 × 11.4 cm)

Michael Peterson

Born: Wichita Falls, Texas, April 18, 1952
Studio: Lopez Island, Washington

AT AN ELEVATION of five thousand feet in a national forest in northeastern Oregon, Michael Peterson had the greatest experience of his life. He had discovered what he called a "natural sculpture garden," literally a vast environment of burled woods with distinct formations, contours, textures, and figurative elements. For five years, beginning in 1975, Peterson gathered from the land the materials for what later became an addiction to wood-turning. His original experience and a keen interest in the natural world gave Peterson the direction he needed. When he began turning in 1980, he immediately knew that vessels with an aesthetic relationship to landscape formations were his raison d'être. And they have been ever since. He also gives credit to the creative efforts of three modern sculptors: Henry Moore, Barbara Hepworth, and Jean Arp.

EDUCATION
Edmonds Community College, Edmonds, Washington, A.A., 1979

PROFESSIONAL EXPERIENCE
Independent sculptor, 1975–present
Arrowmont School of Arts and Crafts, Gatlinburg, Tennessee, workshop instructor in wood, 1991–93 and 1995

SELECTED EXHIBITIONS

1996 Del Mano Gallery, Los Angeles, *Turned Wood: Small Treasures*

1995 Carleton College, Northfield, Minnesota, *Nature Turning into Art: The Ruth and David Waterbury Collection of Turned-Wood Bowls*

1994 Art Museum, Arizona State University, Tempe, *Turning Plus: Redefining the Lathe-Turned Object III*

1993 Hunter Museum of Art, Chattanooga, Tennessee, *Hand of a Craftsman, Eye of an Artist*

1992 Fine Arts Museum of the South, Mobile, Alabama, *Out of the Woods: Turned Wood by American Craftsmen*

1991 Port of History Museum, Philadelphia, *Challenge IV: International Lathe-Turned Objects*

1990 Society for Art in Craft, Pittsburgh, *Innovations in Wood*

SELECTED COLLECTIONS
Museum of Fine Arts, Boston
Craft & Folk Art Museum, Los Angeles
Fine Arts Museum of the South, Mobile, Alabama
American Craft Museum, New York
Renwick Gallery, National Museum of American Art, Smithsonian Institution, Washington, D.C.

SELECTED BIBLIOGRAPHY
Paul Bertorelli et al., *Fine Woodworking Design Book Five* (Newtown, Conn.: Taunton Press, 1990), p. 90.

Arnold Brickman, *Turned Wood: Small Treasures* (Los Angeles: Del Mano Gallery, 1996), unpaginated.

Albert LeCoff, *Lathe-Turned Objects: An International Exhibition* (Philadelphia: Wood Turning Center, 1988), pp. 98, 146.

Richard Raffan, *Turned-Bowl Design* (Newtown, Conn.: Taunton Press, 1987), p. 120.

Eileen Silver et al., *Challenge IV: International Lathe-Turned Objects* (Philadelphia: Wood Turning Center, 1991), pp. 31, 41.

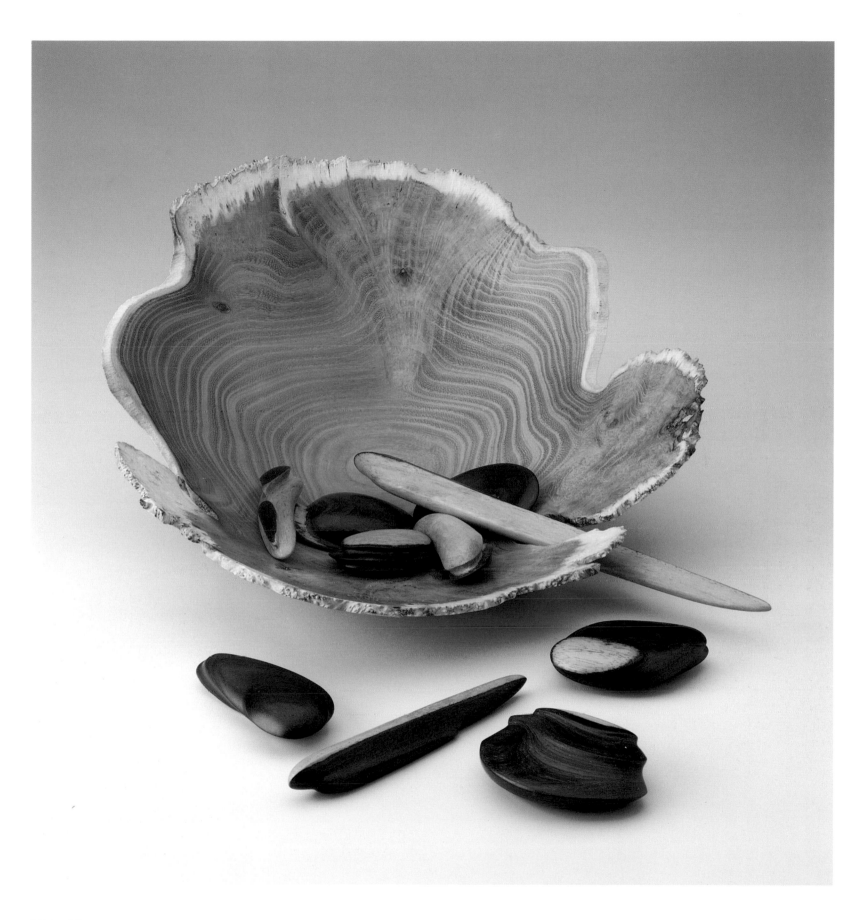

Michael Peterson

BEACHCOMBER, 1988

Coastal Basket series
Turned and carved black locust burl and rosewood
5⅞ × 13⅞ × 12¾ in. (14.9 × 35.2 × 32.4 cm)

Peter Pierobon

Born: Vancouver, British Columbia, May 7, 1957
Studio: Philadelphia

PETER PIEROBON is not part of the mainstream of contemporary woodturning. In fact, he does not have a concentrated interest in this field whatsoever. Pierobon is a maker of furniture forms. His lineage is a prestigious one, having graduated from Wendell Castle's school and subsequently worked for him. Castle has written on Pierobon's work, something he rarely does for another artist. The large turned wooden charger included in this exhibition is an odd one out for Pierobon. What it represents is his development of a particular artistic theme, one that involves a relationship between function and sculpture, tradition and contemporaneity, and the infusion of primitive visual characteristics in a highly sophisticated object. It also shows his interest in encoding his pieces with shorthand script to offer a somewhat more literal interpretation as a cultural artifact. In this particular case Pierobon has not looked to turned wood as the challenge but rather as an obvious answer.

EDUCATION

Wendell Castle School, Scottsville, New York, A.O.S. in furniture design, 1981–83
Capilano College, Vancouver, British Columbia, studies in ceramics, 1976–79

PROFESSIONAL EXPERIENCE

University of the Arts, Philadelphia, senior lecturer, 1987–present
Artist and furniture maker, 1985–present
Studio assistant, Wendell Castle Studio, Scottsville, New York, 1983–85

SELECTED EXHIBITIONS

1996 Franklin Parrasch Gallery, New York, *Peter Pierobon*
1995 The Henry M. Flagler Museum, Palm Beach, Florida, *Masters of the Art of Seating*
1994 The Canadian Craft Museum, Vancouver, British Columbia
1993 Joanne Rapp Gallery, Scottsdale, Arizona, *Peter Pierobon*
1992 Crafts Council Gallery, Dublin, Ireland, *Please Be Seated*
1991 Pennsylvania Academy of the Fine Arts, Philadelphia, *Philadelphia Furniture Makers*
1990 Society for Art in Craft, Pittsburgh, *Innovations in Wood*

SELECTED COLLECTIONS

Rose Foundation, Memphis, Tennessee
Philadelphia Museum of Art
Virginia Museum of Fine Arts, Richmond
Cinetrix Canada, Toronto, Ontario
MCI Corporation, Washington, D.C.

SELECTED BIBLIOGRAPHY

Wendell Castle, *Peter Pierobon* (New York: Franklin Parrasch Gallery, 1994).
Patricia Conway, *Art for Everyday* (New York: Clarkson Potter Publishers, 1990), p. 96.

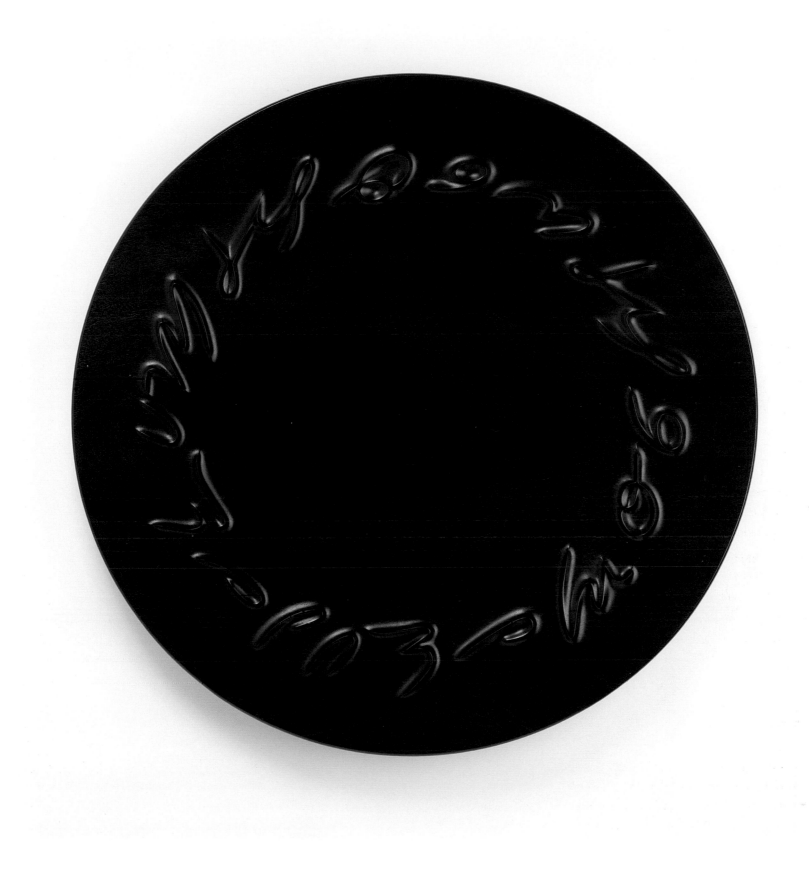

Peter Pierobon

DO YOU LOVE ME BECAUSE I AM BEAUTIFUL, OR AM I
BEAUTIFUL BECAUSE YOU LOVE ME . . . , 1993

Turned, carved, and pigmented mahogany
33⅞ in. (86 cm)

Andrew Potocnik

Born: Melbourne, Australia, February 16, 1963
Studio: Macleod West, Victoria, Australia

AS A STUDIO ARTIST who also teaches full-time, Andrew Potocnik approaches his work from the vantage point of an industrial designer. Potocnik believes in always initiating his wooden vessels as designs on paper. While he allows his finished pieces to vary from their original drawing, Potocnik will actually abandon a work in progress when it cannot be resolved in the way it was conceived. The wood must absolutely conform to the preconceived concept. Potocnik's primary conceptual concern is to question how far the definition of an object can be taken before it is no longer what it was intended to be. For example, what is a box, and to what extent can its form and function be altered while still remaining a box. To further his investigations of this and similar premises, Potocnik looks to many non-Western sources for a given theme.

EDUCATION

Melbourne College of Advanced Education, Melbourne, Australia, B.Ed. in art and craft and studies in wood with Vic Wood, 1986

PROFESSIONAL EXPERIENCE

Christian Brothers College, East St. Kilda, Australia, instructor in woodworking, 1992–present

Council of Adult Education, Melbourne, Australia, instructor in woodturning, 1991–present

Woodturner, 1986–present

SELECTED EXHIBITIONS

1996 Contemporary Art and Design Gallery, Queensland, Australia, *Wood Dreaming*

1995 Forest Hill Woodturners Association, Nunawading, Victoria, Australia, *National Woodturning*

1994 Timber Promotion Council, Melbourne, Australia, *National Woodwork*

1993 Orbost, Australia, *National Wood Design Exhibition*

1992 Shire Council of Upper Yarra, Victoria, Australia, *Go with the Grain*

SELECTED COLLECTIONS

numerous private collections

SELECTED BIBLIOGRAPHY

Scott Gibson et al., *Fine Woodworking Design Book Seven* (Newtown, Conn.: Taunton Press, forthcoming).

Terry Martin, *Wood Dreaming: The Spirit of Australia Captured in Woodturning* (Sydney, Australia: Angus & Robertson, 1996), pp. 141–44.

Vic Wood, "Views from Down Under," *Woodturning*, no. 12 (January–February 1993): 76–77.

———, "Views from Down Under: Boxing Clever," *Woodturning*, no. 34 (July–August 1995): 74–76.

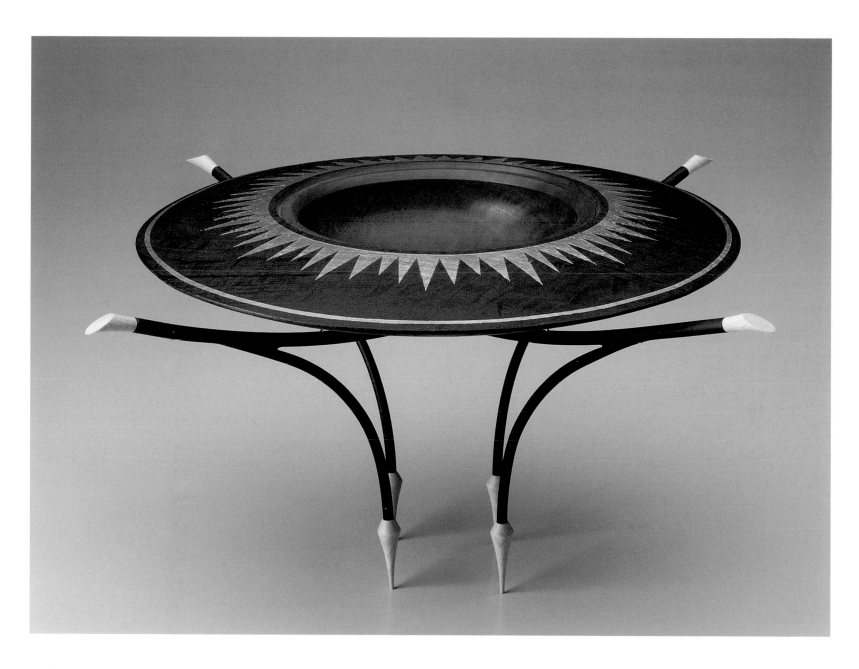

Andrew Potocnik

UNTITLED (Vessel), 1993

Turned, painted, and gilded red gum and metal
9 × 14½ in. (22.9 × 36.8 cm)

Gene Pozzesi

Born: San Francisco, January 14, 1936
Studio: Concord, California

GENE POZZESI is about as straightforward as it is possible to be when it comes to his work in wood. For thirty years, Pozzesi worked in a non-art field, raised three children, and retired. With no formal artistic training, including his special affinity for turned vessels, Pozzesi simply knows what he has to do and he does it. If there is one reason why he creates lathe-turned objects, it is to pursue beauty. Working with both native and exotic woods, preferring darker varieties such as ebony, Pozzesi challenges himself by searching out the ultimate in classic forms. To this end his pieces are historically oriented, offering a poetic interest in earlier cultures, rather than utilizing more obvious contemporary aesthetic devices.

EDUCATION
Apprenticeship with Del Stubbs, Chico, California, 1985

PROFESSIONAL EXPERIENCE
Independent woodturner, 1984–present
Pacific Bell System (subsequently AT&T), San Francisco, various positions including manager of Contra Costa County Division, 1954–84

SELECTED EXHIBITIONS
1996 Del Mano Gallery, Los Angeles, *Turned Wood: Small Treasures*
1995 Craft & Folk Art Museum, Los Angeles, *Points of View: Collectors and Collecting*
1994 Highlight Gallery, Mendocino, California, *National Lathe-Turned Objects*
1993 The Oakland Museum, Oakland, California, *Bay Area Woodturners*
1992 Society of Arts and Crafts, Boston, *Lathe-Turned Objects Defined III*
1991 Village Theater Gallery, Danville, California, *Handwork, Crafts Focus*
1990 Banaker Gallery, Walnut Creek, California, *Contemporary Wood*

SELECTED COLLECTION
Craft & Folk Art Museum, Los Angeles

SELECTED BIBLIOGRAPHY
Arnold Brickman, *Turned Wood: Small Treasures* (Los Angeles: Del Mano Gallery, 1996), unpaginated.
Kevin Wallace, *Turned Wood '92* (Los Angeles: Del Mano Gallery, 1992), unpaginated.
———, *Turned Wood '95* (Los Angeles: Del Mano Gallery, 1995), unpaginated.
———, *Turned Wood '96* (Los Angeles: Del Mano Gallery, 1996), unpaginated.

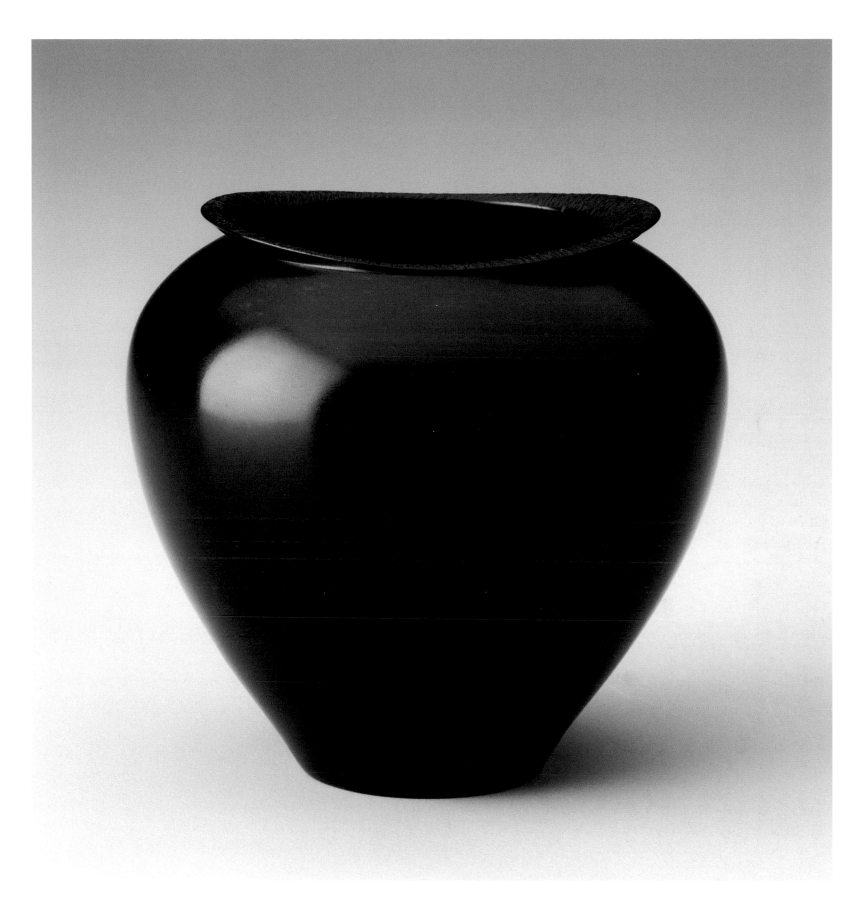

Gene Pozzesi

UNTITLED (Vessel), 1994

Turned ebony
3⅛ × 3¼ × 3⅛ in. (7.9 × 8.3 × 7.9 cm)

Hap Sakwa

Born: Los Angeles, December 6, 1950
Studio: Sebastopol, California

Photograph by Joshua Dylan Sakwa

HAP SAKWA began working with turned wood and other media, particularly clay, by the mid-1970s. His interest in "pure" unencumbered vessel forms in wood soon gave way to self-conscious sculptural explorations. Recently, however, Sakwa has stopped working with turned wood altogether and instead has begun to look at issues of recycling in mixed-media objects. After nearly twenty-five years in the field, Sakwa has described his artistic experience as parallel to his life experience, one driven by a compilation of three distinct generationally motivated social phases: 1) "granola/hand-built house/Whole Earth catalogue days"; 2) "post-modern/neo-geo/new world order/global village days"; and 3) "anti-art/new federalist/maniac militia days." From an artist's point of view, he feels like "a rafter on the American River after a major storm."

EDUCATION

Sonoma State College, Sonoma, California, studies in communications, 1996–present
Santa Rosa Junior College, Santa Rosa, California, studies in pre-law, 1994–95
University of Maryland, College Park, studies in anthropology, 1968–70

PROFESSIONAL EXPERIENCE

Independent commercial photographer, 1995–present
Independent artist, 1970–present

SELECTED EXHIBITIONS

1996 Ferrin Gallery, Northampton, Massachusetts, *Celestial Seasonings: A Loose Interpretation*
1993 Craftsman Gallery, Scarsdale, New York
1992 American Craft Museum, New York, *A Decade of Craft*
1991 California Museum of Art, Santa Rosa, California
1990 Society for Art in Craft, Pittsburgh, *Innovations in Wood*

SELECTED COLLECTIONS

Byer Museum of Art, Evanston, Illinois
Museum of Arts and Sciences, Macon, Georgia
American Craft Museum, New York
The Museum of Modern Art, New York
Oakland Museum of California
The Society for Contemporary Craft, Pittsburgh

SELECTED BIBLIOGRAPHY

Edward Jacobson, *The Art of Turned-Wood Bowls* (New York: E. P. Dutton, 1985), pp. 67–69.
Albert LeCoff, *A Gallery of Turned Objects* (Provo, Utah: Brigham Young University Press, 1981), p. 64
————, *Lathe-Turned Objects: An International Exhibition* (Philadelphia: Wood Turning Center, 1988), pp. 106–7, 146.
Dona Meilach, *Woodworking: The New Wave* (New York: Crown Publishers, 1981), p. 10.
Katherine Pearson, *American Crafts: A Source Book for the Home* (New York: Stewart, Tabori & Chang, Publishers, 1983), p. 187.

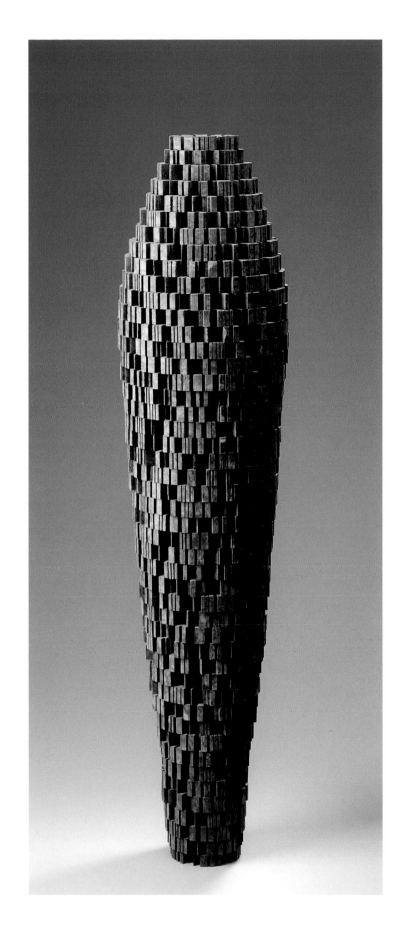

Hap Sakwa

UNTITLED (Sculpture), 1986

Constructed poplar with acrylic lacquer
35¾ × 8⅜ in. (90.8 × 21.3 cm)

Norm Sartorius

Born: Salisbury, Maryland, February 14, 1947
Studio: Parkersburg, West Virginia

SINCE 1974 Norm Sartorius has made wooden forms based on spoons and traditional hand-held pouring devices. "While I follow the work of other American spoonmakers, I am also interested in spoons made in other cultures for both ritual and utilitarian uses." For the first fifteen years, Sartorius carved and shaped his wooden vessels. Only since 1989 has he used a lathe to make component pieces, with a particular emphasis on handles. Often called "ceremonial vessels" because of their distinctively exotic appearance, Sartorius's highly refined objects fall somewhere between what he calls "little sculptures and representatives of a very ordinary and quintessentially human object."

EDUCATION

Apprenticeship with Bobby Reed Falwell, Murray, Kentucky, 1980–81
Apprenticeship with Phil and Sandye Jurus, Baltimore, 1973–74
Western Maryland College, Westminister, B.A. in psychology, 1969

PROFESSIONAL EXPERIENCE

Independent woodworker and spoonmaker, 1974–present
State Mental Hospital of Maryland, social worker, 1969–74

SELECTED EXHIBITIONS

1995 Delaware Center for the Contemporary Arts, Wilmington, *Return to Beauty*

1994 Philip and Muriel Berman Museum of Art, Collegeville, Pennsylvania, *Challenge V: International Lathe-Turned Objects*

1993 Huntington Museum of Art, Huntington, West Virginia, *Honed from the Heart: West Virginia Craft*

1992 Art Museum, Arizona State University, Tempe, *Turning Plus: Redefining the Lathe-Turned Object*

1991 Philadelphia Museum of Art, *Philadelphia Craft Show*

1990 Ohio Designer Craftsman, Columbus, *Winterfair*

SELECTED COLLECTIONS

West Virginia Department of Culture and History, Charleston

Renwick Gallery, National Museum of American Art, Smithsonian Institution, Washington, D.C.

SELECTED BIBLIOGRAPHY

Paul Bertorelli et al., *Fine Woodworking Design Book Five* (Newtown, Conn.: Taunton Press, 1990), p. 140.

John Kelsey et al., *Fine Woodworking Biennial Design Book Two* (Newtown, Conn.: Taunton Press, 1979), p. 156.

———, *Fine Woodworking Design Book Three* (Newtown, Conn.: Taunton Press, 1983), p. 124.

Albert LeCoff, *Challenge V: International Lathe-Turned Objects* (Philadelphia: Wood Turning Center, 1993), pp. 58–60.

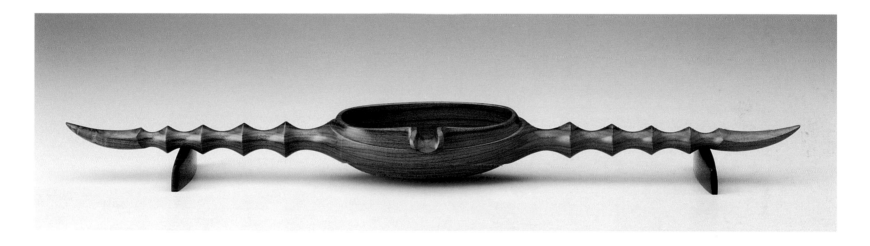

Norm Sartorius

SPOON FROM A FORGOTTEN CEREMONY, 1994

Turned and carved pau ferro and ebony
2 × 19½ × 3⅞ in. (5.1 × 49.5 × 9.8 cm)

Mike Scott, also known as "Chai"

Born: Oxford, England, December 14, 1943
Studio: Anglesey, Gwynedd, North Wales

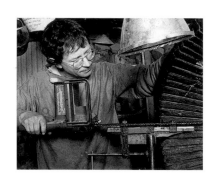

MIKE SCOTT is highly respected in the woodturning field as one of the pioneers of freestyle turning, an approach that focuses on defects in the wood, such as rotten areas, splits, and bark inclusions. Scott's freestyle turning reveals his simultaneous interest in creating aggressive surface texturing through the use of wire brushing, sandblasting, and scorching. He also uses an electric chainsaw to cut into his pieces while they are still on the lathe. Many examples from his series of amphitheater vessels are made in this fashion. During the early 1980s, while studying Eastern religious thought, Scott adopted the abbreviated name "Chai" from the word *Chaitanya,* a Sanskrit word meaning "awareness." The name has since become his artistic persona.

EDUCATION

Crewe and Alsager College of Higher Education, Alsager, England, studies in studio arts, 1982–83

Independent studies in Eastern religious thought, with a particular focus on writings in Sanskrit, 1980–82

PROFESSIONAL EXPERIENCE

Independent maker of wooden vessels, 1984–present

Accountant, Sydney, Australia, 1960–80

SELECTED EXHIBITONS

1996 Rye Art Gallery, Rye, England, *In the Woods*

1995 Bonhams, London, *Decorative Arts Today*

1994 Andrew Usiskin Contemporary Art, London

1993 Galerie für Angewandte Kunst des Bayerischen Kunstgewerbe-Vereins, Munich, *Holzschalen* (The Art of Wooden Bowls)

1992 Model House Craft and Design Centre, Llantrisant, Wales

1991 Olympia, London, *Art '91*

1990 Craft Alliance Gallery, St. Louis

SELECTED COLLECTIONS

West Midlands Arts, Birmingham, England

Halifax Contemporary Arts Collection, Halifax

Contemporary Arts Society, London

Portsmouth City Museum and Art Gallery, Portsmouth, England

SELECTED BIBLIOGRAPHY

Merryll Saylan, "BlackArt," *Woodturning,* no. 21 (July–August 1994): 36–39.

Mike Scott, "Mike Chai Scott, Woodturner," *Practical Woodworking* (October 1989): 40–43.

Reg Sherwin, "A Meeting of Minds," *Woodturning,* no. 10 (September–October 1992): 44–46.

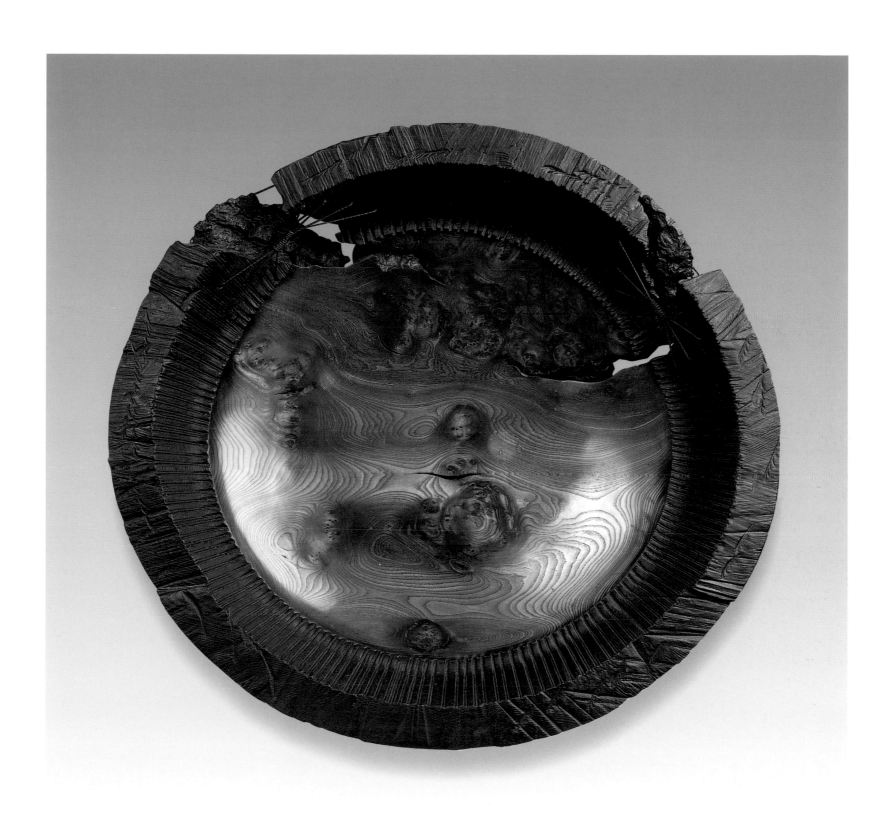

Mike Scott

CHAI, 1990

Turned and carved elm burl and leather
34¼ × 37⅛ × 8 in. (88.3 × 94.3 × 20.3 cm)

Lincoln Seitzman

Born: New York City, August 6, 1923
Studio: West Long Branch, New Jersey

AT AGE FIFTY-EIGHT Lincoln Seitzman began to work with wood, initially producing furniture on a trial-and-error basis, with a passion for manipulating the material. In 1986 Seitzman steered his interest to woodturning. He was motivated to create wooden vessels after seeing Native American coiled basketry at the Heard Museum in Phoenix. By 1991 Seitzman had gained national recognition through museum shows of his work and his fifteen series of lathe-turned vessels based on "basket illusions." Whether the pieces appear to be coiled, stitched, or woven, each series has been directly linked to various Native American cultures and their basket-making traditions. The individual vessels are so complex in their construction that Seitzman finds it necessary to begin with planning sketches followed by detailed engineering drawings. To see his work on the Internet, go to http://www.ftgl.com/iar/10.html.

EDUCATION

Rensselaer Polytechnic Institute, Troy, New York, B.S. in mechanical engineering, 1943

PROFESSIONAL EXPERIENCE

Independent woodworker, 1981–present

Robert Lewis Sportswear, West Long Branch, New Jersey, various positions including vice president of design and production, 1946–81

SELECTED EXHIBITIONS

1996 Del Mano Gallery, Los Angeles, *Artists of the White House Collection*

1995 Art Museum, Arizona State University, Tempe, *Turning Plus: Redefining the Lathe-Turned Object IV*

1994 Philip and Muriel Berman Museum of Art, Collegeville, Pennsylvania, *Challenge V: International Lathe-Turned Objects*

1993 Mendelson Gallery, Washington Depot, Connecticut, *Segmented Turnings*

1992 James A. Michener Art Museum, Doylestown, Pennsylvania, *Revolving Techniques: Clay, Glass, Metal, Wood*

1991 Port of History Museum, Philadelphia, *Challenge IV: International Lathe-Turned Objects*

1990 Society of Arts and Crafts, Boston, *Lathe-Turned Objects Defined*

SELECTED COLLECTIONS

High Museum of Art, Atlanta

Arrowmont School of Arts and Crafts, Gatlinburg, Tennessee

The White House Collection of American Crafts, Washington, D.C.

SELECTED BIBLIOGRAPHY

Arnold Brickman, *Turned Wood: Small Treasures* (Los Angeles: Del Mano Gallery, 1996), unpaginated.

Albert LeCoff, *Challenge V: International Lathe-Turned Objects* (Philadelphia: Wood Turning Center, 1993), p. 63.

———, *Lathe-Turned Objects: An International Exhibition* (Philadelphia: Wood Turning Center, 1988), pp. 110, 147.

Albert LeCoff et al., *Revolving Techniques: Clay, Glass, Metal, Wood* (Doylestown, Pa.: James A. Michener Art Museum, 1992), p. 20.

Michael Monroe, *The White House Collection of American Crafts* (New York: Harry N. Abrams, 1995), pp. 109, 123.

Lincoln Seitzman

APACHE OLLA BASKET ILLUSION, 1994

Turned, painted, then inked guatambú
21⅛ × 14⅜ in. (53.7 × 6.5 cm)

Michael Shuler

Born: Trenton, New Jersey, March 2, 1950
Studio: Santa Cruz, California

MICHAEL SHULER, at the young age of forty-six, has already spent thirty-one of his years involved in woodturning. A child woodturning prodigy? Perhaps. At fifteen, he constructed a lathe for the purpose of replicating rounded chair legs. He credits furniture forms for attracting him to wood. Since then Shuler has been doing it his own way and is self-taught. His interest in vessel making has undergone several formal transitions over two decades. His current focus on segmentation has resulted in very complex, highly refined, and exquisitely delicate forms. These vessels are classic in their profile, almost ceramic-like in their visual dynamics. But it is the exoticism of the internally combined, segmented wood patterns, which for the most part are geometric, that captivates one's attention. Shuler makes it obvious that he has attained significant technical prowess in his pieces, something that should put us on the edge of our aesthetic seats.

EDUCATION
Life experience

PROFESSIONAL EXPERIENCE
Independent woodturner, 1985–present

SELECTED EXHIBITIONS
1996 San Francisco Craft & Folk Art Museum, *Craft at Gump's: The Helen Heninger Years*
1995 Wharton Esherick Museum, Paoli, Pennsylvania, *Soup to Nuts*
1994 Philip and Muriel Berman Museum of Art, Collegeville, Pennsylvania, *Challenge V: International Lathe-Turned Objects*
1993 Hunter Museum of Art, Chattanooga, Tennessee, *Hand of a Craftsman, Eye of an Artist*
1992 Fine Arts Museum of the South, Mobile, Alabama, *Out of the Woods: Turned Wood by American Craftsmen*
1991 Elements Gallery, Greenwich, Connecticut, *Wood*
1990 Society of Arts and Crafts, Boston, *Lathe-Turned Objects Defined*

SELECTED COLLECTIONS
Museum of Fine Arts, Boston
Fine Arts Museum of the South, Mobile, Alabama
American Craft Museum, New York
Wood Turning Center, Philadelphia
The White House Collection of American Crafts, Washington, D.C.

SELECTED BIBLIOGRAPHY
Edward Jacobson, *Nature Turning into Art: The Ruth and David Waterbury Collection of Turned-Wood Bowls* (Northfield, Minn.: Carleton College, 1995), unpaginated.
Albert LeCoff, *Challenge V: International Lathe-Turned Objects* (Philadelphia: Wood Turning Center, 1993), p. 64.
————, *Lathe-Turned Objects: An International Exhibition* (Philadelphia: Wood Turning Center, 1988), pp. 116–17, 147.
Heather Sealy Lineberry, *Turning Plus: Redefining the Lathe-Turned Object III* (Tempe: Art Museum, Arizona State University, 1994), unpaginated.
Michael Monroe, *The White House Collection of American Crafts* (New York: Harry N. Abrams, 1995), pp. 104, 115, 124.
Martha Stamm-Connell, *Out of the Woods: Turned Wood by American Craftsmen* (Mobile, Ala.: Fine Arts Museum of the South, 1992), pp. 68–69.

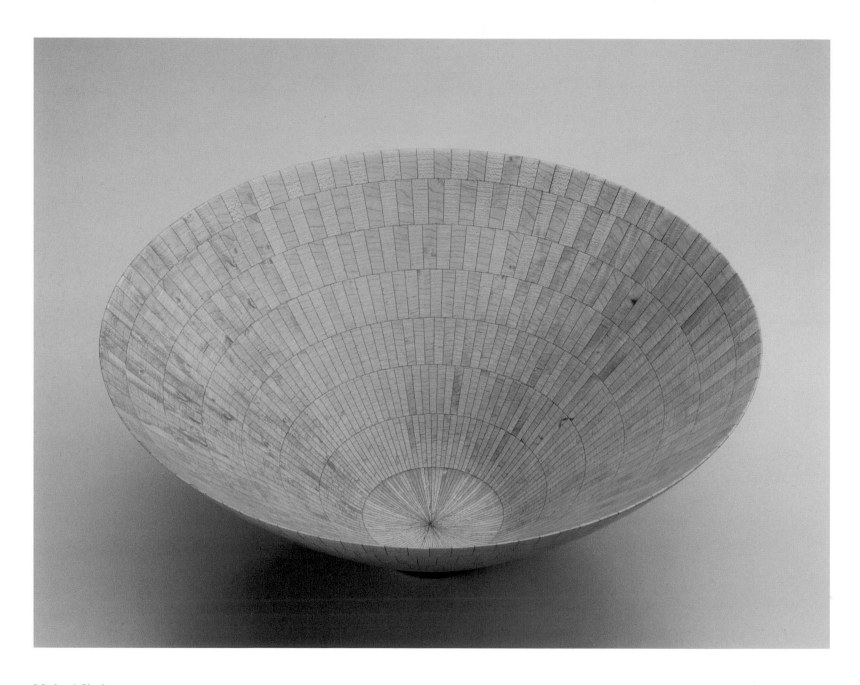

Michael Shuler

SEGMENTED, 1987

Laminated and turned bird's-eye maple
5⅛ × 11⅞ in. (13 × 30.2 cm)

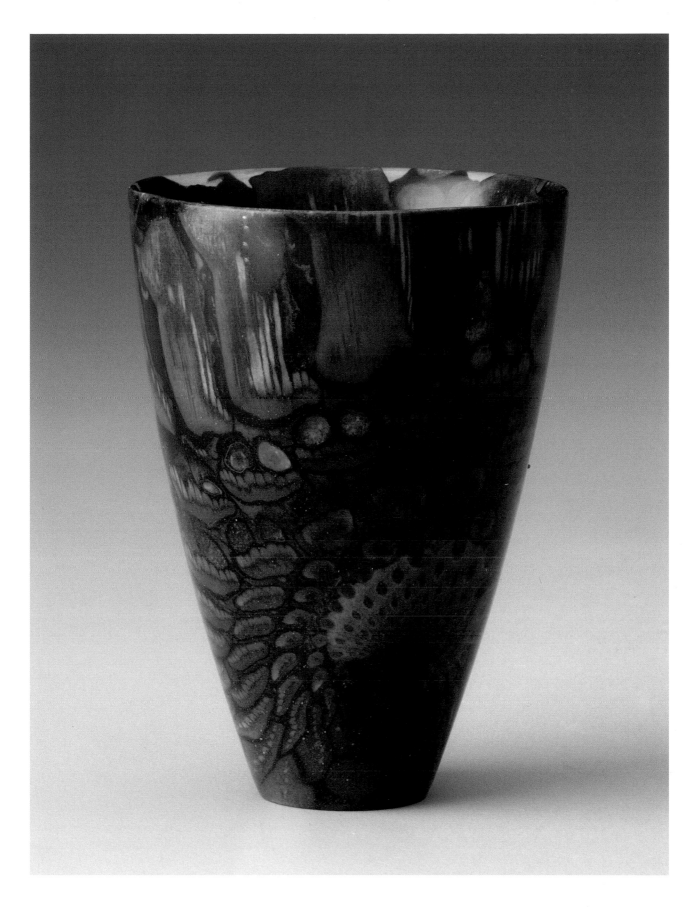

Michael Shuler

UNTITLED (Vessel), 1989

Turned pinecone
3 × 2⅛ × 2⅛ in. (7.6 × 5.4 × 5.4 cm)

Bob Stocksdale

Born: Warren, Indiana, May 25, 1913
Studio: Berkeley, California

MUCH HAS BEEN published about Bob Stocksdale. Unquestionably a legend in the field of woodturning, he can lay claim to more than half a century as an active artist and is still at it every day. Stocksdale, like his peers Sam Maloof and Wharton Esherick, is rare in that, despite his work solely in wood, he is held in high esteem by artists working in all media. His success goes back to the 1950s with shows like *Craftsmen in a Changing World* at the Museum of Contemporary Craft in New York and the Brussels World's Fair, yet at age eighty-three Stocksdale keeps his focus on wood. In fact, he will admit to only one greater love, his wife, Kay Sekimachi.

EDUCATION
Life experience

PROFESSIONAL EXPERIENCE
Independent wood-lathe artist, 1946–present
Independent farmer, Warren, Indiana, 1931–42

SELECTED EXHIBITONS
1996 Del Mano Gallery, Los Angeles, *Turned Wood: Small Treasures*
1993–95 Palo Alto Cultural Center, Palo Alto, California; The Arkansas Arts Center Decorative Arts Museum, Little Rock; and Renwick Gallery, National Museum of American Art, Smithsonian Institution, Washington, D.C., *Marriage in Form: Kay Sekimachi and Bob Stocksdale*
1993 The Oakland Museum, Oakland, California, *Bob Stocksdale*
1992 The Newark Museum, Newark, New Jersey, *Bob Stocksdale*
1991 Purdue University, Lafayette, Indiana, *Forms of Grace: Kay Sekimachi and Bob Stocksdale*

SELECTED COLLECTIONS
The Detroit Institute of Arts
Royal Scottish Museum, Edinburgh
The Metropolitan Museum of Art, New York
Oakland Museum of California
Philadelphia Museum of Art

SELECTED BIBLIOGRAPHY

Arnold Brickman, *Turned Wood: Small Treasures* (Los Angeles: Del Mano Gallery, 1996), unpaginated.

Edward Jacobson, *The Art of Turned-Wood Bowls* (New York: E. P. Dutton, 1985), pp. 74–79.

Albert LeCoff, *Lathe-Turned Objects: An International Exhibition* (Philadelphia: Wood Turning Center, 1988), pp. 120–21, 147.

Signe Mayfield, *Marriage in Form: Kay Sekimachi and Bob Stocksdale* (Palo Alto, Calif.: Palo Alto Cultural Center, 1993).

Michael A. Stone, *Contemporary American Woodworkers* (Salt Lake City: Gibbs M. Smith, 1986), pp. 34–47, 162.

Christopher Wilk, *The Art of Wood Turning* (New York: American Craft Museum, 1983), pp. 34, 47.

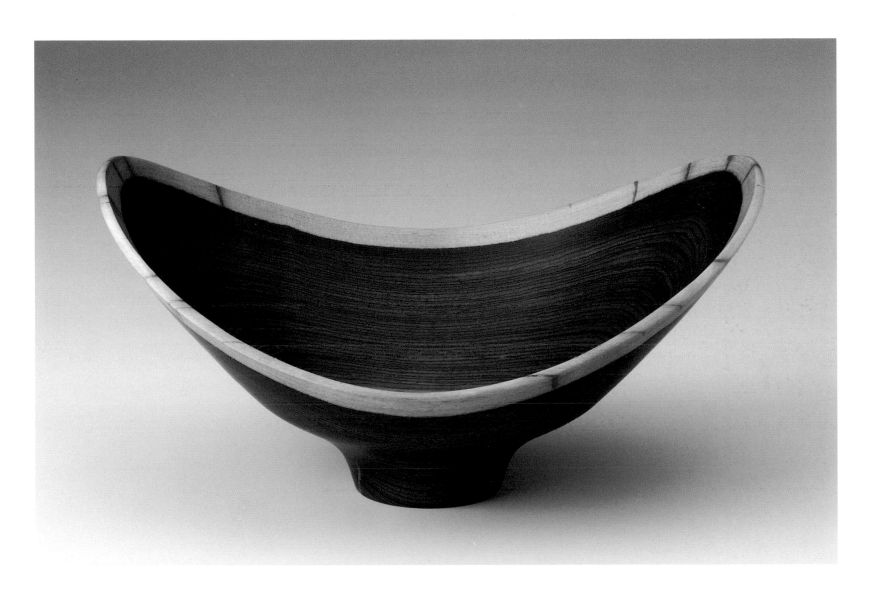

Bob Stocksdale
UNTITLED (Vessel), 1987

Turned Brazilian kingwood
3⅜ × 7 × 5 in. (8.6 × 17.8 × 12.7 cm)

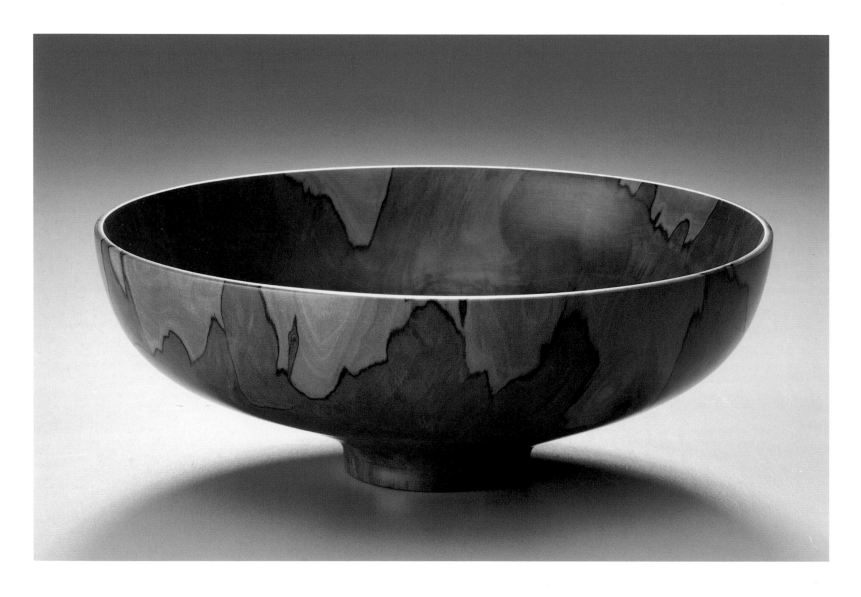

Bob Stocksdale

UNTITLED (Vessel), 1993

Turned flowering pear
2⅛ × 6 in. (5.4 × 15.2 cm)

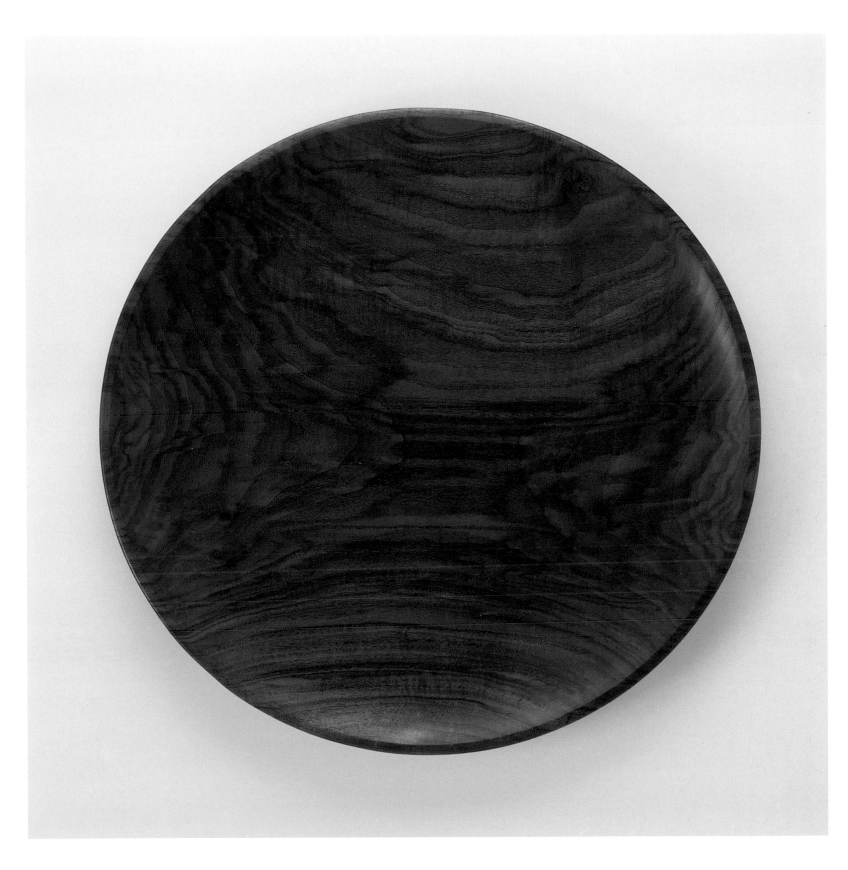

Bob Stocksdale
UNTITLED (Wall Piece), 1995

Turned American black walnut
29⅛ × 28⅞ in. (74 × 73.3 cm)

Ben Trupperbäumer

Born: Bielefeld, Germany, March 31, 1948
Studio: Mission Beach, North Queensland, Australia

BEN TRUPPERBÄUMER received his formal training in sculpture as an undergraduate while living in Germany. He studied with the master Hans Grohe. A full decade would go by, however, before Trupperbäumer took up residence and established a studio in North Queensland, Australia. Then he simultaneously traveled and worked, pursuits he followed at a rigorous pace throughout Europe as well as West Africa and Nepal. For the past fifteen years he has worked primarily as an independent sculptor in wood, although he has kept his hand in teaching and creating both large-scale commissions and small objects for gallery representation. Throughout the 1980s and 1990s Trupperbäumer has maintained an extensive exhibition schedule, although the current project is his first show in the United States.

EDUCATION

Art Academy and College of Education, Bielefeld, Germany, B.A. in studio arts and physical education, 1970

PROFESSIONAL EXPERIENCE

College of TAFE, Townsville, Australia, instructor in sculpture, 1986–present

Sculptor in wood and bronze, 1980–present

Queensland Government Grant Assessment Panel, Queensland, Australia, reviewer, 1991–93

Centre for Tradition, Culture and National Heritage, Cameroon, West Africa, project advisor, 1971–72

Tribhuvan University, Kathmandu, Nepal, lecturer, 1973–75

Teacher Training Institute, Dhankuta, Nepal, lecturer, 1973–75

SELECTED EXHIBITIONS

1996 Perc Tucker Regional Gallery, Townsville, Australia

1994 Mowbray Gallery, Port Douglas, Australia, *Ben Trupperbäumer*

1993 Flinders Gallery, Townsville, Australia, *Ben Trupperbäumer, Sculpture*

1992 Hilton International, Adelaide, Australia, *Trupperbäumer Commissions*

1991 Holdsworth Galleries, Sydney, Australia, *Ben Trupperbäumer: New Works*

1990 Cintra Gallery, Brisbane, Australia, *Sculpture by Ben Trupperbäumer*

SELECTED COLLECTIONS

Brisbane International Airport, Australia

National Gallery of Australia, Canberra

Parliament House Art Collection, Canberra, Australia

Stanthorpe Regional Gallery, Stanthorpe, Australia

James Cook University, Townsville, Australia

SELECTED BIBLIOGRAPHY

J. Shaw, "Variations on Themes from Nature," *Craft Arts International*, no. 23 (1992): 53–56.

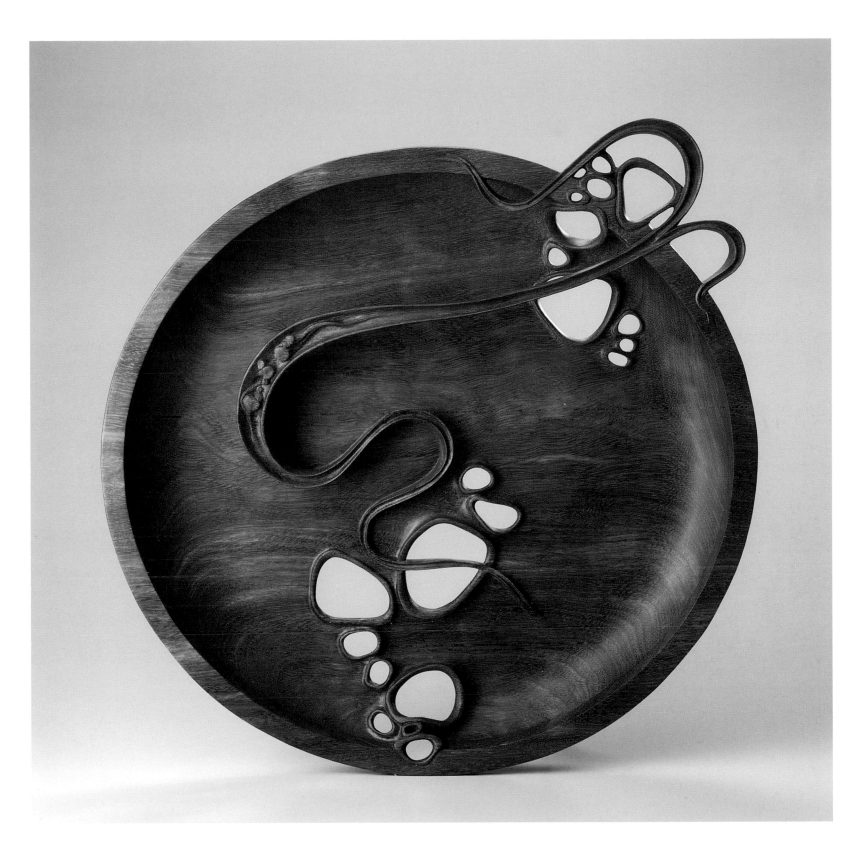

Ben Trupperbäumer

CARVED PLATTER, 1992

Turned and carved albizia tonna
18 × 18¾ × 2⅛ in. (45.7 × 47.6 × 5.4 cm)

Howard Werner

Born: Deal, New Jersey, July 27, 1951
Studios: Mt. Tremper, New York, and Phoenix, Arizona

"THE RAW MATERIAL has a lot of power in and of itself, and I'm more at ease with nature taking some of the credit, while I come up with a design that enhances it." To do this Howard Werner begins with a whole log or tree segment and then, through subtractive woodworking, carves away the excess to reveal a large-scale, often minimalist sculpture or furniture form. Regardless of whether he has intended for a piece to be a chair, table, bench, or other utilitarian object, Werner is interested in using the idea of function as only a minor point of reference. Although solidly trained within the parameters of the studio crafts movement at the School for American Craftsmen, where such notables as Wendell Castle and Albert Paley were teaching, Werner did not follow any of the prevailing attitudes for investigating what he viewed as the "excesses of embellishment in contemporary furniture." Instead, he found himself motivated by a chainsaw and the modernist precepts of artists like Isamu Noguchi and Constantin Brancusi.

EDUCATION

Rochester Institute of Technology, School for American Craftsmen, Rochester, New York, B.F.A. in woodworking and furniture design, 1977

George Washington University, Washington, D.C., studies in pre-med, 1970–71

The Corcoran Gallery of Art, Washington, D.C., studies in painting and furniture making, 1970–71

PROFESSIONAL EXPERIENCE

Independent sculptor, 1977–present

SELECTED EXHIBITIONS

1996 Snyderman Gallery, Philadelphia, *Howard Werner*

1995 The Arkansas Arts Center Decorative Arts Museum, Little Rock, *National Objects Invitational*

1994 The Hand and the Spirit Gallery, Scottsdale, Arizona, *Howard Werner*

1993 The Sybaris Gallery, Royal Oak, Michigan, *Howard Werner*

1992 Crafts Council Gallery, Dublin, Ireland, *Please Be Seated*

1991 O. K. Harris Works of Art, New York, *New Artists*

1990 Mendelson Gallery, Washington Depot, Connecticut, *Five Rising Stars*

SELECTED COLLECTIONS

Dow Foundation, Midland, Michigan

American Craft Museum, New York

Rochester Institute of Technology, Rochester, New York

Art Museum, Arizona State University, Tempe

SELECTED BIBLIOGRAPHY

Paul Bertorelli et al., *Fine Woodworking Design Book Four* (Newtown, Conn.: Taunton Press, 1987), p. 103.

Peter Dormer, *The New Furniture: Trends + Traditions* (London: Thames and Hudson, 1987), p. 190.

John Kelsey et al., *Fine Woodworking Design Book Three* (Newtown, Conn.: Taunton Press, 1983), p. 179.

————, *Fine Woodworking Design Book Two* (Newtown, Conn.: Taunton Press, 1979), pp. 63, 116.

Dona Meilach, *Woodworking: The New Wave* (New York: Crown Publishers, 1981), pp. 9, 56, 57, 100.

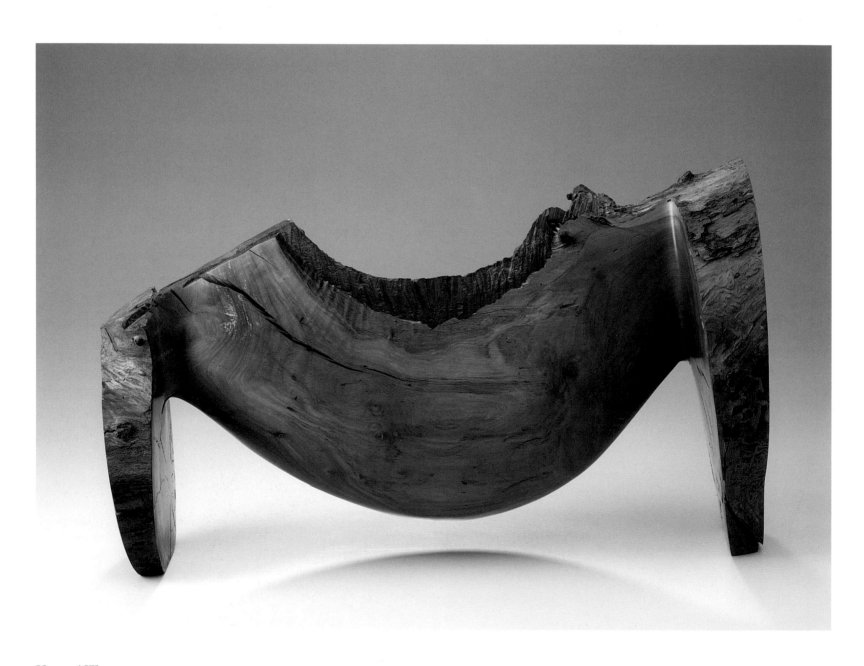

Howard Werner

UNTITLED (Vessel), ca. 1993

Turned and carved apple
12⅞ × 21⅞ × 8⅝ in. (32.7 × 55.6 × 21.9 cm)

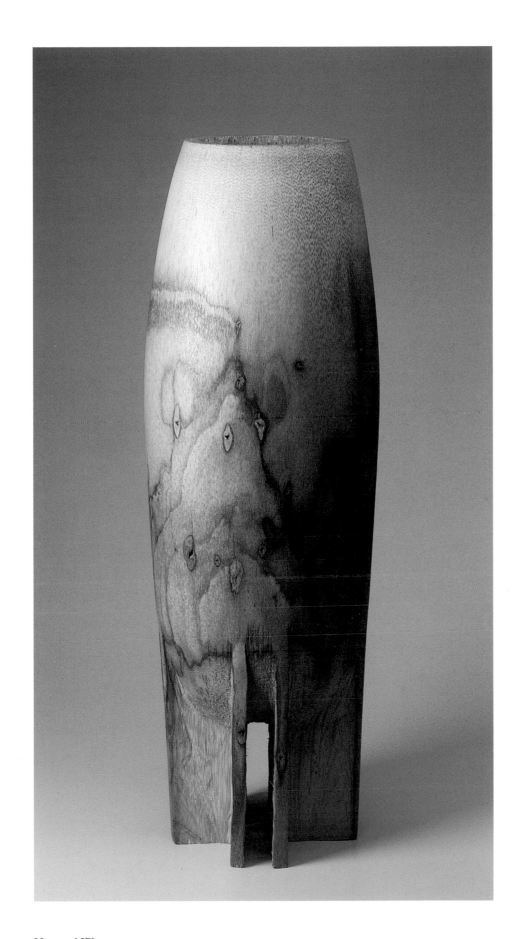

Howard Werner

UNTITLED (Vessel), 1994

Turned and carved palm
42¼ × 13⅞ × 13⅞ in. (107.3 × 35.2 × 35.2 cm)

Victor George Wood, also known as "Vic"

Born: Melbourne, Australia, January 21, 1939
Studio: Burwood, Victoria, Australia

AS FELLOW AUSTRALIAN woodturner Richard Raffan has pointed out, Vic Wood "is in charge of his chosen medium as he continues to explore the relationship between squared forms and the symmetry of turnery imposed thereon." Wood's constant challenge to relate the circle to the square has taken his wooden vessels through many transitions, from large-scale wall pieces to small lidded boxes to monumental free-standing vessel forms. Although he decided in 1982 to give all his attention to woodturning, Wood is also a teacher. Even though he stopped teaching full-time after twenty-two years, he has continued to offer intensive workshops at his studio. Like several of his Australian peers, Wood maintains an extensive lecture and workshop schedule that takes him throughout Australia, England, New Zealand, and the United States.

EDUCATION

Royal Melbourne Institute of Technology, Melbourne, Australia, Fellowship Diploma of Art/Cabinetmaking Theory and Practice Grade 4/Woodturning Grades 1 and 2, 1974

Royal Melbourne Institute of Technology, Melbourne, Australia, Associate Diploma of Art, 1966

Royal Melbourne Institute of Technology (with concurrent studies at Melbourne Teachers' College, Caulfield Technical School, and Collingwood Technical School), Melbourne, Australia, Secondary Teacher's Certificate in Art and Craft, 1959

PROFESSIONAL EXPERIENCE

Independent woodturner, 1983–present

Melbourne State College, Melbourne, Australia, lecturer in woodworking, 1970–82

Huntingdale High School, Melbourne, Australia, instructor in art and craft, 1965–69

Coburg High School, Melbourne, Australia, instructor in art and craft, 1960–64

SELECTED EXHIBITIONS

1995 Atelier Gallery, Victoria, Australia, *Wood Objects*

1994 QDOS for Contemporary Crafts, Lorne, Victoria, Australia, *Wood over 5,000 Years Old*

1992 Meat Market Craft Centre, North Melbourne, Australia, *Bowls*

1991 Eltham Gallery, Victoria, Australia, *Work in Wood*

1990 Victorian Woodworker's Association, Melbourne, Australia, *Circles, Squares, Rectangles*

SELECTED COLLECTIONS

Melbourne State College, Melbourne, Australia

Housing Industry Association of Victoria, Australia

Latrobe Art Centre, Victoria, Australia

National Gallery of Victoria, Australia

Wesley College, Victoria, Australia

SELECTED BIBLIOGRAPHY

John Kelsey et al., *Fine Woodworking Design Book Two* (Newtown, Conn.: Taunton Press, 1979), p. 261.

Albert LeCoff, *Lathe-Turned Objects: An International Exhibition* (Philadelphia: Wood Turning Center, 1988), pp. 134–35, 148.

Terry Martin, *Wood Dreaming: The Spirit of Australia Captured in Woodturning* (Sydney, Australia: Angus & Robertson, 1996), pp. 65, 67–68, 141, 151, 158, 168.

Richard Raffan, *Turned-Bowl Design* (Newtown, Conn.: Taunton Press, 1987), p. 161.

Kevin Wallace, *Turned Wood '88* (Los Angeles: Del Mano Gallery, 1988), unpaginated.

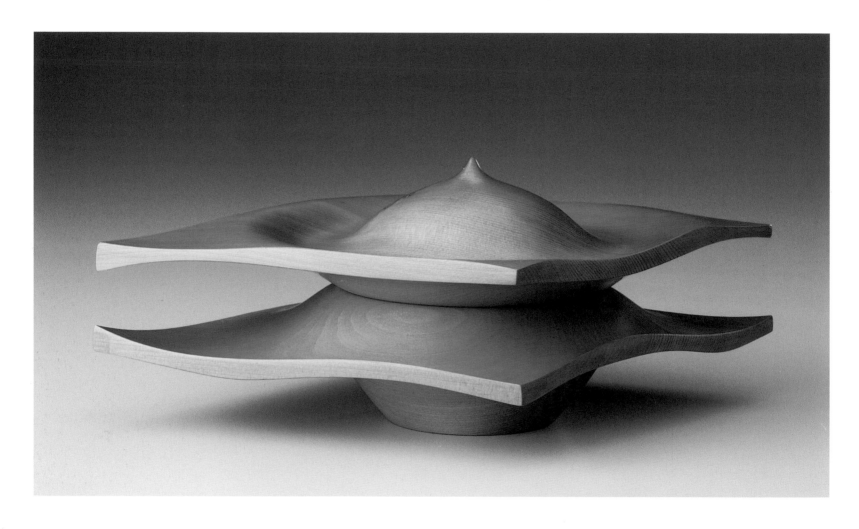

Vic Wood

UNTITLED (Lidded Box), 1987

Turned Huon pine

$2\frac{7}{8} \times 7\frac{1}{2} \times 6$ in. (7.3 × 19.1 × 15.2 cm)

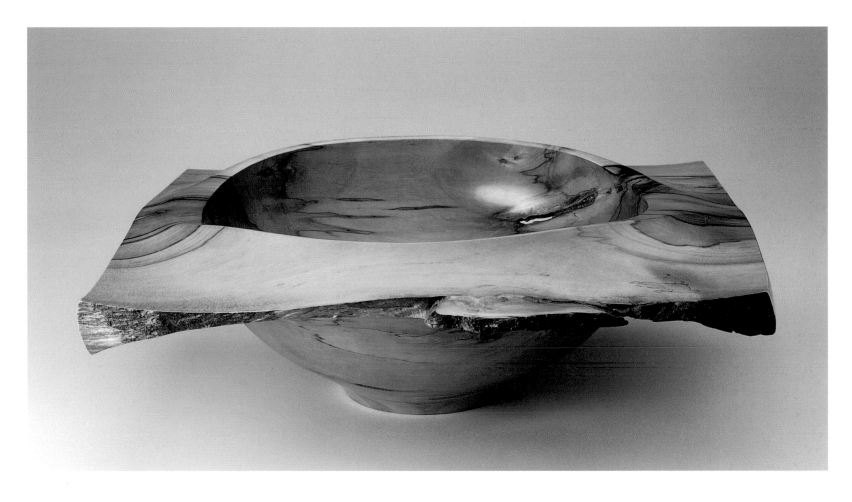

Vic Wood

THE WAVE, ca. 1987

Turned sassafras
8 × 22½ × 20¾ in. (20.3 × 57.2 × 52.7 cm)

Ronald C. Wornick

Born: Malden, Massachusetts, May 21, 1932
Studio: Burlingame, California

FOR A DECADE NOW Ron Wornick has intensively studied what contemporary wood artists have accomplished. His research will continue for many more years. In the exhibition that coincides with this publication, Wornick's astute insight intertwines with artists' aesthetic expressions as a concerted effort to establish a broad-based awareness of the field. Ultimately, this collaboration is intended to give rise to future scholarship.

Wornick is an artist himself and has explored the making of furniture forms as well as turned-wood vessels. His passion for wood does not come from the perspective of being a collector. Rather, Wornick is motivated by his maker's eye. With a family heritage of woodworking as a background, Wornick enjoys the unparalleled freedom of contemporary aesthetic expression, which he sees as coming from "the limitless discoveries in the wood itself."

EDUCATION

Massachusetts Institute of Technology, Cambridge, M.S. in food science, 1958

Tufts University, Boston, B.S. in biology, 1954

PROFESSIONAL EXPERIENCE

The Wornick Company, Burlingame, California, president and chief executive officer, 1977–present

The Clorox Company, Oakland, California, director and group vice president, 1972–76

United Fruit Company, Boston, director of corporate development, 1959–70

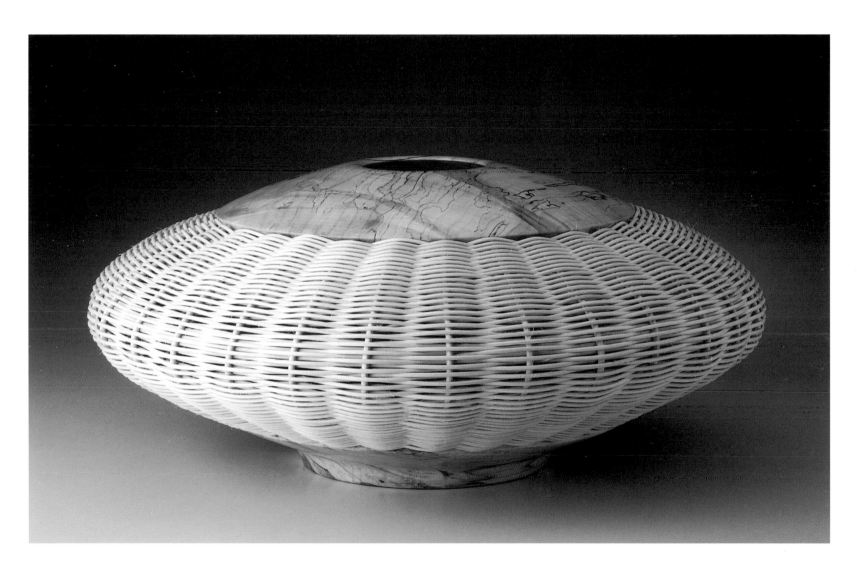

Ron Wornick

UNTITLED (Basket), 1994

Turned and woven spalted maple and reed
7¼ × 16⅛ × 16⅛ in. (18.4 × 41 × 41 cm)

Selected Bibliography and Sources

BOOKS

Abbel, Sydney, et al. *A Bibliography of the Art of Turning and Lathe and Machine Tool History.* 3d ed. Tucson, Ariz.: The Museum of Ornamental Turning, 1987.

Abbott, Mike. *Green Woodwork.* Lewes, East Sussex: Guild of Master Craftsman Publications, 1989.

Bertorelli, Paul, et al. *Fine Woodworking Design Book Four.* Newtown, Conn.: Taunton Press, 1987.

————. *Fine Woodworking Design Book Five.* Newtown, Conn.: Taunton Press, 1990.

Blandford, Percy. *Wood Turning.* London: W. & G. Foyle, 1976.

Boase, Tony. *Woodturning Masterclass.* Lewes, East Sussex: Guild of Master Craftsman Publications, 1995.

Borre, William. *The Art of Freehand Turning in Miniature.* Windsor, Ontario: B. J. Miniatures, 1982.

Boulter, Bruce. *Woodturning in Pictures.* New York: Sterling Publishing, 1983.

Bray, Hazel. *California Craftsmen's Second Biennial.* Oakland, Calif.: Oakland Art Museum, 1963.

Brickman, Arnold. *Turned Wood: Small Treasures.* Los Angeles: Del Mano Gallery, 1996.

Bridgewater, Alan, and Gill Bridgewater. *Award-Winning Designs for Woodturning.* New York: Sterling Publishing, 1987.

Castle, Wendell. *Peter Pierobon.* New York: Franklin Parrasch Gallery, 1994.

Conway, Patricia. *Art for Everyday.* New York: Clarkson Potter Publishers, 1990.

Cox, Jack. *Beyond Basic Turning: Off-Centered, Coopered, and Laminated Work.* Fresno, Calif.: Linden Publishing Company, 1993.

Cramlet, Ross. *Woodturning Visualized.* Milwaukee: Bruce Publishing, 1966.

Darlow, Mike. *The Practice of Woodturning.* 2d ed. New York: Sterling Publishing, 1996.

Dormer, Peter. *The New Furniture: Trends + Traditions.* London: Thames and Hudson, 1987.

DuBois, Alan. *National Objects Invitational.* Little Rock: The Arkansas Arts Center Decorative Arts Museum, 1995.

Fago, D'Ann. *A Diversity of Gifts: Vermont Women at Work.* Woodstock, Vt.: Countryman Press, 1989.

Frankel, Dextra. *Craftsmen of the Southwest.* New York: American Craftsmen's Council, 1965.

Gear, Josephine. *Eight Contemporary Sculptors: Beyond Nature, Wood into Art.* Coral Gables, Fla.: Lowe Art Museum, University of Miami, 1994.

George, Phyllis. *Craft in America: Celebrating the Creative Work of the Hand.* Fort Worth, Tex.: Summit Group, 1993.

Gibson, Scott, et al. *Fine Woodworking Design Book Seven.* Newtown, Conn.: Taunton Press, 1996.

Giles, Dorothy, et al. *Designer Craftsmen U.S.A. 1953.* New York: American Craftsmen's Educational Council, 1953.

Glasgow, Andrew. *Rude Osolnik: A Retrospective.* Asheville, N.C.: Southern Highland Crafts Guild, 1989.

Gustavsson, Ragnar, and Olle Olson. *Creating in Wood with the Lathe.* New York: Van Nostrand Reinhold Company, 1968.

Hall, Julie. *Tradition and Change: The New American Craftsman.* New York: E. P. Dutton, 1977.

Heavenrich, Samuel. *California Designed.* Long Beach, Calif.: Municipal Art Center, 1956.

Herman, Lloyd. *From the Woods: Washington Wood Artists.* Bellingham, Wash.: Whatcom Museum of History and Art, 1991.

———. *Woodenworks.* Washington, D.C.: Renwick Gallery, National Collection of American Art, Smithsonian Institution, 1972.

Hobbs, Robert. *Mark Lindquist: Revolutions in Wood.* Seattle: University of Washington Press, 1995.

Hogbin, Stephen. *Wood Turning: The Purpose of the Object.* New York: Van Nostrand Reinhold Company, 1980.

Holtzapffel, John Jacob. *Hand or Simple Turning.* 1881. Reprint. London: Dover, 1976.

Holzapfel, Michelle. *Michelle Holzapfel.* New York: Peter Joseph Gallery, 1991.

Hopper, Ray. *Multi-Centre Woodturning.* Lewes, East Sussex: Guild of Master Craftsman Publications, 1992.

Hoskins-Brown, Ann, and Albert LeCoff. *Lathe-Turning: Processes, Products, and Practitioners.* Philadelphia: Wood Turning Center, 1994.

Hunnex, John. *Woodturning: A Source Book of Shapes.* Lewes, East Sussex: Guild of Master Craftsman Publications, 1993.

Jacobson, Edward. *The Art of Turned-Wood Bowls.* New York: E. P. Dutton, 1985.

———. *Nature Turning into Art: The Ruth and David Waterbury Collection of Turned-Wood Bowls.* Northfield, Minn.: Carleton College, 1995.

James, Gerald. *Woodturning: Design and Practice.* London: John Murray, 1958.

Jones, Harvey. *California Woodworking.* Oakland, Calif.: The Oakland Museum, 1980.

Kangas, Matthew, et al. *Tales and Traditions: Storytelling in Twentieth-Century American Craft.* Seattle: University of Washington Press, 1993.

Kass, Emily. *Artful Objects: Recent American Crafts.* Fort Wayne, Ind.: Fort Wayne Museum of Art, 1989.

Kaufman, Edgar, Jr. *Prestini's Art in Wood.* New York: Pantheon, Pocahontas Press, 1950.

Kelsey, John, et al. *Fine Woodworking Design Book.* Newtown, Conn.: Taunton Press, 1977.

———. *Fine Woodworking Design Book Two.* Newtown, Conn.: Taunton Press, 1979.

———. *Fine Woodworking Design Book Three.* Newtown, Conn.: Taunton Press, 1983.

Key, Ray. *Woodturning: A Designer's Notebook.* New York: Sterling Publishing, 1987.

Klenke, William. *The Art of Woodturning.* Peoria, Ill.: Charles Bennett Company, 1954.

LeCoff, Albert. *Challenge V: International Lathe-Turned Objects.* Philadelphia: Wood Turning Center, 1993.

———. *Lathe-Turned Objects: An International Exhibition.* Philadelphia: Wood Turning Center, 1988.

———. *Works off the Lathe: Old and New Faces.* St. Louis: Craft Alliance, 1987.

———. *Works off the Lathe: Old and New Faces, II.* St. Louis: Craft Alliance, 1988.

LeCoff, Albert, et al. *Revolving Techniques: Clay, Glass, Metal, Wood.* Doylestown, Pa.: James A. Michener Art Museum, 1992.

Lindquist, Mark. *Sculpting Wood: Contemporary Tools and Techniques.* Worcester, Mass.: Davis Publications, 1986.

Lineberry, Heather Sealy. *Turning Plus: Redefining the Lathe-Turned Object III.* Tempe: Art Museum, Arizona State University, 1994.

Lipsitt, Cyrus. *Woodturners of the Northeast 1990.* Worcester, Mass.: The Worcester Center for Crafts, 1990.

Marsh, Bert. *Bert Marsh: Woodturner.* Lewes, East Sussex: Guild of Master Craftsman Publications, 1995.

Martin, Terry. *Wood Dreaming: The Spirit of Australia Captured in Woodturning.* Sydney, Australia: Angus & Robertson, 1996.

Matthews, Lydia. *From the Center.* Eureka, Calif.: Humboldt Arts Council, 1989.

Mayer, Barbara. *Contemporary American Craft Art.* Salt Lake City: Gibbs M. Smith, 1988.

Mayfield, Signe. *Marriage in Form: Kay Sekimachi and Bob Stocksdale.* Palo Alto, Calif.: Palo Alto Cultural Center, 1993.

Meilach, Dona. *Creating Small Wood Objects as Functional Sculpture.* New York: Crown Publishers, 1976.

———. *Woodworking: The New Wave*. New York: Crown Publishers, 1981.

Monroe, Michael. *The White House Collection of American Crafts*. New York: Harry N. Abrams, 1995.

Nichols, Ann. *Hand of a Craftsman, Eye of an Artist*. Chattanooga, Tenn.: Hunter Museum of Art, 1993.

Nish, Dale. *Artistic Woodturning*. Provo, Utah: Brigham Young University Press, 1980.

———. *Creative Woodturning*. Provo, Utah: Brigham Young University Press, 1975.

———. *Master Woodturners*. Provo, Utah: Brigham Young University Press, 1985.

———. *Rude Osolnik: A Retrospective*. Asheville, N.C.: Southern Highlands Handicraft Guild, 1988.

Nordness, Lee. *Objects: USA*. New York: Viking Press, 1970.

Partridge, Jim. *High Weald Design Project*. Lewes, East Sussex: High Weald, 1994.

———. *Greenwood*. London: Contemporary Applied Arts, 1995.

Pearson, Katherine. *American Crafts: A Source Book for the Home*. New York: Stewart, Tabori & Chang, Publishers, 1983.

Pye, David. *David Pye: Wood Carver and Turner*. London: Crafts Council, 1986.

———. *The Nature and Aesthetics of Design*. London: Herbert Press, 1978.

———. *The Nature and Art of Workmanship*. New York: Van Nostrand Reinhold Company, 1968.

Raffan, Richard. *Turned-Bowl Design*. Newtown, Conn.: Taunton Press, 1987.

———. *Turning Wood with Richard Raffan*. Newtown, Conn.: Taunton Press, 1985.

Rebhorn, Eldon. *Woodturning*. Bloomington, Ill.: McKnight & McKnight Publishing, 1970.

Roszkiewcz, Ron. *The Woodturners' Art*. New York: Macmillan Press, 1986.

Röttger, Ernst. *Creative Wood Design*. New York: Van Nostrand Reinhold Company, 1960.

Rowley, Keith. *Woodturning—A Foundation Course*. Lewes, East Sussex: Guild of Master Craftsman Publications, 1990.

Sainsbury, John. *The Craft of Woodturning*. London and New York: McGraw-Hill Publishing, 1980.

Schultz, Andy, et al. *Fine Woodworking Design Book Six*. Newtown, Conn.: Taunton Press, 1992.

Silver, Eileen, et al. *Challenge IV: International Lathe-Turned Objects*. Philadelphia: Wood Turning Center, 1991.

Spielman, Patrick. *The Art of the Lathe*. New York: Sterling Publishing, 1996.

Sottsass, Ettore. *International Design Yearbook*. New York: Abbeville Press, 1990.

Springett, David. *Woodturning Wizardry*. Lewes, East Sussex: Guild of Master Craftsman Publications, 1993.

Stamm-Connell, Martha. *Contemporary Works in Wood*. Huntsville, Ala.: Huntsville Museum of Art, 1990.

———. *Out of the Woods: Turned Wood by American Craftsmen*. Mobile, Ala.: Fine Arts Museum of the South, 1992.

Stokes, Gordon. *Modern Woodturning*. London: Evans Brothers, 1973.

Stone, Michael. *Contemporary American Woodworkers*. Salt Lake City: Gibbs M. Smith, 1986.

Taragin, Davira S., et al. *Contemporary Crafts and the Saxe Collection*. Toledo: The Toledo Museum of Art, in association with Hudson Hills Press, 1993.

Thorlin, Anders. *Ideas for Woodturning*. London: Evans Brothers, 1977.

Turner, Ralph. *Jim Partridge*. Ruthin, Clwyd, North Wales: Ruthin Craft Centre, 1993.

Turner, Ralph, et al. *Jim Partridge: Woodworker*. London: Crafts Council, 1989.

Wallace, Kevin. *Turned Wood '88*. Los Angeles: Del Mano Gallery, 1988.

———. *Turned Wood '89*. Los Angeles: Del Mano Gallery, 1989.

———. *Turned Wood '90*. Los Angeles: Del Mano Gallery, 1990.

———. *Turned Wood '91*. Los Angeles: Del Mano Gallery, 1991.

———. *Turned Wood '92*. Los Angeles: Del Mano Gallery, 1992.

———. *Turned Wood '93*. Los Angeles: Del Mano Gallery, 1993.

———. *Turned Wood '94*. Los Angeles: Del Mano Gallery, 1994.

———. *Turned Wood '95*. Los Angeles: Del Mano Gallery, 1995.

———. *Turned Wood '96*. Los Angeles: Del Mano Gallery, 1996.

Walshaw, T. D. *Ornamental Turning*. Hemel Hempstead, England: Argus Books, 1990.

Weldon, David. *Shapes for Woodturners*. London: B. T. Batsford Publishing, 1992.

Wilcox, Donald. *New Designs in Wood*. New York: Van Nostrand Reinhold Company, 1970.

Wilk, Christopher. *The Art of Wood Turning*. New York: American Craft Museum, 1983.

Wilson, Rob. *Narratives in Wood*. Redding, Calif.: Redding Museum and Art Center, 1989.

SELECTED MAGAZINES

American Craft
72 Spring Street
New York, NY 10012

American Style
3000 Chestnut Avenue, Suite 300
Baltimore, MD 21211

American Woodturner
RR 1, Box 5248
Montpelier, VT 05602

American Woodworker
33 East Minor Street
Emmaus, PA 18098

Australian Wood Review
330 Mt. Colton Road
Mt. Colton, Queensland, Australia 4165

Australian Woodworker
40–44 Red Lion Street
Rozelli, New South Wales, Australia 2039

Contemporary Craft Review
114 Gertrude Street
Fitzroy, Victoria, Australia 3065

Craft Arts International
P.O. Box 363
Neutral Bay, Sydney, NSW, Australia 2089

Crafts
Crafts Council
44a Pentonville Road
London N1 9BY England

Fine Woodworking
Taunton Press
63 South Main Street
Newtown, CT 06470-5506

Popular Woodworking
1041 Shary Circle
Concord, CA 94518-2407

Practical Woodworking
King's Reach Tower
Stamford Street
London SE1 9LS England

Today's Woodworker
21801 Industrial Boulevard
Rogers, MA 55374

Turning Points
Wood Turning Center
P.O. Box 25706
Philadelphia, PA 25706

Woodcarving
Guild of Master Craftsman Publications Ltd.
166 High Street
Lewes, East Sussex BN7 1XU England

Wood Magazine
1912 Grand Avenue
Des Moines, IA 50309-3345

Woodshop News
35 Pratt Street
Essex, CT 06426

Woodsmith
2200 Grand Avenue
Des Moines, IA 50312

Woodturning
Guild of Master Craftsman Publications Ltd.
166 High Street
Lewes, East Sussex BN7 1XU England

Woodwork
P.O. Box 1529
Ross, CA 94957

Woodworker
P.O. Box 10034
Des Moines, IA 50350-0034

Woodworkers Journal
P.O. Box 1629
New Milford, CT 06776

Woodworkers' Network
P.O. Box 390670
Mountain View, CA 94039-0670

Woodworker West
P.O. Box 66751
Los Angeles, CA 90066

Woodworking Today
Guild of Master Craftsman Publications Ltd.
166 High Street
Lewes, East Sussex BN7 1XU England

SELECTED RESEARCH RESOURCES

American Association of Woodturners
667 Harriet Avenue
Shoreview, MA 55126
(national artist membership organization, index to artists' and craftsmen's addresses, index to state-by-state woodturner organizations)

Crafts Council
12 Waterloo Place
Lower Regent Street
London SW1Y 4AU England
(national artist archives, exhibition and conference organizer, publisher for craft books)

Design Documentation
Woodlands Stone Cross
Mayfield, East Sussex TN20 6EJ England
(index for craft and design magazines)

Directory of Artists & Craftsmen
P.O. Box 424
Devault, PA 19432
(index for artists and craftsmen's addresses)

Guild of Master Craftsman Publications Ltd.
166 High Street
Lewes, East Sussex BN7 1XU England
(publisher of woodworking books)

Knotwhole Publishing
5629 Main Street
Stratford, CT 06497
(index for woodworking magazines)

Linden Publishing
3845 North Blackstone Avenue
Fresno, CA 93726-9949
(publisher of woodworking books)

Taunton Press
63 South Main Street
Newtown, CT 06470-5506
(publisher of woodworking books and magazine)

Wood Turning Center
P.O. Box 25706
Philadelphia, PA 19144
(national artist archives, publisher of woodworking books, exhibition and conference organizer, wood collection)

Woodfind
P.O. Box 2703G
Lynnwood, WA 98036
(index for woodworking magazines)